Scottish Art in the 20th Century

OTHER ART BOOKS PUBLISHED BY MAINSTREAM

JOAN EARDLEY, RSA
by Cordelia Oliver

SCOTTISH ART 1460–1990
by Duncan Macmillan

SYMBOLS OF SURVIVAL: THE ART OF WILL MACLEAN
by Duncan Macmillan

PETER HOWSON
by Robert Heller

THE PAINTINGS OF STEVEN CAMPBELL:
THE STORY SO FAR
by Duncan Macmillan

ALBERTO MORROCCO
by Victoria Keller and Clara Young

JOHN KIRBY: THE COMPANY OF STRANGERS
by Edward Lucie-Smith

PEOPLE'S ART: WORKING-CLASS ART
FROM 1750 TO THE PRESENT DAY
by Emmanuel Cooper

JOHN BELLANY
by John McEwen

DUNCAN MACMILLAN

Scottish Art in the 20th Century

MAINSTREAM
PUBLISHING

EDINBURGH AND LONDON

First published in Great Britain in 1994 by

MAINSTREAM PUBLISHING COMPANY (EDINBURGH) LTD
7 Albany Street
Edinburgh EH1 3UG

ISBN 1 85158 630 X

The publisher gratefully acknowledges the financial assistance of the
The Scottish ▲rts Council in the production of this book

A catalogue record for this book is available from the British Library

Designed by John Martin

Typeset in Perpetua by Litho Link Ltd., Welshpool, Powys
Printed and bound in Hong Kong by Mandarin Offset

For my mother

ACKNOWLEDGMENTS

In writing this book and in doing the research for it, I have incurred many obligations, all of which I gratefully acknowledge. I would particularly like to thank Murdo Macdonald who read my text at an early stage and made a number of very helpful suggestions. Valerie Fiddes has been a great support to me in the Talbot Rice Gallery while I have been working on the book where Morag Thomson has also worked hard in helping me with the collection of the illustrations. I also owe special thanks to the Lord Hindlip of Christies, Manson and Wood for sponsorship towards the cost of the illustrations. The following individuals have also been especially helpful in finding illustrations: Patrick Bourne, Hans Jacob Brun, Jude Burkhauser, Mrs Betty Cumming, Gilly Dobson, Valerie Fairweather, Tom Fidelo, Cyril Gerber, Francis Graham-Dixon, William Hardie, Tom Hewlett, Martin Hopkinson, Deborah Hunter, Barclay Lennie, Robin Lorimer, Mrs Romanna McEwen, Neil McRae, Jennifer Melville, Ewan Mundy, Cordelia Oliver, Fiona Pearson, Guy Peploe, J.D.M. Robertson of S.J.D. Robertson Group Ltd, Orkney, Pamela Robertson, Robin Rodger, Bill Smith of Robert Flemings Plc, Winnie Tirrell, Peter Trowles, Tom Wilson and Clara Young. I have also had assistance with illustrations which I gratefully acknowledge from the following galleries and institutions, Astrup Fearnley Museet for Moderne Kunst, Oslo, the British Council Collection, Browse and Darby, Anthony D'Offay, Flowers East, Gimpel Fils, Annely Juda, the Guardian Insurance Co, Marlborough Fine Art, the Redfern Gallery and the Scottish Arts Council Collection. I am also particularly indebted to Earl Haig and the Trustees of the Scottish National War Memorial who have been generous in very exceptionally allowing access to the War Memorial for the purpose of photography. There and elsewhere Joe Rock has once again produced first-class photographs of a number of works not hitherto properly recorded. In the latter part of the book especially, however, it is the artists themselves who have been a major support in providing illustrations of their works. Indeed without them there would be no book and so it is to them that I owe special gratitude.

Duncan Macmillan

CONTENTS

Frontispiece: CHARLES RENNIE MACKINTOSH, section from the *Willow Tea Rooms* frieze, 1904

INTRODUCTION

Art does not acknowledge frontiers either of place or of time. Great art is truly international and it can speak to all ages, but this internationalism is a measure of the recognition that artists can achieve in their lifetime or afterwards. It can never be a condition of the origin of their art for, in another sense no matter how great it may be, in its roots all art is local. If a community has any kind of independent, intellectual and imaginative life, the production of art in the present is an integral part of the way in which it talks among itself about the things that matter to it. Such a community can be a single city, a metropolis, or a nation. Whatever its size, if it has any vitality, its members will also draw inspiration from what is being said and done elsewhere and will in turn contribute to a wider, international dialogue; but to judge the art of such a community only by its international significance is to expect a supply of exotic cut-flowers without cultivating the garden or heating the greenhouse.

It is in this perspective that art in Scotland in the twentieth century should be judged. Internationally, if the country has not produced a Picasso, it has nevertheless not done badly. Some of the artists who have achieved international reputations like Mackintosh, Fergusson, Johnstone, Davie, Paolozzi, Finlay, Bellany or Campbell together make a respectable showing, but there can be little doubt that even if it was only as something to react against, the coherence of the background from which they came contributed to the achievement of such artists. To understand the parts it is necessary to understand the whole, therefore, and figures like Gillies or Philipson and less celebrated individuals, too, are part of its fabric and of the texture of its coherence. Even if in an international perspective such artists may seem conservative, they are well loved because they gave expression to something that was a valid part of the culture to which they belonged, while the continuity that they represent, and which through teaching they have passed on, has helped to keep alive the art to which they dedicated their lives.

The independence and the strength of the four Scottish art schools where such people have mostly taught, or indeed still teach, has been a vital part of this continuity and should be treasured, but there have also been some powerful outsiders. Without Fergusson and Johnstone, for instance, Scottish art would be far less rich, not only because of their individual achievements, but for the way in which they maintained and passed on the belief expressed so forcefully by Patrick Geddes a hundred years ago that art is part of a nation's vitality and a measure of its well-being; it should be modern and international in its horizons, but it should also be the product of a nation's own values, of its confidence in itself and of its awareness of its history.

Geddes was many things, but in the visual arts he was the champion in Scotland of the ideals of the Arts and Crafts movement, led in England by men like William Morris and Walter Crane. These

ideals have been an important part of the British contribution to twentieth-century art. Lost from sight, but never forgotten, they have come back into their own in the late twentieth century when some of the self-confidence of modernism has been called into question. Underlying the structure of this book, though they are not two mutually exclusive groups, there is perhaps a kind of counterpoint between the academic tradition on one hand and the Scottish artists who have remained loyal to the central truth in these ideals on the other. The latter have subscribed above all to the belief that art is not a self-sufficient and self-fulfilling activity, but a vital part of the fabric of the wider moral and intellectual life of the community that produces it. One of the most remarkable expressions of this idea to be found anywhere is the Scottish National War Memorial, but today, too, artists of Scottish origin like Finlay and Paolozzi are outstanding in the international community in their dedication to a recognisably similar view of the function of their art.

A conspicuous number of major artists in the last hundred years in Scotland have been women and perhaps they too have drawn strength from this tradition. If more recently some among them have worked to establish a specifically feminine agenda in their art, their ability to do this with such success may surely also still owe something to the achievement of such trail-blazers as Phoebe Traquair as well as to the effectiveness of international feminism in fighting for their cause. Traquair was only one of many women encouraged to claim their birthright by men like Geddes, Fra Newbery, John Duncan and J.D. Fergusson.

In the last six chapters of my earlier book, *Scottish Art 1460–1990,* I covered the period that I deal with in this present book and its text is not much longer than those six chapters, although it is proportionately far more richly illustrated. It was my purpose there, however, to present the claim that there is a distinctive Scottish tradition in the visual arts and that it is an integral part of the intellectual and imaginative heritage of the country. Although it was important to me that the story came up to date, in the long time-frame within which I had to work in order to establish that claim, the particular perspective of the more recent past had to be subordinated to this longer objective. Here, I have sought to correct that by presenting the twentieth century in its own perspective. The earlier book, too, dealt exclusively with painting, whereas here I have endeavoured to give some account of sculpture as well, though regretfully for reasons of space, not of the applied arts.

Although my subject is the twentieth century, by starting my story in the 1890s I hope I have shown not only the continuing importance of the Arts and Crafts ideas that had their origin in the late nineteenth century, but also how the achievement of Scottish artists in the last hundred years grew directly out of the longer tradition. The art of this century has not been merely – and from the start – a dim reflection of bright lights shining from elsewhere far across the water. Those bright lights may have been more important than ever previously perhaps; nevertheless, when Mackintosh, for instance, who had at the time only ever lived and worked in Scotland, saw himself as a pioneer of the modern movement,[1] he was simply stating a fact. When, too, artists like Fergusson and Johnstone approached those lights to learn beneath them, whether in Paris or elsewhere, they could do so with the modest confidence that the background from whence

they themselves had come was not without its own illumination in the achievement of such individuals as McTaggart and Melville.

From the start in writing this book, it was my objective to try to produce a work that would not be so large that the price of production would make it too expensive in the shops for anyone interested in the subject to be able to buy, especially the young. This ambition has inevitably put a constraint on space. Particularly in the later chapters where the sheer number of artists working in the country is so large, this is bound to have meant that some artists do not appear who nevertheless have a claim to be mentioned. I would particularly like to have been able to give more space to the up-and-coming generation, but I do not doubt that they are preparing the ground for someone else to write a new and better book. It has certainly not been my aim here to try to have the last word. On the contrary, as it was in *Scottish Art 1460–1990,* my purpose has been to sketch from my own point of view the outlines of a map so that others who are better equipped can explore the territory more thoroughly than I have been able to do. I do not of course forget those who have covered part of this ground before me, particularly Edward Gage in *The Eye of the Wind: Scottish Painting Since 1945,* Jack Firth in *Scottish Watercolour Painting*, William Hardie in *Scottish Painting from 1837 to the Present* and Keith Hartley in *Scottish Art Since 1900.*

Duncan Macmillan,
Balnagrantach,
March 1994

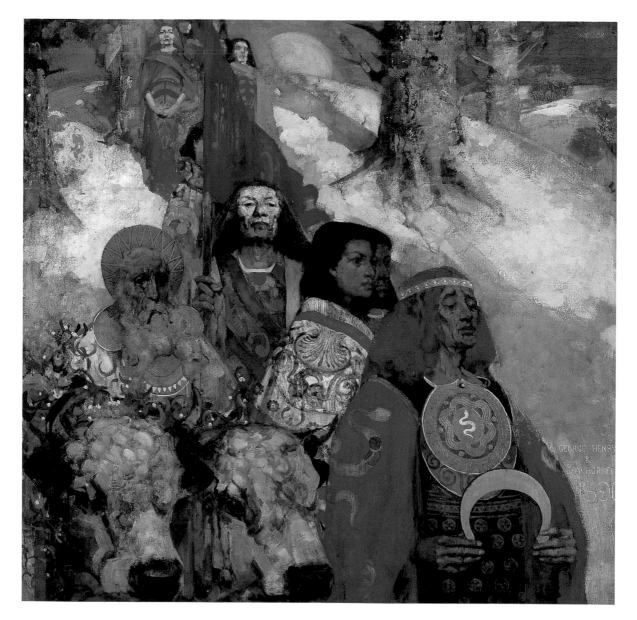

Plate 1. GEORGE HENRY and E.A. HORNEL, *The Druids: Bringing Home the Mistletoe*, 1890

CHAPTER ONE

THE EARLY MODERNISTS

The twentieth century has arguably seen more variety in the visual arts than was seen in the whole of the preceding millennium. Since early in the century, too, we have tended to see this as setting it apart from all previous periods in history. In some ways, of course, this is true, but the continuities are also important. Much of the radical thinking which founded the social and technological revolutions of the twentieth century – and, as it did so, undermined the old certainties that had hitherto shaped human belief – was a product of the nineteenth and even the eighteenth centuries. This is as true in art as in any other branch of imaginative and intellectual activity. To write the history of twentieth-century art as though describing a landscape convulsed by a single earthquake whose epicentre was Paris around 1910, and whose aftershocks have continued to be felt for the succeeding eighty years or more, is dramatically simple but therefore also misleading. The texture of art history is much richer and its field much broader than such an account allows. Looking back into the ten or twenty years before 1910, the art world is strikingly international, with exchanges taking place not only on the well-worn routes from the centre – invariably taken to be Paris – to the periphery, but between such centres as London and Barcelona, or Glasgow and Munich or Vienna.

It is possible, therefore, to start a history of art in Scotland in the twentieth century with an account of Scottish artists like Charles Rennie Mackintosh (1868–1928) or the Macdonald sisters, Margaret (1863–1933) and Frances (1874–1921), not as inferior subjects in some centralised, hierarchical kingdom of art, but as citizens in a wide commonwealth of equals. And, indeed, in March 1903, it was with just this view of himself that, in a letter to Joseph Hoffman in Vienna, Mackintosh raised the banner of modern art, or as he calls it in a term that was to become universal, modernism. Modernism, he wrote, 'is something vital, something good, the only possible art for all and the highest achievement of our time.'[1] It is striking that Mackintosh sees it as a style 'for all' and it is a reminder of the importance of the social vision of the Arts and Crafts movement, but especially of its Scottish spokesman Patrick Geddes, in Mackintosh's own development. It also expresses an aspiration that has remained true, to a significant extent, in Scotland. Here modernism seems to have been associated less often than it was in the south with the kind of conscious élitism that we can forgive in someone like T.S. Eliot, but which crippled some of his lesser contemporaries – though in Scotland Hugh MacDiarmid for one was certainly not entirely immune from it.

Three years before he wrote this letter, in November 1900 when they exhibited at the Eighth Secession Exhibition in Vienna, Mackintosh, the Macdonald sisters and Herbert MacNair (1868–1955) – the Four as they were called at the Glasgow School of Art where they were students together in the 1890s – had left their mark on Viennese art and design. Ten years earlier still, however, a group of some sixty Scottish paintings had been shown by invitation at the Munich Art Society where they had also met with considerable acclaim. These were principally from Glasgow, but among the most important painters represented was Arthur Melville (1855–1904). After this, Scottish painters continued to exhibit in Munich throughout the 1890s, both at the Art Society and

at the Munich Secession when it was formed in 1893. Scottish artists exhibited as a group elsewhere in Europe and in America, too, and when the Four showed in Vienna in 1900 there had already been a significant Scottish presence at the Vienna Secession three years earlier in 1897. Their success there was not without precedent, therefore, and nobody would have questioned Mackintosh's qualification as a Scot to talk as he did about modernism as one of its prime movers and at the very outset of that movement.

To judge by the comments of Richard Muther, a contemporary in Munich, the kind of painting that had made a reputation for the Scots there was the decorative, imaginative and essentially symbolist painting that was represented by Arthur Melville's *Audrey and her Goats,* George Henry's *Galloway Landscape,* or by Henry (1858–1943) and E.A. Hornel's (1864–1933) joint painting *The Druids* (1). In 1896 Muther wrote:

> Here there burst out a style of painting which took its origin altogether from decorative harmony and the rhythms of forms and masses of colour . . . It was all the expression of a powerfully excited mood of feeling through the medium of hues, a mood such as the lyric poet reveals by the rhythmical dance of words, or the musician by tones . . . The chords of colour which they struck were full, swelling, deep and rotund, like the sound of an organ swelling through a church at the close of a service.[2]

Henry and Hornel's *Druids* is a strongly coloured, flat composition, its surface enhanced with embossed gold. Such a frank declaration of a decorative intention was unusual, if it was not unprecedented in continental European painting. It looked back to the Pre-Raphaelitism of Rossetti and among the two painters' contemporaries in Scotland, it surely showed their admiration for Phoebe Traquair. Certainly it reflected in general the inspiration of the Arts and Crafts movement. It was one of the ideals of that movement that art should not be so much a personal as a collaborative venture and Henry and Hornel worked together on this picture. They were not deliberately naive like their contemporaries in

Pont Aven under the leadership of Gauguin. Like them nevertheless, however, as Richard Muther makes clear, it was their objective to take painting into an imaginative, decorative realm in which it was autonomous and where the rules were not borrowed either from representation or illustration. Like the French Symbolist movement of which the Pont Aven painters were a part, therefore, this kind of painting was a reaction against the imperative to achieve a truthful representation of 'reality' that had underlain most European painting in the orbit of Impressionism. Instead it proposed a return to an art that could function imaginatively without the burden of description.

Among the painters in Scotland, the most important inspiration in this shift to a free, flat and richly coloured painting was Arthur Melville himself. He is often treated as though he were one of the Glasgow Boys, but he never lived or worked in Glasgow. He was an east coast painter, though in 1889 he moved to London, and he is associated with the Glasgow painters because of his close friendship especially with Guthrie, and above all because they looked up to him and to the example of his adventurous freedom both as a man and as an artist. At Munich in 1890, Melville showed *Audrey and her Goats,* ostensibly a narrative picture. The subject is from *As You Like It,* but it is not treated as narrative in the conventional Victorian way. Instead it is a kind of enigmatic confrontation between us and Audrey, the goat-herd, half hidden in the patterns of light and colour from which the picture is composed. The scene is a conversation between Audrey, a simple country girl, and Touchstone, her apparently cultivated but pedantic suitor. He opens his declaration of love to her with great condescension by comparing himself to Ovid in exile among the Barbarians and saying: 'I am here with thee and thy goats as the most capricious poet Ovid was among the Goths.' Responding to his poetic claims, Audrey replies with a disarmingly simple question: 'I do not know what poetical is. Is it an honest and true thing?'

It is a question whose apparent naivety belies what must have been its pertinence to countless encounters between a properly sceptical rural proletariat and the painters who professed to see

Plate 2. ARTHUR MELVILLE, *Brig o' Turk*, 1893

in their lives a poetry that was remote from their real experience of relentless agricultural toil. Melville was surely mocking the grey skies and the imagery of rural labour so much favoured throughout Europe by such painters in the 1880s, painters of 'reality' who followed the example of the French master of 'realism', Bastien-Lepage, and solemnly identified themselves with this peasantry amongst whom, like Touchstone, and with due condescension, many of them went to live.[3]

Certainly, looking at *Audrey and her Goats,* it is easy to see how the Munich painters saw this picture, or alongside it Henry's poetic *Galloway Landscape,* with black and white Galloway cows camouflaged in a wonderful patchwork of sunshine and shadow, as a refreshing move away from the grimmer kinds of realism. They represented a move towards something that was vivid and imaginative in a way that exploited the special qualities of painting. Such pictures as these, or as Melville's own watercolours like *Brig o' Turk* (2), or Sir James Guthrie's (1859–1930) pastels, make clear how rich Scottish painting was at the beginning of the 1890s – especially when, in addition, it is remembered how in the older generation in England, the Scot W.Q. Orchardson was one of the leading painters, while in Edinburgh, William McTaggart (1835–1910) was at the height of his powers.

In 1890 McTaggart exhibited *The Storm* which was followed by such extraordinary pictures as *Jovie's Neuk* (1894) and *The Sailing of the Emigrant Ship* (1895) (3). In terms of the subject

Plate 3. WILLIAM McTAGGART, *The Sailing of the Emigrant Ship*, 1895

of the story of the Highland people, the pendant to McTaggart's *The Sailing of the Emigrant Ship* is his *The Coming of St Columba.* The two subjects represented a perceived beginning and a perceived end of the Highland story, but if *Jovie's Neuk* is taken as partner to *The Sailing of the Emigrant Ship* instead of the Columba picture, the theme suggested by this new coupling becomes universal. *Jovie's Neuk* celebrates the simple tranquillity of children lying on the beach in the summer sun. McTaggart expresses with magical completeness the unity of nature and human innocence. In *The Sailing of the Emigrant Ship* on the other hand, the theme is the dislocation and alienation of experience. In both pictures he achieves his effect by purely pictorial means. The warm ground and broken brushwork in *Jovie's Neuk* unite the children with their environment in a harmony that seems secure because it is unified. In the *Emigrant Ship,* the broken colour and the same brushwork are used to convey the opposite effect, a sense of desolation derived from the insecurity of fragmented experience. Here McTaggart, by birth a Gaelic-speaker, gave the social fragmentation of the Highlands literal expression as in his picture, left behind, the scattered remnants of a displaced people dissolve into the landscape and the land itself dissolves into a stormy and uncertain sea. These two pictures present the universal theme of the Enlightenment and the Romantic movement, therefore: the ideal of a society based on sympathy and in harmony with nature, but also its subsequent evolution into the alienated, urban society of the nineteenth and twentieth centuries. If, sixty years before, Wilkie's *The Cotter's Saturday Night* had encapsulated the humane idealism of the Enlightenment, McTaggart — with the same economy — summarises the forces that shattered it and which bore the modern world.

McTaggart continued to exhibit till near the end of his life paintings which looked right back into the great historical landscapes of Constable, Turner and even Claude on the one hand, yet which on the other hand were prescient of the way in which twentieth-century painters, drawing on the landscape tradition, were finally to seek to resolve one of the fundamental dilemmas of western art, namely the reconciliation of objective vision with subjective experience. The freedom with which McTaggart constructs the image in his work conveys the intuitive and irreducible subjectivity of the modern vision of the world and the dissolution of self in the action which unites the painter with what he describes. Thus he finally bridged the gap between objective and subjective that had for so long been the central problem for a tradition of painting based on an empirical description of the world. He does this, too, in a way that is remarkably like the solution reached a decade later, though it was in a different art form, by Mackintosh in the Glasgow School of Art library. In such paintings, too, McTaggart looks forward to the Abstract Expressionists and to their Scottish equivalents in the later work of William Johnstone and the seascapes of Joan Eardley. Looking at these pictures, therefore, we can see that in its origins, modernism in Scotland as Mackintosh defined it, though it was in close contact with Europe, could also draw on indigenous roots. However much it drew its inspiration from outside, it was not someone else's language borrowed to discuss an agenda that was also set elsewhere.

Plate 4. J.Q. PRINGLE, *Man with Tobacco Pouch,* 1908

It is against this background that we must judge the achievement of painters like the younger Glasgow Boys, or in the next generation artists like Fergusson and Peploe. Melville's tendency to create an abstract pattern of rich colour, light and shade from observed nature was perhaps partly inspired by the example of Monticelli, who was both admired and collected in Scotland at this time; but Melville in turn also clearly influenced contemporary works like Henry's *Autumn* and Hornel's *The Goatherd*. His art was also certainly a factor in the evolution of the painting of J.Q. Pringle (1864–1925), a chemist who was a gifted amateur painter (4), and the use of brushstrokes as decorative accents can still be seen in the work of more abstract and consciously decorative artists like the Macdonald sisters, Jessie M. King (1875–1949) or Annie French (1872–1965). McTaggart, too, continued to play a part. He exhibited one of his *Emigrant* pictures in London along with a group of Scottish artists as late as 1906[4] and the example of his freedom may well have influenced Peploe and Fergusson.

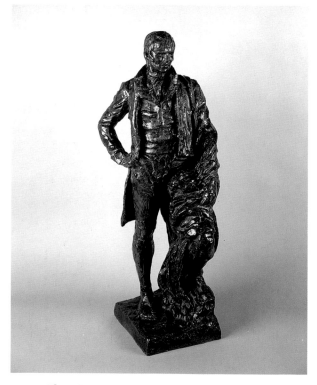

Plate 5. PITTENDRIGH MACGILLIVRAY, maquette for the *Burns Monument*, Irvine, 1895

In its flatness and obvious joy in colour, the kind of painting promoted by Melville was, in the contemporary sense, decorative art; but it also owed something to the improvisations of impressionism, so it occupies an intermediary position between what had by this time become conventional impressionism and the more austere and design-conscious decorative art advocated by the leaders of the Arts and Crafts movement represented by William Morris and Walter Crane. Crane argued that decorative art was the highest form that art could have. If it adorned public buildings, it could be the means of expression for the collective consciousness of the community. This was, of course, a function which traditionally belonged to sculpture, and at the beginning of the twentieth century sculpture itself did receive a significant boost from the ideals of the Arts and Crafts movement in Scotland through the work of the architect Sir Robert Lorimer (1864–1929). The Thistle Chapel in the High Kirk of St Giles in Edinburgh, opened in 1909, was the first project in which he used sculpture extensively. There he employed the remarkable woodcarvers, the Clow brothers, Alexander (1864–1946) and William (*fl.c.*1900–*c.*1940), working from models by the sculptor Percy Portsmouth (1874–1953) and others to create an extraordinarily rich, sculptural decoration.

The way that Lorimer promoted the use of sculpture in architecture and the training of artists and craftsmen to realise it created a new school of sculptors, though there were also brilliant individuals like the leading sculptor in this generation, Pittendrigh Macgillivray (1856–1938). Macgillivray was a remarkable man with whose art the new freedom of sculpture established by Rodin came to Scotland. He was not only a sculptor but also an articulate champion of Scottish Nationalism and of the ideals of public, decorative art. Echoing Crane, for instance, he said of sculpture that it 'inhabits architectural places; it is for the jewelling of cities'.[5] In keeping with this, his major works include such ambitious public monuments as the Gladstone Memorial in Edinburgh which was completed in 1917 with nine figures in all, and

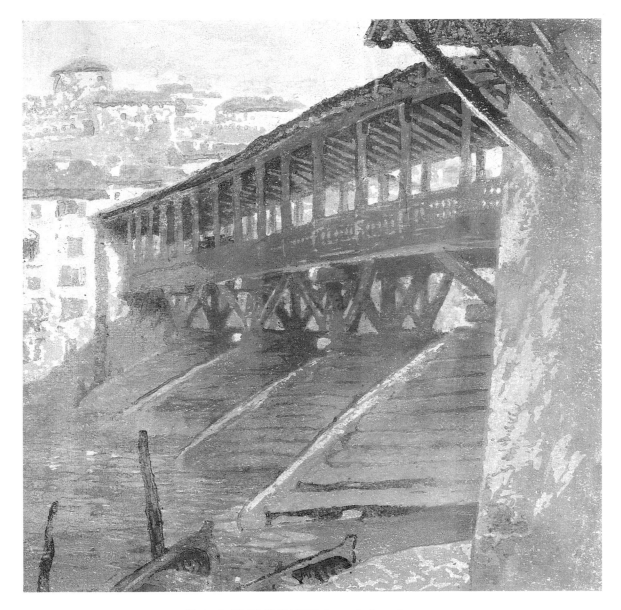

Plate 6. CHARLES MACKIE, *Bassano Bridge*, n.d.

that of Gladstone himself is nine and a half feet high. It is when he works on a smaller scale – as in the model for another monument, that for Burns in Irvine (5) – that the spontaneity of Macgillivray's work can be seen to best advantage, however. For him, the 'handwriting' of the sculptor's touch was a vital part of his art.

What Macgillivray said about sculpture as decorative art also stood for painting, as Crane's definition made clear. Through mural painting, art could function socially, and this became one of the main preoccupations of progressive artists in Britain in the 1890s. These ideas also extended into the applied arts, for they could take beauty into domestic life. Such arts as bookbinding, jewellery-making, needlework and embroidery were accessible to the amateur. It is important to bear in mind here the exalted, moral function that beauty had in the kind of discourse that had

been framed by Ruskin for the nineteenth century, a function that was also fulfilled ideally through the exercise of skill in useful work and which the crafts extended into daily life.

The principal champion of such things in Scotland was Patrick Geddes (1854–1932), a key figure in much of this story. Geddes, of course, was not just a champion of the Arts and Crafts, but he gave a special thrust to its ideals through his vision of society. This stemmed from his recognition of the fact that society is organic and that, in consequence, men and women are no more divisible from the architecture they inhabit and the cities it forms than the polyp is from its coral or the coral from its reef. Like any organism, society is capable of sickness and health, and art – the expression of its mind – is necessary to its healthy function.

In pursuit of this vision, Geddes promoted a

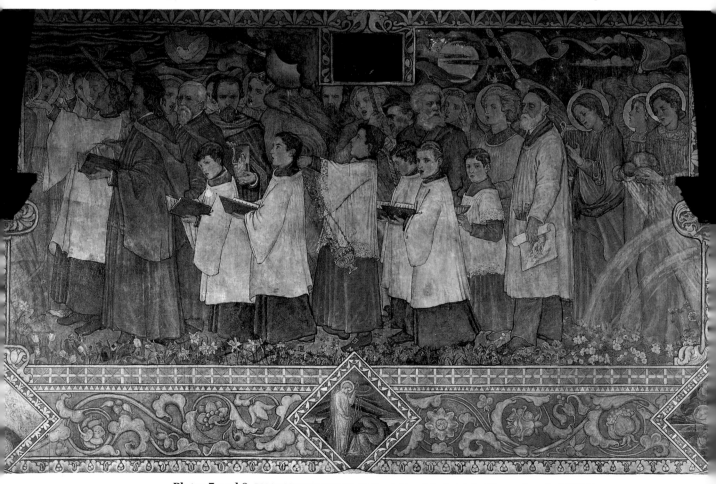

Plates 7 and 8. PHOEBE TRAQUAIR, *St Mary's Song School*, detail of the south wall, 1888-92

number of mural schemes in Edinburgh. At the same time in Glasgow a project for the decoration of the new City Chambers was formed which eventually bore fruit in a series of paintings by Sir John Lavery (1856–1941), Alexander Roche (1861–1921), E.A. Walton (1860–1922) and George Henry. In the Edinburgh City Chambers, too, Robert Burns (1869–1941) painted a more modest series of historical paintings. These are, nevertheless, of interest as they bring the tradition of narrative painting – not just of Orchardson, but of Wilkie himself – well into the twentieth century, though Burns was by no means an old-fashioned artist. Geddes's own patronage included work by Charles Mackie (1862–1920) and John Duncan (1866–1945) in his own flat in Ramsay Garden where Mackie painted a series of pastorals. Not much can be said about these, which only survive in two

reproductions in *Studio*,[6] but Mackie was a talented and independent painter. Through his friendship with the French painter, Paul Serusier, he was the principal link between the Scottish artistic community and the Gauguin circle. Serusier was one of the central figures in the group of Gauguin's followers known as Nabis.

Looking at such paintings by Mackie as *The Bonnie Banks o' Fordie* from the early 1890s, it is clear, however, that he had also developed his own response to symbolist ideas. What he was doing at the time is very close to the work of Henry and Hornel in Glasgow. Later, Mackie's most distinctive work was in his remarkable colour woodcuts where he developed in a highly original way his sense of the relationship between design and representation (6).

For Geddes in Ramsay Garden, John Duncan painted the story of pipe music which, like

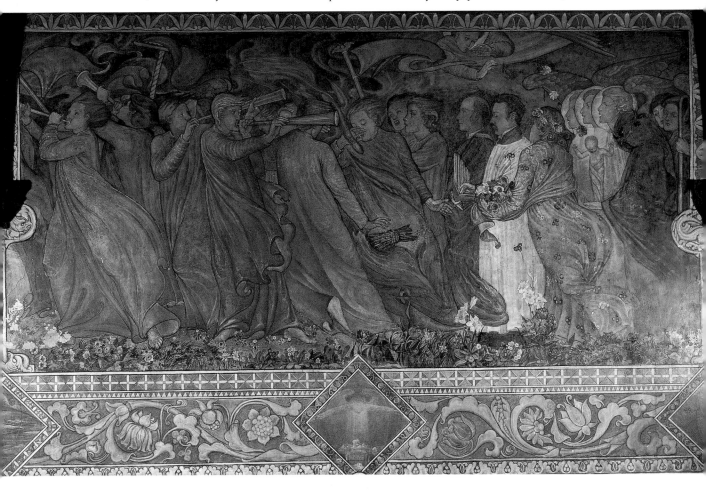

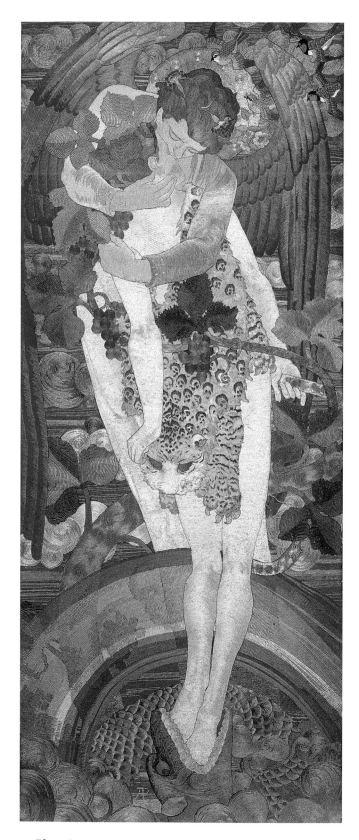

Plate 9. PHOEBE TRAQUAIR, *The Progress of a Soul: The Victory*,
1899-1902, NGS

Mackie's pastorals, has disappeared. In the adjacent Ramsay Lodge – one of the first halls of residence for students in Edinburgh, founded by Geddes – Duncan also began *c*.1896 a set of twelve murals which do survive. The paintings tell the story of Scottish intellectual and imaginative achievement throughout history. The series opens with *The Awakening of Cuchullin*, the first of three scenes from pagan Celtic history. It then moves through the Christian era, starting with *The Coming of St Mungo* and proceeding by way of such figures as the Admirable Crichton – for Geddes, the personification of his idea of the European Scot – Lord Napier, inventor of logarithms and one of the pioneers of modern mathematics, and Walter Scott. The series ends with Lord Lister, pioneer of antiseptics and so a Scottish benefactor of all mankind. It was a typical example of Geddes's vision of the artist as interpreter, not simply of history as something retrospective, but as a source of identity and therefore as an agent in the present of self-esteem and pride in a nation. The art itself becomes a primary vehicle of that self-respect. This helps to explain why the ideal of public art was so important. Significantly, too, prefiguring Paolozzi almost a century later, in Duncan's paintings scientific and technological imagery is interpreted through imaginative, poetic forms. For instance, James Watt stands over his steam engine as Prometheus approaches bearing the gift of fire.

Geddes was one of the founders of a philanthropic organisation called the Social Union, formed with a view to promoting this sort of improvement. Its activities ranged from active intervention in housing to the promotion of decorative and mural schemes and of such self-help teaching as could be provided by technical evening-classes. Geddes also promoted craft skills of this kind among the community through the Old Edinburgh Art School that he founded in 1892 in Ramsay Lane where John Duncan was in charge. Through the Social Union, Geddes was instrumental in promoting several of the mural schemes undertaken by Phoebe Traquair (1852–1936), who was the most successful of all the interpreters of the ideals of the Arts and

Crafts movement in Scotland. (She herself came originally from Ireland and provided a link with the Celtic revival there.) As a mural painter, though, she was not alone. William Hole (1846–1917), for instance, also painted a number of mural schemes, including those for the Scottish National Portrait Gallery where he included one of Geddes's favourite themes, a procession, or pageant of history. No other painter had such a command of the decorative qualities of mural painting as Phoebe Traquair, however. Her first murals, painted in 1885–86, were for the mortuary chapel in the Sick Children's Hospital. These were altered and supplemented when the chapel was moved ten years later, so the original scheme only survives in part.

The mortuary chapel was followed by Traquair's paintings in the St Mary's Song School (1888–92) (7 and 8). These are her most suc-

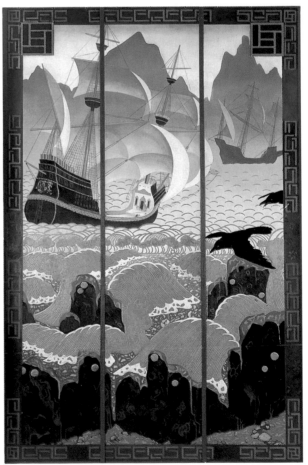

Plate 10. ROBERT BURNS, *A Ship of the Armada*, 1923-27

cessful as decoration. In style they are a brilliant combination of the pre-Raphaelitism of Rossetti with Blake and Quattrocento Italian art, but blended to form a completely coherent decorative language, realised in brilliant colour. The figures in the two long walls form a kind of spiritual choir. This choir joins the boys and girls in the earthly choir practising in the hall in a wonderful, heavenly anthem. It is a perfect example of the Arts and Crafts ideal of the interpenetration of art and life in spiritual and imaginative activity. The same mixture of the real and the spiritual appears in the painting on the walls which includes portraits of such individuals as Rossetti, Holman Hunt and William Morris, and members of the team that built the church, including both clerics and craftsmen.[7]

The most ambitious project by any artist of the whole period was undoubtedly the one that Traquair painted for the Catholic Apostolic Church between 1893 and 1897, covering with a complex and brilliant scheme of paintings the whole upper register of the church and its two chancel aisles. Margaret Macdonald Mackintosh wrote of the decorations in one of the chancel aisles, whose quality is sustained throughout this large building: 'We catch our breath at surroundings so rich and so little anticipated. For the whole chapel scintillates and glows like a jewelled crown.'[8]

In spite of the scale of these undertakings, Phoebe Traquair was also active in many other fields. She was outstanding as an enameller, bookbinder and illuminator of manuscripts, but among her most remarkable works are her large-scale embroideries, especially the *Progress of the Soul,* begun in 1893 and completed in 1902. It consists of four panels of great richness. Together they have a complex iconography that seems to combine Christian and pagan elements. It draws part of its inspiration from Walter Pater[9] and a number of features from Blake's *Book of Job* — which suggests that its theology is far from orthodox and, indeed, at one level it seems to represent the reconciliation of Apollo and Dionysus. The fourth panel, which shows the soul reunited with the divine in an image that recalls the final illumination of Albion reunited

with God in Blake's *Jerusalem,* is an outstanding piece of symbolist art (9). The work was clearly important to the artist, as she kept it hanging in her house throughout her life.

A good many other artists were associated with Geddes and a fair number — including Duncan, Burns and Mackie — contributed to the four numbers of *The Evergreen,* the 'seasonal' review that he and his partners published between 1895 and 1896. One of the most distinguished contributions was the drawing *Natura Naturans* by Robert Burns (actually executed in 1891). Burns was a fine decorative painter; his most easily seen surviving work is the set of panels that he did for Crawfords Tea Rooms in Edinburgh in the 1920s (10). It is important, too, that both Burns and Duncan went on to teach at the new Edinburgh College of Art, opened in 1907, where Burns was the first head of painting. (The new college incorporated the Royal Scottish Academy schools which had themselves earlier incorporated the Trustees Academy, and so in part of its origins the college went back to the foundation of that institution in 1760.)

Gerard Baldwin Brown (1849–1932), first Watson Gordon Professor of Fine Art at Edinburgh University, had been appointed in

Plate 11. STANSMORE DEAN, *Meditation, c.*1899

Plate 12. BESSIE MacNICOL, *Vanity*, 1902

1880 to a chair created in memory of the painter, Sir John Watson Gordon (1788–1864), with the intention that the professor should teach art history to the students at the RSA schools. Baldwin Brown was a close associate of Geddes and was a member of the Social Union. He even taught beaten-metalwork in evening-classes. The relationship between Edinburgh University and the practising artist that his chair represented, was continued in the new institution and, indeed, continues to this day. Although Robert Burns's appointment was terminated early, he, John Duncan and Baldwin Brown together extended the currency of these ideas well into the present century. William Johnstone (1897–1981), for example, remembered the inspiration that he took from hearing Baldwin Brown's lectures on Celtic and Anglo-Saxon art when he was a student in the early 1920s.

The removal of the art schools from the Royal Institution to the new Edinburgh College of Art in Lauriston Place freed space for the RSA. The Academy was finally separated from the National Gallery with whom the academicians had shared Playfair's building since 1859, and since 1910 the Royal Institution building has been known as the RSA. In Glasgow the Exhibition of 1901 had already given the opportunity for the provision of a fitting home for the city's art collections in Kelvingrove. At this time in Edinburgh, the National Gallery was also given a purchase grant for the first time and was

at last able to pursue a coherent policy in building up its collections and to take an active part in the art life of Scotland, which it did successfully under Sir James Caw (1864–1950) and Stanley Cursiter (1887–1976), both of whom were intimately connected with the living business of art.

Among the other leading painters of the time, Arthur Melville himself never undertook a mural scheme, but during the last years of his life he concentrated his efforts on a series of large-scale historical paintings. The first and largest of these was *The Return from the Cross,* which was followed by four paintings from the Christmas story. These all have 'historical' subject matter but are decorative in style, similar in fact to the two co-operative works by Henry and Hornel from the beginning of the decade, the *Druids* and its companion painted a little later, the *Star in the East.* The two together seem to represent respectively the pagan and the Christian vision of the winter equinox, and the latter was, of course, also the subject of Melville's pictures.

It is customary to see Edinburgh and Glasgow as remote from each other, but this is a view that was no more true in the 1890s than it is now. The train between the two cities took little longer then than it does today. (It was certainly cheaper and was probably more reliable.) The progressive principal of Glasgow School of Act, Fra (Francis) Newbery (1855–1946), who did so much to bring forward the talent of artists like the Four, was a friend and associate of Geddes, and although the young Glasgow artists developed a distinctive style, it is only sensible to see their ambitions in the light of this whole contemporary context. Mackintosh, for instance, was typical of his generation in being at the same time painter, designer and architect, while the Macdonald sisters were among a considerable number of young women who took advantage of the new freedom which art education offered them. Here, too, there may be something of Geddes's influence, for his ideas about the roles of the sexes as they were set out in the book that he wrote with J. Arthur Thomson, *The Evolution of Sex,* proved an important document in the liberation of women.[10] Nevertheless, the Macdonald sisters were still typical in the way that, as women, they were directed towards the applied arts. There were many other women in their generation like them specialising in the applied arts with great distinction – such as Anne Macbeth (1875–1948), who was a brilliant designer and embroiderer and who taught at Glasgow School of Art – but there were also successful painters who were exceptions to this rule like Phoebe Traquair herself, or other first-class artists like Bessie MacNicol (1869–1904), Kay Cameron (1874–1965) and Stansmore Dean (1866–1944). Unlike Phoebe Traquair, all these artists were primarily easel painters.

Kay Cameron's reputation has been a little overshadowed by that of her brother, D.Y. Cameron; she is best known as a flower painter, but her work is much more diverse than this. Stansmore Dean was a graduate of Glasgow who went on to study in Paris. She was a distinguished painter whose *Meditation* of c.1899, for example, is in a light, free manner, quite untouched by academic formality (11). She became the second wife of the critic Robert Macaulay Stevenson, though she did continue to paint. Bessie MacNicol died in childbirth in 1904 when she was only 35, but in her short career she achieved a considerable reputation. She, too, studied at Glasgow School of Art, from 1887 to 1892, and she continued her studies in Paris at the Académie Colarossi. In the mid-1890s, she spent time in Kirkcudbright in the company of painters, among them younger Glasgow Boys like David Gauld (1865–1936) and Hornel. The latter's influence is apparent in her work at this time in the dappled light of pictures like *A Girl of the Sixties,* but she had an independent vision that took her close to the Colourists at times in pictures like *The Green Hat.* The paintings from the last two or three years of her life included the remarkable *Vanity* of 1902 (12). This is a sensual study of a female nude with a distinct and – in a Scottish context – quite unexpected air of voluptuous decadence about it. It is reminiscent of some contemporary German painting; MacNicol had exhibited quite widely on the continent including, on several occasions, in Germany.

What distinguished Mackintosh and the rest

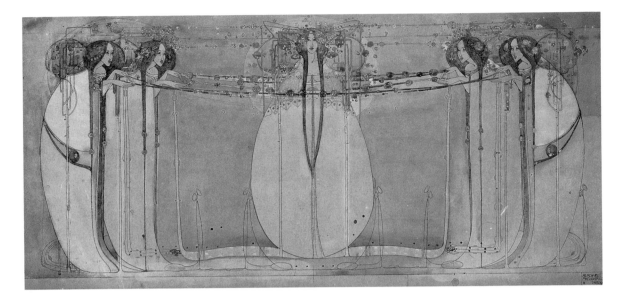

Plate 13. MARGARET MACDONALD, sketch for *The May Queen*, 1900

of the Four as artists, however, was first of all their inventiveness. They created a decorative language that was exploited and developed by a number of their contemporaries. This began with the rather wild imagery which earned them the sobriquet of 'the Spook School'. It was not in itself exceptional when it is compared to contemporary work of the Belgian symbolist Toorop and other artists seen in the pages of *Studio* such as Aubrey Beardsley, but it evolved into the kind of genuine originality of such nearly abstract designs as Mackintosh's two watercolours the *Tree of Influence* and the *Tree of Indifference* and later designs related to these like his frieze for the Willow Tea Rooms (*Frontispiece*). This is a brilliant, almost completely abstract design, though within it the forms of the willow tree's growth are still recognisable. Similarly, Margaret Macdonald's decorative frieze, the *May Queen,* shown in Vienna (13), and her twelve panels carried out for the Waerndorfers' Music Salon, also in Vienna, balanced purely formal, abstract design and decorative surface with the demands of figuration in a way that was highly original. It also seems to have had a significant influence on the development of one of the best-known contemporary Viennese artists, Gustav Klimt. Margaret showed the same decorative brilliance in smaller watercolours and designs in a variety

of other media. Her sister Frances showed a similar talent, though her imagery is more haunted and perhaps at times autobiographical – as in watercolours like *The Choice,* or *'Tis a Long Road that Wanders to Desire* (14). The latter picture reflects an introspective anxiety worthy of Munch.

Among the artists and designers who developed this Glasgow style, perhaps the most successful was Jessie M. King (1875–1949). Unlike so many of her sister artists whose creative lives were cut short by marriage, King's career was long and fruitful. She trained at Glasgow and later also taught there. She began her career as a book illustrator and this remained the dominant area of her activity. She developed an intricate and delicate style which is related to Margaret Macdonald's work. It shows the same command of abstract pattern and decorative surface, but she always respected the narrative requirements of illustration. In the same spirit, she created a very successful mode of decorative topography, as in her published views of Edinburgh and Kirkcudbright, for example, and she branched out into a variety of other areas, including interior design, jewellery, ceramics and the applied arts generally (15).

In Edinburgh, John Duncan did not go so far as his contemporaries in the west. He did exper-

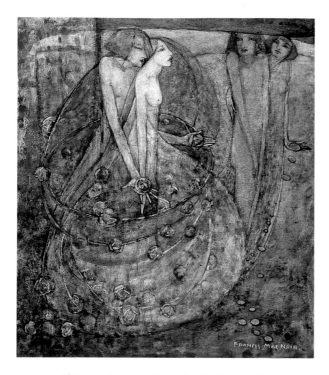

Plate 14. FRANCES MACDONALD, *The Choice*, n.d.

iment with some semi-abstract designs, however, and under his influence his young protégé George Dutch Davidson (1879–1905) produced some remarkable images in which the symbolist intention almost overwhelmed the demands of representation. Duncan himself was really a symbolist in the continental sense and, like many of his contemporaries, his work shows his admiration for Puvis de Chavannes. But in paintings like *St Bride* or the remarkable drawing of *Deirdre of the Sorrows* and related works (16), he shows that he was also capable of a high degree of stylisation in which the pre-Raphaelite tradition is united with his own sense of decorative values in a quite uncompromising way, and which parallels what is seen in the work of some of his more adventurous contemporaries. It is also of interest that in his easel paintings he used tempera in preference to oil paint.

Duncan went on to paint several other schemes along the lines of his work in Ramsay Lodge. For instance, he painted the *Stations of the Cross* for St Peter's, Morningside. This is the very beautiful, proto-modern church completed in 1906 which Lorimer built on the initiative of the Revd John Gray and Andre Raffalovich, two

Edinburgh Catholics with a remarkable range of connections in the contemporary art world. In its spare beauty, Lorimer's church is in keeping with the austerity of Duncan's painting, though it presents a startling contrast to the richness of the Thistle Chapel which was almost contemporary. Duncan also produced several schemes of stained glass and he may also have produced paintings for some of Geddes's projects in India and in France.[11]

It was in the use of flower and natural motifs and the balance between natural and abstract form that the decorative work of the Glasgow artists is seen at its most inventive. Theirs is an approach to natural form which coincides closely with the recommendations of Owen Jones, whose influence in the whole Arts and Crafts milieu was enormous even though he had died in 1874. One of Jones's key 'Propositions', as he set them out in the *Grammar of Ornament* (1856), was that the designer should abstract from natural forms. Proposition 13 reads: 'Flowers or other natural objects should not be used as ornaments, but conventional representations

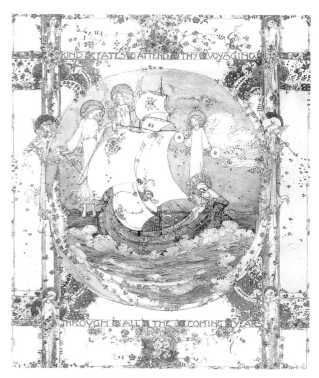

Plate 15. JESSIE M. KING, *Kind Fates Attend the Voyaging*, 1909

founded upon them sufficiently suggestive to convey the intended image to the mind, without destroying the unity of the object they are employed to decorate.'

It was this and related recommendations that gave rise to the imitation of the patterns of growth in plants becoming one of the most characteristic features of Art Nouveau design universally – and the phrase itself was coined by Jones, though in English, 'new art' – but with Mackintosh and Margaret Macdonald one can see that these design elements are based on a particularly close study of actual, natural forms and in particular of flowers (17). It was this process that gave rise to the two most characteristic motifs of their art, the rose and the chequerboard.[12] The former is self-evidently floral, but the latter also seems to derive from a flower, from the patterns on the petals of the fritillary. If so, it is a good example of how fruitful this approach to design could be in the hands of artists of genius.

This also throws light on the importance of Mackintosh's flower drawings which, it can be

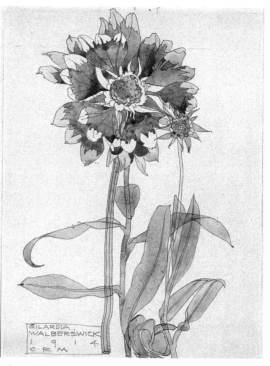

Plate 17. CHARLES RENNIE MACKINTOSH, *Gilardia, Walberswick*, 1914

seen, were central to his inspiration and which are particularly closely reflected in the brilliantly inventive textile designs with which he and his wife heralded the advent of Art Deco. It is a design process, literally of 'abstraction' in the active sense of that verbal noun – as opposed to the passive sense in which the word has subsequently come to be used to denote a style of painting – and as a process, this approach to abstraction was to become one of the most popular forms of modernism in painting.

To make such a link with the theories of Owen Jones is not to diminish the originality of the results that Mackintosh and the Macdonald sisters achieved, but it does help to locate part of their inspiration in an area that was widely shared. Equally important, though, and especially for Mackintosh in his architecture, was the example of Japanese design. The library of the Glasgow School of Art – which is his most original interior – echoes the intersecting wooden structures of Japanese temple architecture. In so doing, it offers another insight into Mackintosh's 'modernism', for by using this inspiration he has arrived at a spatial structure in which, instead of

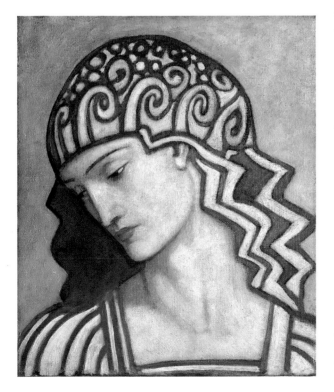

Plate 16. JOHN DUNCAN, *A Symbolist Head*, *c*.1905

Plate 18. ROBERT BROUGH, *Dolly Crombie, c.*1896

the separation of solid and void which had been the guiding principle of western classical architecture for so long, he has created a space whose unifying principle is the interpenetration of space and structure. In Japanese architecture, this seems to express the indivisibility of creation according to the Zen world view, and in Mackintosh's interpretation it seems to echo the evolution in the West of a parallel idea, for at just the moment that the library was completed, following the inspiration of Bergson, very similar ideas were the formative influence on cubist painting. Amongst the Scots, they are reflected at the same time in the work done in Paris of the artist who was to become one of Mackintosh's close friends, J.D. Fergusson (1874–1961).

Amongst Mackintosh's contemporaries generally, Japanese art was an important inspiration. This is seen in the way in which Melville used watercolour, for instance: some of his works are outstanding in the equal importance that, in the Japanese manner, he gives to the marks that he makes and the spaces that surround them. Melville's example was a formative influence on

the approach to watercolour of a number of painters including Robert Burns, Joseph Crawhall (1862–1913), Sir William Russell Flint (1880–1969), Garden Smith (1860–1913) and James Watterston Herald (1859–1914).

Whistler was, of course, an important intermediary for Melville's own approach to Japanese art as well as for that of his contemporaries, but in 1892 Henry and Hornel did the logical thing and actually travelled to Japan. They were funded in this by William Burrell and Alexander Reid. Only a few years earlier Reid had shared a flat in Paris with Van Gogh, another passionate admirer of Japanese art. Reid was one of the leading Scottish dealers at a time when there was a lively art market in the country and a number of important collectors, not only in Glasgow but in the other Scottish cities, too, collecting a wide variety of French and Dutch work, especially of the Barbizon and Hague schools. Along with P. McOmish Dott in Edinburgh and followed by his son McNeill Reid, Alexander Reid helped to encourage some of the more progressive Scottish painters, including Leslie Hunter. At Aitken Dott's, P. McOmish Dott supported Peploe, whose work he occasionally shared with Reid, and he continued faithfully to support McTaggart when his art had evolved far beyond the understanding of most of his contemporaries who were already complaining of his lack of finish at the very beginning of his career and who found his late work incomprehensible.

The results of Henry and Hornel's trip were somewhat mixed. Henry's oil paintings were effectively destroyed when they were rolled and the paint stuck, but the few that do survive are of real quality. Hornel on the other hand already showed signs of the stylistic tricks which in the end degenerated into mannerism. Robert Gemmell Hutchison (1860–1936) is a minor painter who evolved along similar lines. He was influenced first by Dutch painters like Isräels, but then by McTaggart with a result rather similar to Hornel.

Tragically Melville died of typhoid in 1904, predeceasing McTaggart by six years. The work of both painters has a bearing on the achievement of the younger generation, however, and above all on the work of the four painters known col-

lectively as the Colourists, though that is a group title which is rather misleading. Although they had certain things in common, their identification as a group was retrospective; in fact the term, Colourist, though it was coined in 1915,[13] was not used for them as a group till 1948 when it was used in the title of an exhibition in Glasgow. T.J. Honeyman gave it universal currency when he used it in the title of his book, *Three Scottish Colourists,* published in 1950.

Honeyman did not include Fergusson, but the term has been naturally extended to include all four painters, John Duncan Fergusson, Samuel John Peploe (1871–1935), Francis Campbell Boileau Cadell (1883–1937) and Leslie Hunter (1877–1931). They were beyond doubt the outstanding artists of their generation, but the strength of their identity in the eyes of posterity has also tended to diminish the importance of good painters of similar, if less advanced, tendencies among their contemporaries. Here one could include painters like Robert Brough, Alexander Jamieson, James Kay, William Yule, William Walls, Stanley Cursiter and John Campbell Mitchell for example. One could also consider older painters, not only McTaggart and Melville, but also George Henry, W.Y.

Macgregor (1855–1923), D.Y. Cameron (1865–1945), William Strang (1859–1921), Charles Mackie and others, while slightly younger painters like John Maclaughlan Milne (1886–1957) worked alongside Cadell and Peploe and reflected their manner.

Robert Brough (1872–1905) and Samuel Peploe were friends at an early date and went together to Paris. Brough determined to become a portrait painter and moved south where he was a neighbour of Sargent. He was killed in a railway accident, but had already demonstrated a striking command of the fashionable portrait, bringing to it a brilliance to rival Sargent's own, but supported by an incisive honesty (18). Alexander Jamieson (1873–1937), who studied in Paris at the end of the nineteenth century, painted his best work at the beginning of his career, exhibiting a number of vivid paintings in a colourist manner in 1911. Like Brough, William Yule (1869–1900) died young. His most typical work is portraiture in a distinctive manner using rich and sonorous colour, though this is derived ultimately from Whistler. Caw thought very highly of him[14] and a few small works from the early 1890s suggest that he did indeed have originality. James Kay (1858–1942)

Plate 19. JOHN CAMPBELL MITCHELL, *Low Tide with Three Figures Bathing,* 1917

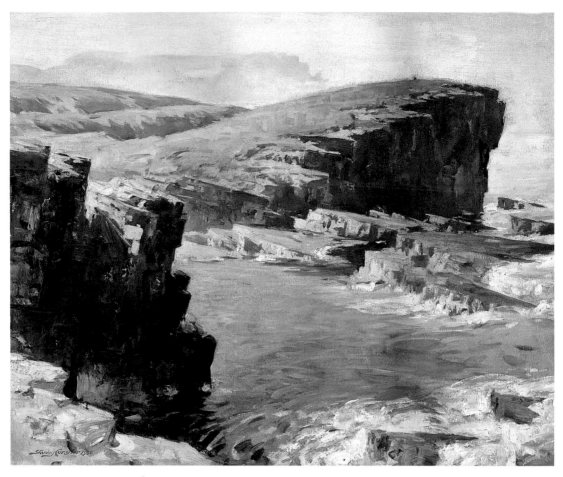

Plate 20. STANLEY CURSITER, *The Cliffs, Yesnaby, Orkney*, 1950

became best known for his paintings of the Clyde but he, too, was an individual talent who already showed striking originality in the 1890s, adapting the new freedoms of impressionism into a personal language. William Walls (1860–1942) is best known as a painter of animals, but he was an effective painter in an impressionist manner as was John Campbell Mitchell (1875–1922). A landscape painter, Mitchell was inspired by McTaggart. He developed a vocabulary of wide horizons, whether of sea or moorland, which he handled with broad, simple design and luminous colour (19). Cursiter eventually succeeded Caw as director of the National Gallery of Scotland, the last artist to hold the position. His early work is in an elegant, social style which degenerated into portraiture in the 'boardroom' manner, though he continued to paint the landscape of his home, Orkney, with some feeling (20). He made

a small footnote in history with a group of paintings in which he experimented with the futurist manner in 1913. W.W. Peploe (1863–1933), elder brother of S.J. Peploe, a banker and an amateur painter, also produced a few small futurist works which are occasionally reproduced, but which are really of no significance.

The comparison of the work of all these painters with that of the four Colourists illuminates what is distinctive about the painting of the latter, but the existence of such contemporaries also indicates the extent to which these four were the product of a wider Scottish art scene and not wholly dependent on the inspiration of Paris as it is sometimes represented, though Paris was certainly very important for all of them in different ways and at different times. J.D. Fergusson acknowledged the importance to him of Arthur Melville, although he never met

Melville, and for Cadell, too, Melville was a direct influence. This can be clearly seen in the work of both Cadell and Fergusson at the turn of the century, although Cadell was much slower to mature thereafter than Fergusson. Thinking about the origins of such painting it is also important to remember the continuing presence, not only of McTaggart and Melville until his untimely death, but also of the Glasgow Boys who, although they may not have maintained the more radical impetus of their early work, were nevertheless still representatives of a brilliant and successful generation. Though Guthrie and Lavery concentrated more and more on formal portraiture, painters like James Paterson (1854–1932), E.A. Walton or Alexander Roche were still painting creatively. Working in Edinburgh, Roche directly encouraged Fergusson by taking an interest in his work. Roche's elegant interiors seem also to have influenced Cadell. Fergusson, too, later recalled Robert Burns advocating the importance for a young painter of going to Paris.

Geddes and the activity surrounding him seem to have been of abiding importance to Fergusson. Throughout his whole career he remained loyal to Geddes's ideas about the importance of the Celtic tradition on the one hand, and of a modern, international perspective on the other. It is the way that he maintained a powerfully held set of convictions of this kind which distinguished Fergusson from the other painters with whom he is associated and it was the basis of the profound influence that he had on art in Scotland almost up to the present day. Indeed he is one of the central figures in the history of twentieth-century Scottish art. This was no doubt in large part the reflection of his own strong personality and his first-hand experience of modernist Paris. But, as with MacDiarmid, it clearly also reflected the continuing vitality of the inspiration of the leading figures of the older generation and, above all, of Geddes.

It was, however, Peploe who emerged first from this group. Before the turn of the century he was already painting pictures of considerable originality. When he was in Paris with Robert Brough in 1894, it seems to have been what was

by now the classic kind of impressionism that had interested him. Rather than any specific French model, his pictures of the late 1890s, like his portrait of *Tom Morris,* for instance, seem to echo the view of impressionism put forward by Robert Macaulay Stevenson in his influential book on Velasquez published in 1896. There, Stevenson defined impressionism not so much as a specific historical phenomenon, but as a recurrent stylistic tendency – a view which allowed Raeburn, for instance, to be granted an honourable place in this longer history of European 'impressionism'. Following Stevenson, Raeburn

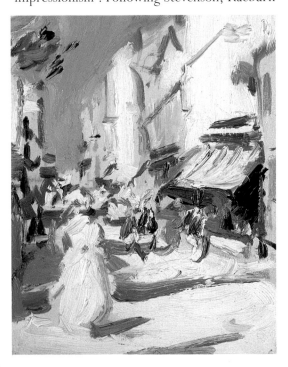

Plate 21. SAMUEL JOHN PEPLOE, *Street in Paris, c.*1907

and Frans Hals were both perhaps part of Peploe's inspiration.

In the early 1900s, Peploe's most characteristic productions were brilliant still-lifes like the *Black Bottle.* These took their inspiration directly from Manet, but they had few rivals in their own time as pure painting. As early as 1902, however, Peploe was experimenting with freer and more radical ways of working. There are signs of his interest in Van Gogh in some small paintings of this period, and this was confirmed by his further experience of Paris and by painting in France in the company of Fergusson. Back in Scotland and

Plate 22. SAMUEL JOHN PEPLOE, *Still-Life: Roses in a Blue and White Vase, c.*1924

working in Raeburn's studio, Peploe painted some of his most spontaneous and beautiful works in a series of studies of his wife; and in the summers in France, between about 1906 and 1910, painting beside each other at Royan or Paris Plage, he and Fergusson produced some luminous, free and lovely on-the-spot paintings which, though they look very French, also have something of McTaggart about them (21). Peploe stayed in France between 1910 and 1912 but, unlike Fergusson, he never really settled there and, too, he was a more intuitive painter. He never took up the kind of intellectual interests which are clearly seen in Fergusson's painting, though around 1911 Peploe's interest in cubism is apparent. For him, however, it was really only a new stylistic element in what was still at root a conventional way of making pictures rather than a radically new way of seeing – though that may have been how it seemed to his contemporaries in Scotland.

Throughout his life, Peploe's most characteristic work is the still-life. Although this had been true since his earliest still-life paintings inspired by Manet, the way that he uses the form in his later career shows how the formative influence on his mature style was first of all the work of Cézanne on to which his interest in cubism was grafted (22). There can be no doubt that it was above all through Peploe's example that still-life became one of the most characteristic subjects in Scottish painting where, with the notable exception of W.Y. Macgregor's *Vegetable Stall,* it had hardly ever featured significantly before.

Cézanne's influence is apparent in Peploe's landscapes, too, such as his paintings of Kirkcudbright, or the lovely, luminous pictures that he painted working alongside Cadell on Iona in the 1920s. In the last years of his life Peploe started to use simpler compositions and a palette dominated by tonal values and muted harmonies. The result is an understated poetry and a kind of contemplative beauty which is quite original (23).

Fergusson was much more closely involved than Peploe in the artistic excitement of Paris where he was resident in the years before the war. He exhibited at both the Salon des Indépendants and the Salon d'Automne, the two progressive exhibiting societies, and he was a member of the latter. Years later, he dreamed of creating a similar institution in Scotland.[15] His painting between 1908 and 1911 went through a series of rapid transitions. He moved away from the expressive freedom seen in his lovely *La Terrasse, Café Harcourt* or *The Chinese Coat* (26) of *c.*1908–9 to paint a number of pictures in which his awareness is demonstrated not only of the Fauves and their circle to which as a member of the Salon d'Automne he belonged, but also of the cubist group. *The Blue Beads* of 1910, for instance, is distinctly Fauve in its breadth and simplicity of handling. In *At My Studio Window* of the same year, however, the figure, the curtains and the view out of the window are held together by the intersecting patterns that they create in a way that reflects cubist painting. There is a distinct rhythm to these patterns, and in the eponymous painting *Rhythm* of 1911, this pictorial effect becomes the subject of the painting (25). It is a picture of a statuesque female figure sitting beneath a painted tree. She is holding an apple in her hand and so, it seems, is intended for Eve as the prototypical woman.

We have the contemporary comment of John

Plate 23. SAMUEL JOHN PEPLOE, *Cyclamen, c.*1930

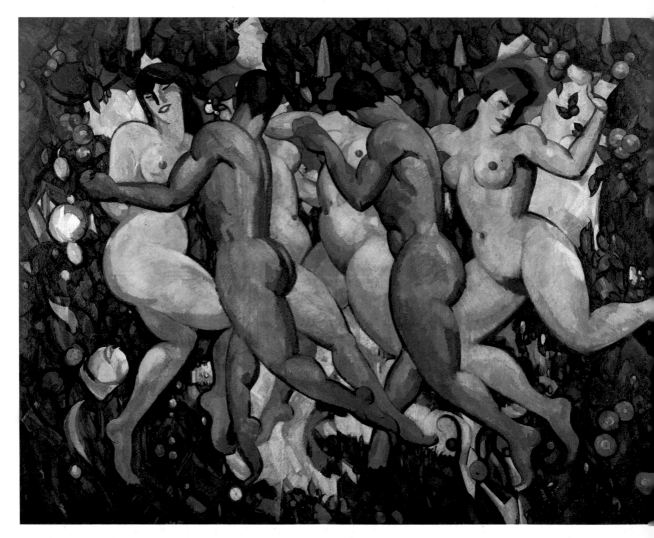

Plate 24. JOHN DUNCAN FERGUSSON, *Les Eus, c.*1910-13

Middleton Murry on Fergusson's interest in Bergson's philosophy, which was the height of fashion at the time, and rhythm was one of Bergson's key ideas.[16] According to Bergson it is the artist's task to apprehend the rhythms which unite the disassembled fragments of experience, thus 'breaking down by an effort of intuition the barrier that space puts up between him and his model'.[17] (One might consider McTaggart's late work in the light of this remark.) For Bergson, too, intuition is a feminine principle and what Fergusson seems to be doing in *Rhythm* is personifying this principle as Eve. The picture is much more monumental and deliberately structured than anything that he had painted before and it looks forward to the truly monumental *Les Eus* which was probably begun at much the same time, but was not finished till 1913 (24).

Les Eus represents a group of life-sized naked figures dancing together under exotic, fruit-bearing trees. The basic idea is probably the same as that of *Rhythm*.[18] Some of the figures suggest that Fergusson knew Matisse's contemporary *La Danse,* but his is a quite independent picture. For Bergson, dance was understandably an expression of the idea of rhythm, and such a Dionysiac dance of naked figures in a kind of Garden of Eden as Fergusson has painted clearly expresses such an idea. It is very much a picture of men and women under nature behaving in an intuitive and spontaneous way. It is a social picture, therefore, and it takes up Bergsonian ideas of sympathy expressed through the rhythm of the dance. It was perhaps partly inspired by the spectacle of the Ballets Russes, but it also looks back to the Enlightenment tradition of a natural society based on moral sympathy and so memorably expressed by both David Allan and David Wilkie in their respective paintings of the *Penny Wedding.*

Remembering the importance of Geddes's restatement of what was still essentially the Enlightenment ideal of society, it is not surprising to find Fergusson himself making such a statement and on a scale worthy of the ambitions of public art. That he did so in Paris more or less at the moment of the birth of modernist painting is also a reflection both of his own independence of mind and of the strength of the Scottish tradi-

tion. For as the analogy with Wilkie and Allan makes clear, the ideas to which Fergusson gives such dramatically modern expression go back into the eighteenth century and to the origins of some of the central ideas from which modernism sprang, yet such social ideals were a long way from the mind of most of Fergusson's contemporaries. There is also, in a more contemporary context, perhaps a reflection of the common ground and sympathy between two of Fergusson's main sources of intellectual stimulus, Geddes and Bergson, who had in fact met in Paris in 1900.[19] Bergson's own origins in the empirical tradition which in France owed so much to Scotland is another dimension of that sympathy.

The other two Colourists may not have been so ambitious, but they were not lesser painters. Cadell was closest to Peploe, both personally and in his way of painting. His painting really took off in 1910 with a series of brilliant small

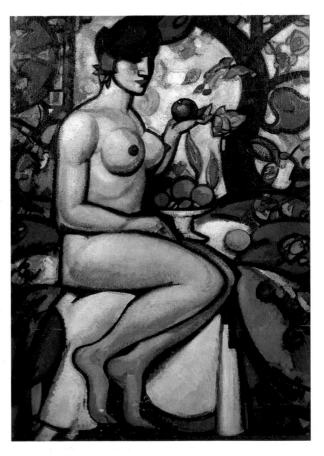

Plate 25. JOHN DUNCAN FERGUSSON, *Rhythm,* 1911

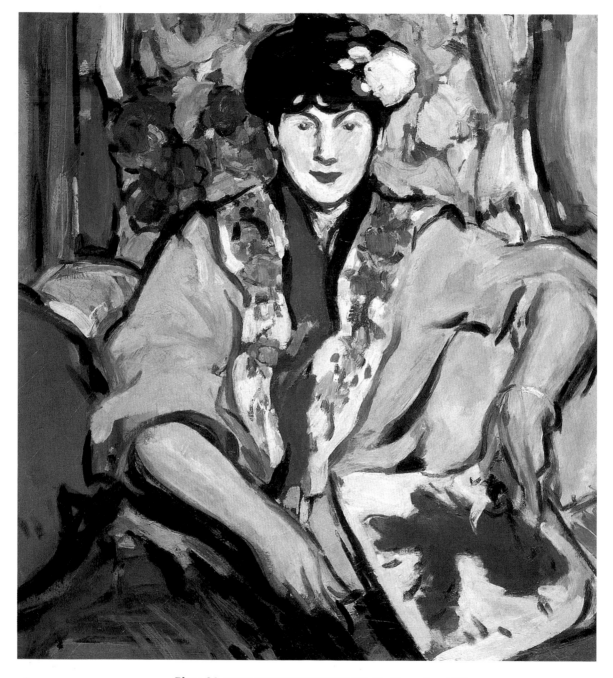

Plate 26. JOHN DUNCAN FERGUSSON, *The Chinese Coat*, 1908

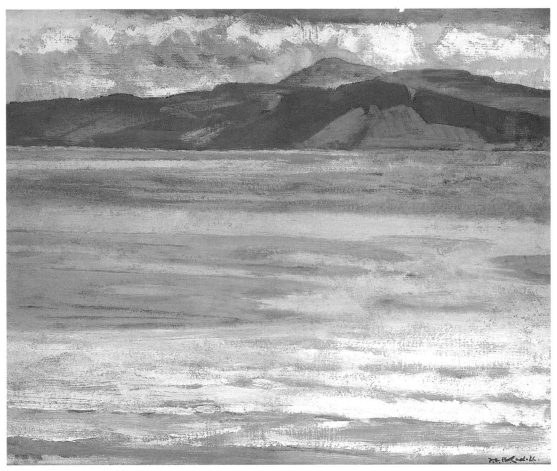

Plate 27. FRANCIS CAMPBELL BOILEAU CADELL, *Iona, c.*1924

pictures which he painted in Venice that year, similar in their richness and freedom to the paintings that Peploe and Fergusson produced away from the studio that summer and in the two or three preceding years. The same qualities are seen in some of Cadell's still-lifes of this period, but his most characteristic pictures are the series that he did of fashionably dressed women in elegant interiors. In these he frequently uses silvery white, set off by intermediate tints like lilac, and by sharp accents of black and scarlet, all in the luminosity of daylight reflected in mirrors. This creates pictures of surpassing, airy beauty and he summarises the informal elegance of the Edwardian age better than almost any of his contemporaries (28).

The same effortless brilliance is seen in Cadell's Iona landscapes (27). He first went there in 1912, following the lead of John Duncan, and he worked on the island regularly in the summer months from then onwards, though with a break during the war when he served in the army. Cadell's outdoor paintings continued to be dominated by the light of the sky, the white of the Iona sand and the blue of the western sea, but in the last fifteen years of his life his studio paintings became more formal, using flat colour in brilliant juxtapositions. This process seems to begin around 1920 when it is also apparent in Peploe's still-lifes. Cadell's choice of high key colours set side by side in truly jazzy harmonies of red, yellow or orange – as in the *Red Chair,* for instance – suggest that he was well aware of Fauve painting (29). Later, in paintings like the *Orange Blind* he extended this kind of colour harmony to articulate the light and space in a whole interior. The result is highly original, though latterly it sometimes seems a little contrived.

Plate 28. FRANCIS CAMPBELL BOILEAU CADELL, *Reflections*, *c.*1915

Although Leslie Hunter's career as a painter began in San Francisco, where he had spent part of his childhood, as early as 1906, he did not really emerge as an independent artist until 1913, when the dealer Alexander Reid gave him his first solo show, though he had certainly been in Paris by that time. His work was first shaped by impressionism and post-impressionism rather than any of the more recent developments in French painting, and, in his approach to still-life at this time, he was wont to use formal arrangements that are reminiscent of Dutch seventeenth-century painting (30). Another characteristic group of his works was produced in Fife around 1919 and 1920, and in these something of Van Gogh's palette can be seen in the way that he paints the red roofs of the Fife cottages. It was not until some years after the First World War, however, that Hunter began to produce his most characteristic work in which, of all the four Colourists, he is most directly beholden to Matisse. In some of his views of Balloch, for instance, where he lived in a houseboat for a while in the 1920s and in his still-lifes, he paints freely and spontaneously, putting brilliant colours side by side with no sign of premeditation. In this his paintings are radically different from those of Peploe, for example, and it is of course also a way of painting in which the results are bound sometimes to be uneven (31).

Alongside these brilliant painters, some of the most remarkable achievements of the turn of the century were those of the printmakers who emerged between 1890 and 1910. There was an unbroken tradition of printmaking in Scotland going back through David Scott (1806–49) and Andrew Geddes (1783–1844) to the eighteenth century, but these printmakers in the late nineteenth century were also part of the wider etching revival which had its origins in the art of Whistler. His brother-in-law, Francis Seymour Haden, and the French painter and etcher, Alphonse Legros, teacher at the Slade, also played an important part, but the four principal figures among the Scots were nevertheless outstanding in their generation. They were William Strang, D.Y. Cameron, Muirhead Bone and James McBey. The English artist, E.S. Lumsden (1883-1948), who

Plate 29. FRANCIS CAMPBELL BOILEAU CADELL, *The Red Chair, c.1920*

came to teach at Edinburgh College of Art in 1908, was important not only as an artist in his own right, but also as a continuing advocate well into the mid-century of the importance of etching and as a teacher and transmitter of its special skills whose influence can be felt to this day in the thriving activity of the printmakers' workshops.

Plate 30. GEORGE LESLIE HUNTER, *Still-life with Fruit on a White Tablecloth*, 1921

Plate 31. GEORGE LESLIE HUNTER, *Houseboats, Balloch, c.* 1924

Lumsden was also associated with Geddes.

The oldest of this group, William Strang (1859–1921), studied in London at the Slade with Legros and throughout the 1890s produced a series of striking etchings that included fantastic, almost surreal imagery as well as explicitly political social realism. Prints like *Socialists* and *The Cause of the Poor* are direct and unambiguous in subject matter and in treatment, but Strang also extended this kind of treatment to religious subjects to give them a new, democratic force and urgency (33). There is a certain parallel between Strang's work and that of Walter Grieve (1872–1937), a minor academician who nevertheless is part of the history of this kind of social realism in Scotland, which is still an important feature of painting in the present day.

Strang was an incisive draughtsman and this works to full advantage in his portraits, both etched and drawn, as in his portraits of Kipling and William Sharp (Patrick Geddes's associate who published novels under the pseudonym

Plate 32. SIR DAVID YOUNG CAMERON, *Tewkesbury Abbey*, 1915

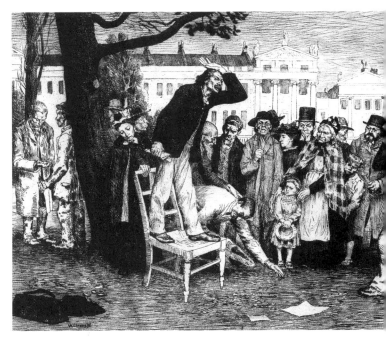

Plate 33. WILLIAM STRANG, *Socialists*, 1891

Fiona MacLeod). After 1900, Strang concentrated increasingly on painting, keeping his independent point of view in pictures with a distinctive, symbolist content such as *Bal Suzette* of 1913, or a sharply focused variation on Fauve colour like *The Jazz Hat.*

D.Y. Cameron followed more closely in Whistler's footsteps, making his mark first with a series of etchings of the Clyde called the *Clyde Set* which was modelled directly on Whistler's etchings of the Thames. Thereafter, Cameron specialised in architecture and in landscape, creating images of buildings which at times have an almost hallucinatory intensity, reflecting the inspiration of the etchings of Paris of Charles Meryon, while some of his images of Highland and mountain scenery are spare and economical in a way that seems to be a deliberate rejection of the clichés of Highland landscape. Cameron's paintings also exploit this kind of economy (32).

James McBey (1883–1959) started as an amateur, but from early in his career he produced some remarkable prints. After 1910 he worked professionally, and during the war, first as a serving soldier and then with an appointment as a war artist stationed in the Middle East, he produced some of his most memorable images. Muirhead

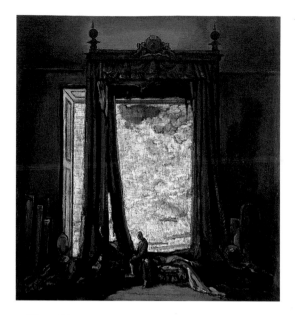

Plate 34. JAMES PRYDE, *Lumber: a Silhouette, c.1920*

achievement is of special interest for the qualities that made him so suitable for that role. Bone's interests were from the start architectural, but whereas Cameron really belonged in the tradition of artists recording the historical and picturesque, a tradition that led back to David Roberts and beyond, Bone was like Baudelaire, an artist of the city. Architecture was not a matter of buildings for him, but of a living environment. He saw the city as an organism and later he commented on how it was Glasgow that made him an artist.[20] This is important for there were few artists before Bone with quite this vision, a vision, too, that lent itself to the graphic economy of black and white, whether of etching or of pencil.

Although he was not a printmaker, in his preoccupation with dramatic, architectural themes, James Pryde (1866–1941) is perhaps closest to Cameron and Bone among his contemporaries. Pryde trained briefly in Edinburgh and Paris before trying a career as an actor. With William

Bone (1876–1953) had been the first artist to be appointed an official war artist, however, and his

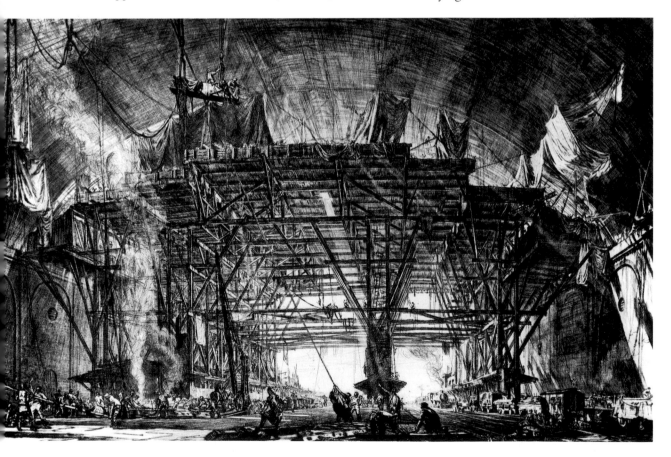

Plate 35. MUIRHEAD BONE, *The Great Gantry, Charing Cross, 1906*

Nicholson, as one of the Beggarstaff Brothers, he was responsible for some remarkable pieces of graphic design in the 1890s. Around 1902, Pryde also produced some vivid, even grotesque characterisations of criminals, street characters and such like which are painted in a very fluid style that resembles Peploe's figure studies of the period, but it is Pryde's architectural fantasies which are most characteristic of his work. Like Cameron, he achieves a dramatic simplicity in his paintings of buildings, but the mood of his images is dreamlike. He creates a fantastic vision of buildings, usually half ruined and often resembling the towering tenements of the Edinburgh of his boyhood. A parallel, almost obsessive theme from his childhood is a great seventeenth-century bed in Holyrood, which he made the subject of a series of strange paintings over many years (34).

It was, nevertheless, Muirhead Bone who produced the finest architectural images of the time. *The Great Gantry, Charing Cross* (1906) (35) is the most memorable of a group of etchings that clearly show the inspiration of Piranesi, but in which this inspiration is used to bring out the drama of ordinary urban reality, not of something surreal or fantastic. In this Bone stands midway between Baudelaire's idea of the painter of modern life and Geddes's vision of the organic city. In a collection called *Glasgow: Fifty Drawings* that he

published in 1911, Bone comes even closer to a description of Geddes's vision of the modern city in its light and in its dark, and in its perpetual processes of growth and decay. It is, in Geddes's phrase, 'the human hive' and it was this vision that underlay Bone's drawings of the Western Front which were his first undertaking as a war artist. In such an official position, he could not be as outspoken as the poet Wilfred Owen was, for instance, or as Otto Dix was on the other side in the war, but Bone's images are all the more effective for their restraint and the indirect way in which he conveys the enormity of what he had seen. In these drawings, he constantly returns to the destruction of the environment, but especially the human environment as it is seen in architecture. This is not because of a failure of imagination on his part, but because in his art he had already identified how it is this which is the physical fabric of society – the body of the social organism, injured almost mortally by the fearful violence of the new technology, product of Mr Hyde, the demon released when science goes beyond the control of Dr Jekyll's humanity. The way in which this physical body of society was shattered beyond recognition and shorn of its human association by the appalling machinery of war reflects the way in which the war itself threatened the fundamental values on which society depends (36).

Plate 36. MUIRHEAD BONE, *A Via Dolorosa: Mouquet Farm*, 1917

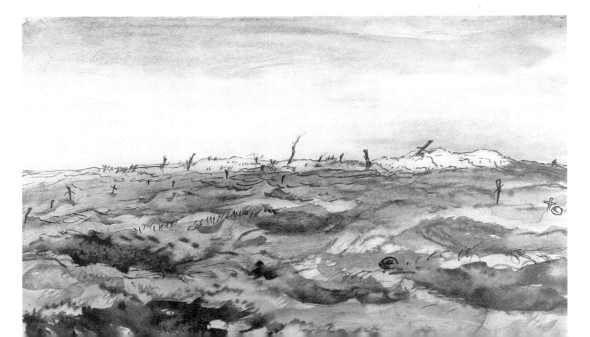

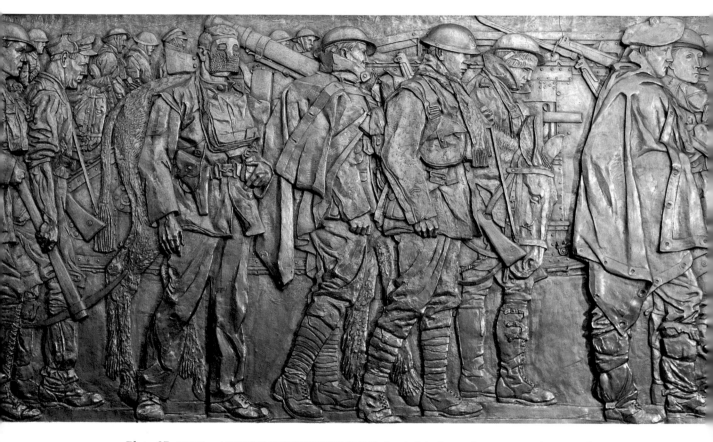

Plate 37. ALICE and MORRIS MEREDITH WILLIAMS, detail of the frieze of servicemen and women, the Scottish
National War Memorial, *c.*1927

CHAPTER TWO

BETWEEN THE WARS

Though they seem low-key and avoid any direct reference to the individual tragedies that were compounded into the terrible death toll, Muirhead Bone's Western Front drawings are a fitting commentary on the First World War. They reach its inhumanity through the mute witness of the devastation that it caused to the natural and human environment. It is in a similar way by presenting the loss of the war in human terms, but avoiding any attempt to dramatise it, that the Scottish National War Memorial fulfils its function. It was created on the summit of Edinburgh Castle by Sir Robert Lorimer between 1924 and 1927. To analyse the success of a War Memorial may seem at variance with its special function, but the National War Memorial is a solemn and beautiful place which grants dignity to the dead without surrendering to military rhetoric.

Lorimer assembled a team of artists and, working co-operatively, they created one of the most ambitious schemes of public art of the time. Somehow its grandeur is the grandeur of real human feeling. It achieves the genuine expression of a nation's collective grief and it is above all through art that it succeeds in this. Using part of the walls of an earlier building on one side of the courtyard at the top of the castle, Lorimer designed a long, transverse aisle like a classical basilica with a barrel vault that runs east and west. At either end of the south wall, there is a square chapel and there is stained glass on the east, west and south walls. These parts contain the monuments to the different services and regiments. To the north, opposite the grand entrance which has extensive decoration inside and out, there is a second grand entrance leading through an arch to the shrine. This is gothic and

is tall, narrow and much darker than the rest of the building. The stained glass here is much more deeply coloured than the rest. The shrine is dominated by a hanging, carved wooden figure of *St Michael*. There is a bronze frieze running round the walls at eye level and at the centre on a marble pillar set on the natural rock is a steel casket containing the regimental rolls of honour.

The main work on the War Memorial is by the sculptors Percy Portsmouth, Pilkington Jackson (1887–1973) (38), Alexander Carrick (1882–1966), Alice Meredith Williams (c.1880–1934) and her husband Morris (1881–1973), the Clow brothers, Phyllis Bone (1894–1972) and others. The bronze frieze at its centre, executed by Alice and designed by Morris Meredith Williams, represents a procession of the men and women of the

Plate 38. PILKINGTON JACKSON, *Reveille, c.1925-27*

Plate 39. PHYLLIS BONE, *Reindeer*, c.1927

services, sixty figures in all. It sets the tone of ordinary humanity which pervades the whole monument (37). Alice Meredith Williams also designed the figure of *St Michael* which was carved by the Clow brothers and the steel casket with its attendant angels. The same kind of simplicity as in the frieze is seen in the monuments to the Nursing Services also by Alice Meredith Williams, and in those to the Royal Engineers and the Royal Artillery by Alexander Carrick (40), or in the animals executed by Phyllis Bone, the camels, the mules and even the canaries and the mice – 'the tunnellers' friends'. The stained glass is all by

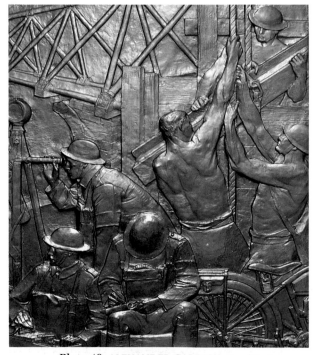

Plate 40. ALEXANDER CARRICK, *Royal Engineers Memorial*, the Scottish National War Memorial, c.1925

Douglas Strachan (1875–1950) and is very adventurous both in style and in iconography. The seven windows in the shrine are particularly rich in colour and complex in design (41). There is also extensive sculptural decoration carved into the fabric of the building on the outside.

In 1908 Strachan had set up the stained-glass department at Edinburgh College of Art and he had also worked for Lorimer on the Thistle Chapel. He played a central role in establishing modern stained glass in Scotland. It was also characteristic of Lorimer to continue to use the same artists as he did with Strachan. Phyllis Bone, for instance, carried out a fine set of large-scale reliefs of animals for one of his last buildings, the Zoology Department of Edinburgh University (39). Indeed, during this period, thanks to Lorimer's encouragement, Edinburgh seems to have developed something of a reputation as a centre for stone-carving as Flora Macdonald, who later became William Johnstone's first wife, was sent over from Paris by Antoine Bourdelle to study carving with Alexander Carrick. After Lorimer, architects like Reginald Fairley (1883–1952) continued to incorporate sculpture into the design of their buildings as Fairley did on the Robertson Memorial Church where he employed Alexander Carrick in 1933, or on the National Library of Scotland which was not finished till 1953 though it was designed much earlier. Even Basil Spence (1907–76) in his early work at Broughton Place in the Borders also employed Hew Lorimer (1907–93) to create two fine stone lions for the gates.

Not all war memorials were as fitting as the one that Sir Robert Lorimer designed for the nation:

> The war memorial of Segget toun, an angel set on a block of stone, decent and sonsy in its stone night gown, goggling genteel away from the Arms, as though it wouldn't . . . ever condescend to believe there were folk who took a nip to keep out the chill . . . Chris thought it was fine, a pretty young lass. But then as she looked at it there came doubts, it stood there in memory of men who had died . . . folk who

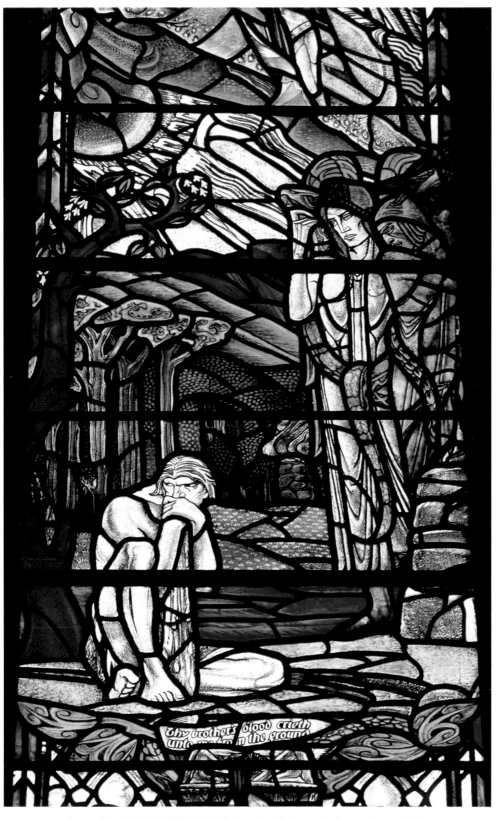

Plate 41. DOUGLAS STRACHAN, *Cain*, detail of stained-glass window, *c.*1927

had slept and waked and had sworn, and had lain with women and had lain with pain . . . Folk of her own who had died, out in the dark strange places of earth and they set up THIS to commemorate THEM – this, this quean like a constipated calf![1]

In this eloquent passage from *Cloud Howe,* Lewis Grassic Gibbon gives vivid expression to what must have been a common reaction to the dubious aesthetic of some of these things: monuments where the bland generalisation of academic art was an offence to a common grief which was a compound of countless individual tragedies, each no less painful for being one among so many.

Inevitably, though, the First World War touched the lives of many artists more directly than the later involvement of some of them in the business of building war memorials. James Cowie (1886–1956) was a conscientious objector. Eric Robertson (1887–1941) for the same reasons served in the Friends Ambulance Service. William Gillies (1898–1973) served in

the trenches, but never spoke of his experience there. William Johnstone was enlisted, but was fortunately too late to be sent to the Front. After the war there was a change in the artistic climate, too. It was not just that the art market was far less buoyant – which was certainly the case – but there is also more introspection and uncertainty in the work of the best artists. The twentieth century lost its innocence in the war and the artists knew this.

In Edinburgh in 1912 an exhibiting society called the Society of Eight had been formed, including Cadell, Lavery, James Cadenhead (1858–1927), James Paterson and others. Membership remained limited in number to the eight of the title. Peploe later became a member and the Society originally showed in the New Gallery in Shandwick Place. A year or two later a group of younger artists followed this example and founded the Edinburgh Group. They included Eric Robertson, Cecile Walton (1891–1956), Dorothy Johnstone (1892–1980), W.O. Hutchison (1889–1970, later knighted as PRSA), D.M. Sutherland (1883–

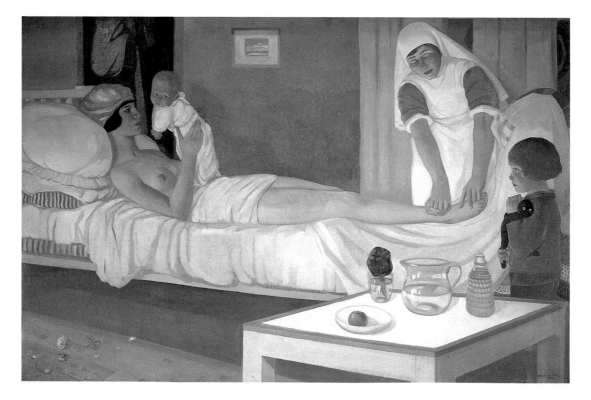

Plate 42. CECILE WALTON, *Romance,* 1920

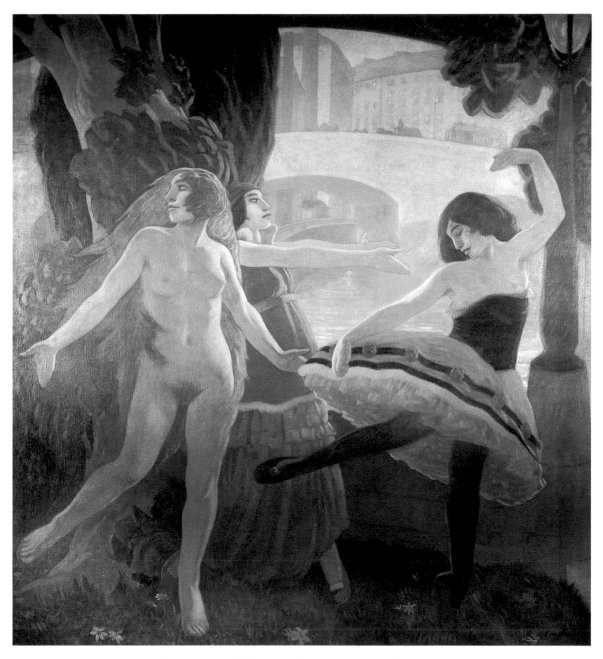

Plate 43. ERIC ROBERTSON, *Le Ronde Eternel*, 1920

1974), Alick Sturrock (1885–1953), J.G. Spence Smith (1880–1951), J.R. Barclay (1884–1963) and others. After the war, in 1919, they revived the Group though it only had two further shows, also in the New Gallery. Several of these painters had been pupils of John Duncan, of whom they thought very highly, and Cecile Walton, Eric Robertson and Dorothy Johnstone in particular preserved something of

his approach. Robertson married Cecile Walton who was the daughter of the Glasgow painter, E.A. Walton, and another later member of the group was her friend, Mary Newbery (1892–1985), the daughter of Fra Newbery, who married Alick Sturrock. Cecile Walton was a book illustrator in a style similar to that of Jessie M. King, who had befriended her when she was in Paris before the war, but she was also

Plate 44. JOHN BULLOCH SOUTER, *The Breakdown*,
1926-62

a gifted painter. Her best painting, *Romance* (42), is a study of herself half-nude with her infant son, a nurse and her first child standing by her. Iconographically, the picture takes up the theme of Manet's *Olympia* and, before it, of Titian's *Venus of Urbino,* but, provocatively, it combines those classic images of the female nude with the very different iconography of the mother and child. It is a bold and original woman's picture.

Eric Robertson was a fine draughtsman whose drawings charge the austere chastity of Duncan's drawing with a kind of subversive sensuality. Even before the war, some of his drawings had proved too suggestive for Duncan's taste, and in 1919 he celebrated the theme of erotic beauty quite openly in his painting *Love's Invading.* It shows a group of women dancing towards us from out of a wood, the foremost clad only in mane of golden hair. The theme is similar to Fergusson's *Les Eus,* but in Robertson's picture, stylisation only endorses the sensuality of the image. It does not distance it and so we are confronted with a personal erotic fantasy, not an idealised statement. The painting is based on *The Daughters of Beauty,* a drawing Robertson had made in 1915 which was also the basis of a painting of a similar group of dancing women called *Le Ronde Eternel* (43). The freely expressed sensuality of these pictures is striking, particularly

in the context of contemporary Edinburgh. One critic wrote of the Edinburgh Group shows in the New Gallery: 'Half of Edinburgh goes to Shandwick Place, secretly desiring to be righteously shocked, and the other half goes feeling deliciously uncertain it may be disappointed by not finding anything sufficiently shocking.'[2]

A single picture which attracted similar notoriety was John Bulloch Souter's (1890–1971) *The Breakdown* (44). It showed a naked girl who has stripped to the music of a black saxophonist. Several fragments of broken statuary, strewn with items of her clothing, look suspiciously like bits of a broken-down figure of Britannia. When the picture was shown at the Royal Academy in 1926, it was removed from exhibition at the request of the Colonial Office because the Colonial Secretary 'feared it would increase our difficulties in ruling coloured people'. Souter destroyed it, though he repainted it many years later. He was ruled by a determined wife whom he recorded in a very fine portrait, and he never attempted anything so risqué again. He settled down to a career as a fashionable portrait painter in the south, though at the end of his life he returned to live in Aberdeen, where he had been born.

Eric Robertson's work included some experiments in a vorticist style such as a semi-abstract painting of an exploding shell called *Shellburst.* Painted a few years later, his painting, *Dance Rhythm,* is a vivid evocation of the movement of a group of dancers. It is Art Deco rather than vorticist. Nevertheless, the comment about the risk of shock at the Edinburgh Group exhibition probably reflected as much the notoriety of Robertson's private life as the modernity of his painting, or of that of any of the other members of the group, for he had the reputation of being rather free-living.[3] Among these, Hutchison had a justifiable reputation as a much better than academic portrait painter, a reputation that he shared with his contemporary and friend, James Gunn (1893–1964). D.M. Sutherland (1883–1974) left his mark as head of Gray's School of Art in Aberdeen where he brought Robert Sivell (1888–1958) and, for a short time, James Cowie, from Glasgow to join him (45). Spence Smith and Sturrock worked

principally as landscape painters in a fairly conventional, contemporary version of the impressionist style. They belong with those painters like George Houston (1869–1947), Stanley Cursiter and John Maclauchlan Milne, who, almost throughout the first half of the century, maintained an ongoing tradition of sub-impressionist landscape painting. It was really only superseded by the new landscape style of Gillies in the 1930s. In this company, John Maclauchlan Milne, through his closeness to Peploe and Cadell, was more adventurous, as was J.R. Barclay in the Edinburgh Group.

It was, however, Dorothy Johnstone, who married D.M. Sutherland, who was perhaps the best painter of the group after Robertson and Walton. Her most interesting work is a series of pictures of single girls, such as *Girl with Fruit* (47), and groups in a classroom that belong to the first part of her career. Some of these, like *September Sunlight* (1916), are marked by brilliant colour and luminosity. It was painted at Jessie M. King's home in Kirkcudbright, but its palette seems to reflect

the influence of Cadell. These pictures are personal and human in a way that Johnstone shares with Robertson and Walton, and although it is clear that she is concerned with pure painting, in this warmth her work is quite unlike that of Cadell who usually seems detached from his subject matter, as indeed all the Colourists tend to be. Johnstone's work has some similarity to that of her contemporary in Glasgow, Norah Neilson Gray (1882–1931), though Gray's *The Belgian Refugee* has a forceful simplicity that is not easily matched in the work of any Scottish painter of the time (46).

In the years after the war, the situation in Glasgow was not very different from that in Edinburgh, and the Edinburgh Group had close links with their equivalent in the west, the Glasgow Society of Painters and Sculptors. It was founded in 1919 on the initiative of the painter Robert Sivell, with himself, James Cowie, Archibald McGlashan (1888–1980) and Benno Schotz (1891–1984) as the original members. Benno Schotz was the sculptor in this group. He came to Scotland from Russia as a young man and

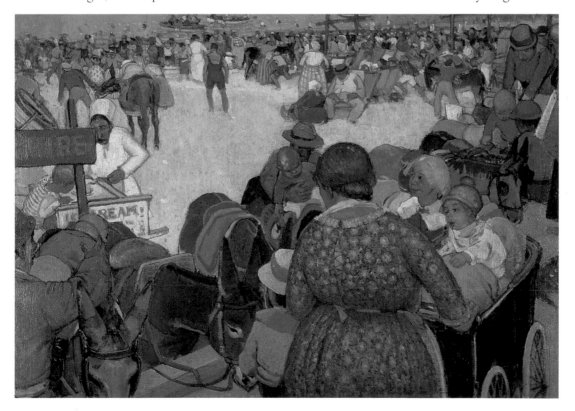

Plate 45. DAVID MACBETH SUTHERLAND, *Donkey Rides, Portobello Beach, c.1926*

Plate 46. NORAH NEILSON GRAY, *The Belgian Refugee*, 1916

became one of the leading personalities in his generation of artists. Although he produced a number of figure compositions and even monumental works, he specialised in portrait busts and recorded most of the leading personalities of his time in Scotland, and also a good many in Israel.

Invited to Aberdeen by D.M. Sutherland, Robert Sivell's most memorable work is the wall painting that he did for the Aberdeen Students Union. There is a certain early Renaissance formality about Sivell's painting – and, indeed, not over-modest, in a notorious remark (and with some condescension to the older artist) he compared himself to Botticelli – but he shared this formality with Cowie and McGlashan (48). McGlashan's best works are paintings of mothers and children which clearly evoke the classic form of the Madonna and Child, but with both McGlashan and Sivell, it is possible to see how Augustus John's example played a part in their devotion to draughtsmanship.

These painters were also responding to the teaching of Maurice Greiffenhagen (1862–1931) and Frederick Cayley Robinson (1862–1927) at Glasgow School of Art. Robinson, in particular, paralleled John Duncan's blend of symbolism and the Pre-Raphaelite tradition. Greiffenhagen and Robinson were both imported from the south by Fra Newbery. In Edinburgh, too, Henry Lintott (1878–1965) was a teacher from the south much admired by a number of the younger painters. Through the example of such painters, a new generation carried on this kind of approach even as they developed it. This is clearly seen in the art of Olive Carleton Smyth (1882–1949), for example, whose work is very close to that of Frederick Cayley Robinson, though with qualities of design in narrative that echo both Jessie M. King and John Duncan.

James Cowie (1886–1956) was the outstanding artist of this generation in Scotland and he, too, continued in this essentially symbolist tradition. Cowie came from a farm in Aberdeenshire. While studying for teacher-training in Aberdeen, he became interested in painting through the teaching of James Hector (1868–1940) and went to study at Glasgow

School of Art. His mature painting looks back into the nineteenth century to Puvis de Chavannes and the Pre-Raphaelites, even while it reflects the artist's knowledge of such central features of modernism as the painting of Cézanne, and the work of the Cubists and latterly also of the Surrealists whose work he knew through their English followers like Paul Nash and Edward Wadsworth. His art shows once again how the native tradition remained vital and was able to absorb outside influences. As such a mixture of inspiration would suggest, Cowie's art is complex. It is also introspective in a way that is profoundly modern even while he held up as his central model the lucid and transparent art of fifteenth-century Italy.

Cowie certainly imitated the early Renaissance masters in the way he used drawing to prepare his work. He made careful studies from the life and he used as models the boys and girls in his classroom at Bellshill Academy where he taught for fifteen years after the war, just as Perugino or Raphael used the boys in their studios as models for the figures in their monu-

Plate 47. DOROTHY JOHNSTONE, *Girl with Fruit*, *c.*1925

Plate 48. ROBERT SIVELL, *Girl in a Wood*, 1933

others, is *Falling Leaves,* completed in 1934 (49). In it, two girls are sitting in front of an open window. The falling leaves of the title are visible against the sky. They are an echo of Millais's picture *Autumn Leaves* and, as in it, they evoke the passing of time and the transitory nature of youth. This theme is developed in Cowie's picture to suggest not just a generalised sense of nostalgia for the loss of childhood innocence, but the obverse of that coin which is the development of self-awareness in adolescence. He achieves this by leading us in a series of transitions from the blank drawing-boards in the upper right, through the partly defined plaster model of Michelangelo's *Dawn* and the recessive colours of the right-hand girl, to the strong colours and complex outward gaze of the foremost girl who is to the left.

Like Eric Robertson's paintings which may have influenced him, Cowie's *Falling Leaves* introduces the theme of individual sexuality into Scottish painting in a way that is quite new. It does so, however, with a subtlety and a sense of humanity that can be compared to Lewis Grassic Gibbon's contemporary novel, *Sunset Song,* which likewise traces the progression of its heroine, Chris Guthrie, from childhood to adulthood. In his later work Cowie developed this kind of allusiveness under the influence of surrealism to create some of his most remarkable pictures, still-lifes endowed with a kind of metaphysical quality such as *Transparencies* (50). In this and a number of related pictures, he set up an actual still-life using a variety of objects and sheets of glass leaning against each other with reproductions of paintings suspended between them. A central inspiration to him here was the Surrealists' hero, Giorgio De Chirico, and he captures the metaphysical quality of De Chirico's painting more than many of the Italian's more famous imitators were able to do. From rather prosaic elements, Cowie created a kind of landscape of memory, a vision of the way that the mind is stocked with images whose interrelationship is often unexpected and always quite autonomous. It is a technique that in a way also anticipates Eduardo Paolozzi's much more dynamic use of the intercutting of collage to

mental compositions. Like his Renaissance heroes, too, Cowie used his study of these children from his everyday environment to build up images that are reflective and rich in meaning, though as the process of reflection was slow and the method laborious, his major finished works are not numerous. His drawings, studies and lesser works are more plentiful, however, and some are of great beauty as he was an outstanding draughtsman, disciplined, fluent and precise. It is, nevertheless, on his finished works that he would wish to be judged.

The first group of these are the pictures of schoolchildren that he produced at Bellshill. Several share the theme of the passing of time and the transition from child to adult, already present in the first of them, *Sumer is icumen in* of 1925–26. Cowie maintained the interest in poetry that had led him to study English at the outset of his career. In a real sense, his painting is often poetic and this particular picture takes its title from the first poem in *The Oxford Book of English Verse*. The most ambitious of these schoolroom pictures, and one which summarises the

Plate 49. JAMES COWIE, *Falling Leaves*, 1934

Plate 50. JAMES COWIE, *Composition (Transparencies)*, 1947

reflect on the complex interaction of the images that make up such a large part of our experience.

This same kind of 'mindscape' is seen in some of Cowie's later figure paintings like *The Evening Star*. Its composition derives from Seurat's *Les Poseuses* and from a painting by Puvis de Chavannes, but it also incorporates other recognisable historic figures by Piero della Francesca and the setting of Leonardo's *Madonna of the Rocks* into a real, coastal landscape near Arbroath. Cowie creates a kind of imaginary, surreal studio, a complex, poetic subject, inspired ultimately by Byron but seeming to reflect, too, on the nature of his own inspiration. Painted somewhat later, the very beautiful *Noon* is a quite independent variation on the surrealist theme of dream imagery adapted to evoke Cowie's own theme of sexual awakening in adolescence (51). In the picture, a girl is lying sleeping on the grass in the hot sun and, as she dreams, she conjures up the enigmatic figure of a satyr, its ancient imagery charged with fresh erotic power by the conjunction. It is an image that parallels Debussy's composition *L'Après-Midi d'un Faune* and it also seems to echo a picture called *The Dream* by Puvis de Chavannes, but it is wholly original and among Cowie's contemporaries it suggests a comparison with Balthus.

When he painted himself, Cowie is characteristically enigmatic. His last and most important *Self-Portrait* echoes Poussin's and in it, Cowie's own face is superimposed on another Poussin composition, *The Inspiration of the Poet,* suggesting the complexity of Cowie's perception of himself and his art (52). Although he was such a complex individual, Cowie had some impact as a teacher on the younger generation from the position that he occupied between 1936 and 1948 in charge of Hospitalfield, the Scottish Colleges joint school in Arbroath. It is now run as a summer school, but during Cowie's tenure of office students went there as post-graduates and could stay for a longer period. Robert Colquhoun (1914–62) and Robert MacBryde (1913–66), Joan Eardley (1921–63) and many of the most distinguished artists in the younger generation spent time there and learnt from Cowie's draughtsmanship and his example of fastidious, visual discipline.

In nearby Montrose, Cowie had Edward Baird (1904–49) as a neighbour and also the sculptor William Lamb (1893–1951). Baird made some experiments with surrealist imagery which parallel Cowie's. He was, however, a less inventive artist and on the whole the surrealist quality in his work is no more than an echo achieved through a kind of preternatural definition in his vision of reality; but such paintings as the wedding picture of *The Birth of Venus* that he

Plate 51. JAMES COWIE, *Noon*, 1946

Plate 52. JAMES COWIE, *Self-portrait: the Blue Shirt*, c.1945-50

Plate 53. EDWARD BAIRD, *The Birth of Venus*, 1934

painted for James McIntosh Patrick (*b.* 1907) in 1934, *Unidentified Aircraft* of 1942, and some of his portraits and still-lifes nevertheless show a distinctive vision (53).

Cowie, in fact, professed to have little time for impressionism and its offspring, but there were other artists who embraced the modernist aesthetic more directly than either he or Baird ever did in spite of their interest in surrealism. At the outbreak of the First World War, J.D. Fergusson had moved from France to London. There he produced a number of works that show his interest in futurism and vorticism, and, incidentally, he also established a close friendship with Charles Rennie Mackintosh. The most remarkable of Fergusson's wartime paintings are those that he did in the dockyards at Portsmouth in 1918 (54). They celebrate the machine environment with an almost classical grandeur and, though it is a very different image, a similar qual-

ity is seen in his fine sculptured head, *Eastra*. A little later, Fergusson brought this more modern approach to bear on the landscape of Scotland when he toured the Highlands with his friend, John Ressich, in 1922. Ressich played a part in arranging a very successful joint exhibition of all four Colourists in Paris in 1924.

Mackintosh himself turned to painting full-time during the last years of his life. He was a remarkable artist, though his achievements here have inevitably been overshadowed by his stature as an architect. His flower painting, though highly developed, was, as we have seen, in a sense an integral part of his study of design. The watercolours of these last years extend this sense of design into the landscape. His chosen subjects almost always include buildings, southern French hill-towns or farm buildings among the rocks, and they are shown as completely integrated with their environment. This is not

just a compositional trick; it is a way of expressing something about the nature of good architecture in its context and so about the relationship of landscape and human use. Mackintosh was in touch with Geddes, who was spending a lot of his time at Montpellier. One does not necessarily need to look for Geddes's influence here, but these images certainly reveal the basis of the sympathy that existed between the two men. Mackintosh is also describing in this different medium, however, the same indivisibility of space and form which he had successfully conveyed in the Glasgow School of Art library. The way that he binds together structure and space in such a picture as *Mont Alba* not only conveys the successful integration of man and nature through an organic approach to architecture, but it also creates a kind of personal, one-man cubist vision of the interpenetration of light and form (55).

In the early 1920s William McCance (1894–1970) was in London at the same time as Fergusson and Mackintosh. He had gone there from Glasgow in 1919. Perhaps influenced by Fergusson and certainly by Wyndham Lewis, he produced some dramatic interpretations of the machine aesthetic. McCance was an art critic as well as a painter, and in alliance with Hugh MacDiarmid in a number of statements he used these ideas to attempt to formulate an equivalent frame of theoretical reference for art to that evolved by MacDiarmid and others for literature in the Scots Renascence or Renaissance movement. The idea of such a renaissance was first formulated by Geddes in an essay in *The Evergreen.* (Renascence is Geddes's spelling.) There and elsewhere, he argued that the arts were a vital organ of national self-expression, and to fulfil this function they should draw on the ancient roots of the nation's culture, but in a context that was both modern and international. In this way, the Celtic Revival and the Scots Renaissance are two aspects of the same thing, and the strength of the Renaissance was to lie in the depths of its roots. Throughout his life, Fergusson stood for this. He was one of the most committed of all British Modernists and one of the very few who could claim to have partici-

pated at first hand in the early modernist milieu in Paris, but he also always maintained the importance and continuing relevance to his art of his Celtic roots.

In addition to this McCance, Fergusson and MacDiarmid, echoing Wyndham Lewis and the Vorticists, all argued that such a renaissance should embrace the Scottish industrial tradition:

> The Scot has a natural gift for construction, combined with a racial aptitude for metaphysical thought and a deep emotional nature . . . out of this combination can arise an art that can be pregnant with Idea and (which) will have within it the seeds of greatness.[4]

It was a combination of the poetic and the technological which was already present in John Duncan's paintings in Ramsay Lodge where Prometheus brings fire to James Watt and Pan offers inspiration to Charles Darwin. MacDiarmid and McCance were certainly influenced by Wyndham Lewis, but also by Léger and the Purists in France. They were familiar at an early date with the Purists' idea of a new art for a new industrial order whose high priests were to

Plate 54. JOHN DUNCAN FERGUSSON, *Portsmouth Docks*, 1918

Plate 55. CHARLES RENNIE MACKINTOSH, *Mont Alba, c.*1924-27, SNGMA

be the engineers. Taking up these arguments, the Scots proposed that the great ships of the Clyde, like the medieval cathedrals, represented the collective achievement of the modern nation's genius. McCance only gave expression to these ideas in a number of small works, however, such as the linocut *The Engineer, his Wife and his Family* (56), or the study for a sculpture of a colossal head which is distinctly mechanistic in form. In much of his later career, though he also continued to paint and to exhibit, he devoted his energy to other areas such as running the Gregygnog Press in Wales, an interest that he shared with his first wife, Agnes Miller Parker (1895–1980), who was a brilliant wood-engraver and an outstanding book illustrator (57).

It was William Johnstone who provided the most convincing expression of the ambitions of the Scots Renaissance in painting, though as he did so he turned his back on the urban and industrial inheritance that McCance had been trying to incorporate into the national aesthetic. Lewis Grassic Gibbon successfully did this in the *Scots Quair* trilogy which follows the story of Chris Guthrie from her rural origins, through small-town life, to the final part, *Grey Granite,* which is set in the big industrial city. In this progress, the author argues that the underlying values are the same, and that this continuity is a source of strength in the struggles of the modern world. This is the point of much that Johnstone did, but his method was at first closer to that of Neil Gunn, who followed the inspiration of the Celtic Revival towards a Jungian kind of symbolism that placed more stress on the ancient continuities of the people and the landscape.

When Johnstone was enlisted at the very end of the war, though he did not see active service, going into the army gave him the break he needed from his background on a Border farm. He had been introduced to painting by the watercolourist Tom Scott, a brilliant technician and an inspired painter of the Border landscape (58). Johnstone then went to study in Edinburgh where he met MacDiarmid, who remained a close friend throughout his life. They were introduced by Johnstone's cousin, the composer Francis George Scott, and from the beginning dreamt of a renaissance uniting painting, music and poetry. From Edinburgh, Johnstone went to Paris where he studied with André L'Hôte. L'Hôte was by now almost an academic figure and a number of other Scots worked in his studio, including William Gillies and William Crozier (1897–1930), and even after the Second World War, Jack Knox (*b.*1936) spent

Plate 56. WILLIAM McCANCE, *The Engineer, his Wife and his Family*, 1925

Plate 57. AGNES MILLER PARKER, *Hares*, 1937

time there. It was the system of travelling scholarships that made this possible for young students for whom neither patronage nor private income was any longer an option. In conjunction with the studio system by which artists like L'Hôte and Léger took in a polyglot community of students for a modest fee, these scholarships played a vital role in keeping young Scottish artists in touch with the outside world. Johnstone was adventurous and he took full advantage of the opportunity this offered of engaging himself at first hand with some of the exciting ideas available in Paris in the early 1920s. His experience of surrealism, for instance, through his friendship with artists like Gonzalez and Giacometti, continued to shape his art throughout his life and it is reflected in some interesting early essays in free abstraction inspired by the surrealist idea of automatism.

Johnstone travelled to California in 1928 with his wife and fellow student, Flora Macdonald, who came from the west coast. There he encountered the search for a kind of modern, national expression in the work of painters like Arthur Dove and Georgia O'Keefe. This made a deep impression on him and helped to shape his own ideas of how such a thing could be done in Scotland in fulfilment of the ambitions of the Scots Renaissance. Picking up again the inspiration of the Celtic Revival, he connected the American interest in pre-Columbian

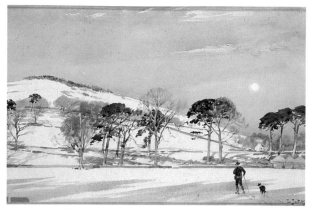

Plate 58. TOM SCOTT, *A Man and his Dog, Winter Afternoon*, 1917

art with his own knowledge of Pictish and Celtic art. He put this inspiration to work in his major painting, *A Point in Time* (1929–38) (59). The picture was begun immediately after his return from the States to Scotland, though he continued to work on it over a number of years after he had moved to London.

The composition is abstract and is the most ambitious of a number that he painted at this time and that are related to it, such as *The Garden of the Hesperides*. The forms that he uses in these reflect the abstract landscapes of Arthur Dove, but although the picture is abstract, it also sug-

gests a great, dark landscape reminiscent of Johnstone's native Border hills, and there are several powerful landscape paintings of the Eildon Hills which have a bearing on its genesis. Indeed, he himself once remarked to the author that it was the Eildon Hills that made him a painter – and with their mysterious symmetry, their associations with Thomas the Rhymer and, before him, with the battles of the Picts and the Romans, and even King Arthur, they do have an extraordinarily powerful presence in the landscape of his childhood.

Johnstone himself called *A Point in Time* 'a primordial landscape',[5] and even at his most abstract, he always thought of his painting primarily as landscape. Within this picture, though, some of the landscape forms in turn suggest half-formed human figures. In a contemporary essay called 'The Land', Lewis Grassic Gibbon reflected on the then fashionable idea of parallel time, on the continued presence of memory and how, 'if events never die, . . . but live existence all time in Eternity, back through the time spirals',[6] then the ancient inhabitants of the landscape would always be there in parallel to our own present existence. It was Johnstone's objective in just this way to evoke the continuing pres-

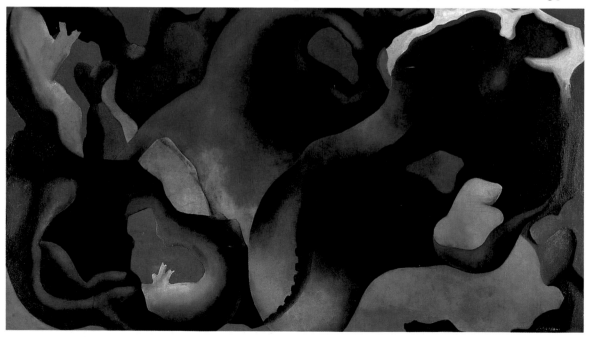

Plate 59. WILLIAM JOHNSTONE, *A Point in Time*, 1929-38, SNGMA

ence throughout time of the former inhabitants of his native landscape and his own identity with them.

The picture is a study in time, therefore, and it evokes the dynamic interaction of the present with the immemorial through the artist's own identification with the landscape of the Borders. It has certain analogies with some of the things that J.D. Fergusson was doing in works like *Megalithic* of 1931, pictures in which he, too, was inhabiting the landscape with images that evoke primeval memories (60). In 1922, when Fergusson toured the Highlands, it had inspired some of his best painting of the time, and in an essay of 1944 called 'Art and Atavism', he addressed these ideas of continuity – 'of the mystery of life that goes to make a tradition'[7] – in words that seem to fit Johnstone's intention. The younger artist is closest perhaps to the poets, however, not just to MacDiarmid, but also to T.S. Eliot who was a mutual friend. Some of the ideas in this picture are paralleled in Eliot's contemporary *Four Quartets,* but in a Scottish context Johnstone's approach to time in the landscape reflects most closely the novels of Neil Gunn.

Gunn's *Highland River,* written later in the decade, is just such an exploration of the interweaving of the time frame of an individual existence with folk memory and history, and of these in turn with the far greater time frame provided by the landscape. In its swinging lines and hinted figures, Johnstone's painting is also a dance and so provides a parallel to Fergusson's *Les Eus,* and also to some of the paintings that Eric Robertson was exhibiting in Edinburgh when Johnstone was a student, such as *Dance Rhythm.* From a photograph of another dance picture done even earlier in his career and now lost, it seems that Johnstone had also been interested in American painting before he crossed the Atlantic. From the photograph, this picture resembled an illustration to an article on rhythm by Jackson Pollock's mentor, Thomas Hart Benton.[8] Given the later development of Johnstone's own abstract expressionism, the parallel between his artistic origins and those of Pollock is quite striking.

Johnstone's paintings in the 1930s were original, but were also recognisably part of contem-

Plate 60. JOHN DUNCAN FERGUSSON, *Thorenc, Afternoon,* 1929

porary developments in painting in Europe and America. Teaching in London from the 1930s to the late 1950s, first as head of Camberwell and then of the Central School, Johnstone was a considerable influence on the younger generation, particularly on those Scots who like himself sought their fortune outside of their native country. Few of his contemporaries who stayed in Scotland were as adventurous as he was, but William Gillies (1898–1973), William MacTaggart (1903–81), William Wilson (1905–72), Penelope Beaton (1886–1963), John Maxwell (1905–62) and Anne Redpath (1895–1965) between them evolved a style that became identified with Edinburgh and was a dominant influence in Scotland through the middle decades of the century. As early as 1922, several artists graduating from Edinburgh College of Art, following the example of the Edinburgh Group, had formed an exhibiting society called the 1922 Group. As well as Gillies and MacTaggart, this group included William Crozier and William Geissler (1896–1963). Crozier died young, but his surviving paintings show how closely he was influenced by André

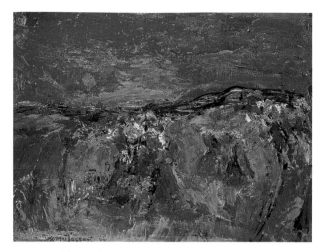

Plate 61. WILLIAM MacTAGGART, *Stooks at Sunset,*
1964

L'Hôte. Geissler's work is principally landscape
and is close to that of Gillies.

If, for Johnstone, his links with literary,
poetic and even philosophic thought were
important in a way that set a standard for some
of the younger artists whom he influenced, these
Edinburgh painters were in contrast consciously
anti-intellectual, or perhaps more accurately
anti-ideological, for their art was strongly sub-
jective. In the early 1930s, for instance, one can
clearly see how it was the naivety of Alfred Wallis
and the work of the St Ives painters who admired
him, especially Christopher Wood and Ben
Nicholson, that was a formative influence on the
work of Gillies and Maxwell. Munch and Ensor
were an important example, too, however, and
there was a strong element of expressionism in
the work of these painters. They saw Scotland
and the Scottish landscape as belonging in the
northern tradition, and on this basis they created
something that was worthy of the ideals of the
Scottish Renaissance. Their work was the begin-
ning of the development of a quite new iconog-
raphy of the Scottish landscape.

Seeing works by Munch in Edinburgh in
1931 affected Gillies very profoundly, and at
times in the 1930s and later, his work is strongly
expressionist, but it never became the dominant
force in his art as it did later for Anne Redpath
and for MacTaggart who, of all this generation,
became the most committed to expressionism.
He was prevented by illness from going to Paris

and to L'Hôte's studio, though sharing a studio
with Crozier for a time must have exposed him
to the essentials of L'Hôte's teaching. Nolde and
Matthew Smith were vital influences on him as,
later, was Rouault. Throughout his life he used
strong colour. Sometimes in his later career this
was piled on so heavily that it loses coherence,
but in his best work he achieves a sombre inten-
sity and expresses genuine feeling (61).

Although she belonged to this generation,
Anne Redpath was away from Scotland for much
of the interwar period. She returned in 1934,
but she really only re-established herself as a
painter in the 1940s. When she did so it was in a
vivid style that looked back to Matisse, though
she was also clearly influenced by the example of
Peploe and Cadell who had, of course, continued
to work and exhibit in Edinburgh through the
1920s and until their deaths in 1935 and 1937
respectively. They kept alive the link with France
and above all with the Fauve tradition, and
Redpath's *Still-Life with Orange Chair* of c.1944
owes as much to Cadell as it does to French
painting. Peploe actually spent a short period
teaching at Edinburgh College of Art near the
end of his life and although Redpath at first lived
in Hawick after her return to Scotland, in a
lovely, cool painting like *Tulips in a White Vase* of
c.1938, she shows her understanding of the
austerity and limited palette of Peploe's late
work. It was this quality of control in her use of
colour, perhaps learnt from Peploe and very
much in contrast to the overloaded palette of

Plate 62. MARY ARMOUR, *Maple Leaves,* n.d.

MacTaggart, for instance, that continued to distinguish her work as it developed. It is still apparent in her best work which belongs to an even later period in her life as she responded to the new current of expressionism coming from America (see Chapter Three).

In Glasgow, Mary Armour (born Mary Steel in 1902 and married to her fellow student at Glasgow, William Armour, 1903–79) occupied a rather similar position to Anne Redpath. She studied at Glasgow in the early 1920s and later

Highland Landscape with Suilven of 1936, or *Skye Hills from Near Morar* of a similar date (63). There is a clear echo of Nolde as well as of Munch in these pictures, but the palette that Gillies uses and the transparency of the light that he creates are quite his own. The results are among the most individual and yet also the most characteristic landscapes of the north-west ever painted. In Constable's phrase, they represent 'the chiaroscuro of nature', but in its very special Highland form.

Plate 63. WILLIAM GILLIES, *Skye Hills from Near Morar, c.*1934

developed a rich and increasingly expressive way of painting whose origins still lay ultimately in the work of the Colourists (62).

Throughout his life, William Gillies's work could vary quite markedly in response to the motif, the mood or the weather, though there is an underlying consistency which makes his hand immediately recognisable. For example, in the early 1930s several trips to the north-west resulted in a series of the freest and most spacious watercolours that he ever painted, such as

At much the same time as these masterly watercolours Gillies painted pictures in which he was experimenting separately with the abstract, imaginary structures of Klee, whose work was exhibited at the Scottish Society of Artists in Edinburgh in 1934, the naive perspective of Wallis, or the dark, expressionist handling of Vlaminck.

Gillies and John Maxwell were close friends but although they seemed like partners, their work was in fact very different. When Maxwell

Plate 64. JOHN MAXWELL, *Still-Life in the Country, 1936*

painted landscape, (65), he and Gillies were still close, but Maxwell's real strength was in a kind of fantastic dream imagery that was often close to Chagall, one of his greatest heroes (64). He does not use this kind of imagery to formulate a complex, allusive poetry as Cowie did, but rather to give poetic form to a simpler, more sensual – even hedonistic – sensibility. Maxwell enjoyed an immense reputation and in the context of Scottish art he played an important role both through his example and as a teacher. Indeed, his influence was similar in a way to that of Johnstone, for both painters for the first time offered a model to younger artists of a function for the imagination that was not dependent on the concrete – as even the example of Arthur Melville had still been – but which was now creatively free. Alan Davie, for instance, is an artist who took vital inspiration from both Maxwell and Johnstone. Maxwell's freedom, though vital, could be a risky model, however, for it was not supported by a sense that this imaginative activity still needed to justify itself in some way. Gillies on the other hand, though certainly influenced by Maxwell, used this imaginative freedom to develop a new, poetic contemplation of the world of tangible experience.

Gillies's approach to the expressive use of painting, especially in landscape, was a powerful influence on Scottish art, an influence that was given institutional status by his position at Edinburgh College of Art where he taught from 1925, was head of painting from 1946 till 1960 and was principal from 1960 till 1966. He shaped a generation and his influence is still apparent to this day. Donald Moodie (1892–1963), Adam Bruce Thomson (1885–1976), (67), T. Elder Dickson (1899– c. 1978), Earl Haig (b.1918) and others either shared or were shaped by his example. Penelope Beaton, too, although she was considerably older, was much influenced by Gillies. She graduated from Edinburgh College of Art in 1917 and taught there from 1919. With all this group, it is a general approach to landscape as a provider of themes on which to work poetic variations that is the unifying characteristic of their art. This is also an approach which can be seen to unite them more broadly with their contemporaries in the south like John Piper or Graham Sutherland, though the work of these Scots was rarely touched by the darker shadows whose presence sometimes gives a more sinister force to the work of the best of their English contemporaries.

For this reason, the visible integrity of Gillies's best work is to be valued for it gives a different kind of validity to his painting. He was very prolific, however, and inevitably uneven. In still-life especially, he was sometimes a little fantastic and occasionally too obviously beholden to French models at the expense of his own individuality, but he developed primarily as a landscape painter. He is at his best working from the motif and when it in turn is most austere. This approach to landscape developed in his work particularly after he moved to live in Temple in Midlothian in 1939 and was able to work constantly in the surrounding countryside (66). He became the supreme poet of the spare beauty of the Lothian hills, the Moorfoots and the Lammermuirs, and of the little communities that they shelter. He based his landscape on drawing, using a wiry line to investigate the intricate contours that give so much interest to these

Plate 65. JOHN MAXWELL, *Harbour with Warning Light*, 1937

seemingly bald hills. He also developed a palette and a sense of the tonal balance of colour, derived in part from Bonnard, that was able to capture the soft harmonies of the close-toned greens and greys, enlivened by pinks and ochres, that characterise the light and the landscape of Lowland Scotland (68).

Like Gillies and Maxwell, William Wilson and Ian Fleming (1906-94) were close friends. Wilson was an apprentice with the stained-glass firm of James Ballantyne and was attending evening-classes at Edinburgh College of Art when he was persuaded by Adam Bruce Thomson, one of his teachers there (and subsequently, too, by a scholarship from the College) to study art full-time. It was also Adam Bruce Thomson who introduced Fleming and Wilson and they became close friends through their mutual interest in printmaking and their membership of the Society of Artist Printmakers which was run at the time by E.S. Lumsden. Up until the crash of 1929, there had been a great boom in etching, inspired no doubt by the success of the older generation of etchers to which Lumsden belonged. He was a superb technician and he seems to have taken it as a personal mission to ensure that the craft of printmaking survived the hard times of the 1930s (69).

Ian Fleming trained at Glasgow School of Art. Charles Murray (1894–1954) was teaching etching there and Chica Macnab (1889–1960) was teaching wood-engraving. A number of distinguished printmakers came from this background. William and Mary Armour, Ian Cheyne (1895–1955) and the MacKenzie sisters, Alison (1970–82) and Winifred (b.1905), all produced

very accomplished woodcuts in the early 1930s. Ian Cheyne went on to specialise in colour wood-cuts on the Japanese model. The MacKenzie sisters went from Glasgow to study the technique with Chica Macnab's brother Iain (1890–1967) who was teaching in London. Iain Macnab was one of the outstanding wood-engravers of the time and one who reached furthest beyond the constraints of his antecedents.

Also in Glasgow, James McIntosh Patrick (*b.*1907) showed a precocious talent as an etcher, producing some first-class plates before 1930. Since that time, McIntosh Patrick's reputation has depended on his luminous but meticulous landscape painting in a style which was fully formed in the early 1930s and has varied in substance very little over sixty years. His painting might seem unrelated to his prints, but there is a continuity of inspiration between them. In his etchings, along with a hint of the influence of

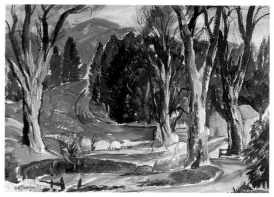

Plate 67. ADAM BRUCE THOMSON, *A Wooded Country Lane, c.*1930

Mackintosh's watercolours, one can see reflected the printmaking tradition that goes back through Samuel Palmer and the English Romantics to its origins in the prints of Brueghel and Dürer and the same feeling inspires McIntosh Patrick's painting. It reflects a love for the particularity of things, the way a group of

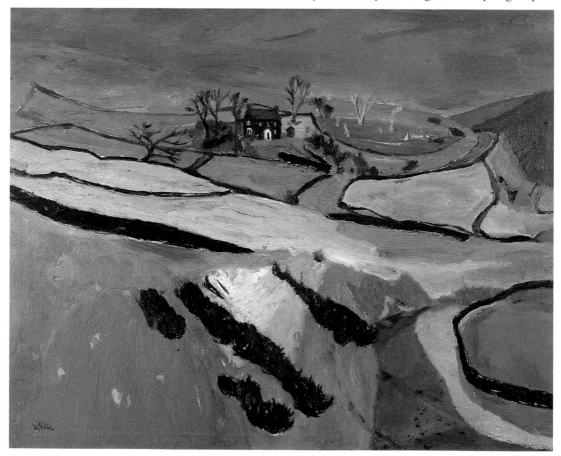

Plate 66. WILLIAM GILLIES, *Landscape with House and Fields*, 1961

farm buildings sits among the black silhouettes of the leafless winter trees, or the fall of light on the soft brown of ploughed fields, or on the washing on a line, all the kinds of things that Brueghel first brought into the vocabulary of the northern landscape painter (70).

Fleming also showed his aptitude as a print-maker at a very early date. His first outstanding print is his large engraving completed in 1931 and called *Gethsemane* (71). It is what might be called a modern-life, religious image. It is reminiscent of some of William Strang's work in this, though not in style. The figure of Christ is in modern dress in a landscape that is part Spain and part Glasgow, including the petrified forest at Victoria Park. In some ways this deliberate inter-weaving of different times also parallels Johnstone's contemporary painting *A Point in Time,* but Fleming's choice of the archaic tech-nique of engraving, which William Wilson also used in a number of his earliest prints, and his use of details like the foreshortened sleeping figures that recall Bellini or Mantegna, is closer to the interest that inspired Cowie and Sivell. They looked to the early Renaissance for models of simplicity, and paintings by Fleming from the period confirm the importance of this link.

The interest in early printmakers was, of course, not confined to Scotland, and in the 1920s there was a marked revival of interest in deliberate, craft-based techniques like wood-engraving and in the vision of an 'innocent' rural world reflected in the work of artists like Samuel Palmer and Thomas Bewick. It was a reaction against the Whistler tradition of facility and sum-mariness in etching. This background inspired Fleming and Wilson to produce some of the finest Scottish prints of the time – like, for exam-ple, Wilson's etchings of the north-west. These are quite different from Gillies's contemporary watercolours of the area, but they match their intensity. In a letter to Ian Fleming, Wilson wrote of his inspiration in these extraordinary prints: 'I have a passion for rocks. I am afraid I also have a failing for romanticism though I try to live it down.'[9]

Wilson's 1937 etching of *St Monance* is per-haps his masterpiece (72). Not only Fleming and

Plate 68. WILLIAM GILLIES, *Heriot, c.*1942

Wilson, but Gillies, Maxwell and many others painted the picturesque ports of East Fife, but in this print Wilson has evoked something deeper than the undoubted charm of these ancient little towns. The architecture is the setting, but this is not an architectural print. Instead, the artist has captured the timelessness of the place. It is shaped by the unchanging needs of the fisher-man's trade, and indivisibly by both the domestic

Plate 69. E.S. LUMSDEN, *The Saut Buckets,* n.d.

Plate 70. JAMES McINTOSH PATRICK, *A City Garden*, 1940

and the spiritual needs of the community. It is not only the church by the sea that evokes this spirituality: it is the light and the fishing imagery itself which creates an atmosphere of such solemnity. In the manner of Puvis de Chavannes's painting *The Poor Fisherman,* which was one of the universal icons of the early part of the century, Wilson engages our sense of the religious symbolism and the almost sacramental character that the Christian tradition invests in the fisherman's trade. This is an example that Ian Hamilton Finlay, John Bellany and Will Maclean were all to follow in the next generation.[10]

Wilson also produced some fine prints of Edinburgh. These parallel some of Lumsden's best work, etchings of tall tenements, dark and grim; but Fleming's etchings of Glasgow are closer to this kind of truly urban theme and in this they look back to Muirhead Bone's Glasgow drawings of thirty years earlier. Fleming's painting and etching of a slag-heap for instance,

though no doubt unconsciously, echo Bone's *St Rollox,* a drawing of a heap of poisonous waste by the Tennants bleachworks at St Rollox in Glasgow, one of the most uncompromising

Plate 71. IAN FLEMING, *Gethsemane*, 1931

Plate 72. WILLIAM WILSON, *St Monance*, 1937

images of its time of the real landscape of industry. Fleming had always been inspired by social and even political concerns and this is clearly apparent in the way in which in these etchings he sought to capture the real quality of the urban and industrial environment. It has its own kind of dignity and this he awards it.

The kind of humane spirituality that Wilson achieves in an etching like *St Monance* should not be unexpected in his work. It was a quality that was at the heart of his stained glass and in 1937 he opened his own stained-glass studio. He was frank in his admiration for Douglas Strachan's work and, like Strachan's, his own work could be spiritual without being in the least pious. For almost thirty years, he produced a series of stained-glass commissions, like that in St Salvator's Chapel, St Andrews, made in 1967 and characterised by rich, deep colours. He produced secular as well as religious glass and some of the small panels like the *Irish Jig* of 1948 that decorated his own hallway are a lively departure from the conventional piety or heraldic formality of the stained-glass artist (73). In its social satire and informal structure, this image also shows Wilson's appreciation of German artists like Otto Dix. This was a remarkable point of view to take at the time, and it prefigures the interest in German progressive art taken by artists in the next generation.

Wilson's influence was considerable. His free and expressive use of colour and imagery in his glass is closely paralleled in the painting of his contemporaries in Edinburgh. His example may well have influenced them, for not only do they often use expressive colour in a similar way, but stained glass itself is a frequent theme in the painting of Robin Philipson (1916–92) and Anne Redpath. Among the other artists who first made their mark in the 1930s were the painters William Crosbie (*b.*1915) and Denis Peploe (1914–93) and the sculptors William Lamb (1893–1951), Tom Whalen (1902–75), George Innes (1913–70) and Hew Lorimer (1907–93). Crosbie studied at Glasgow a year or two after Fleming and went from there to Paris where he studied with Léger and Maillol (74). His early work, which reveals his knowledge not only of Léger's painting but also of the ideas of the Surrealists, is interesting in the context of the relative conservatism of much that was being done in Scotland at the time. Unlike Johnstone, however, he did not build on this to make something that was enduringly distinctive, though he

Plate 73. WILLIAM WILSON, *The Irish Jig*, 1948

Plate 74. WILLIAM CROSBIE, *Tumblers*, 1958

himself said of his work: 'subject dictates style, therefore variation in subject equals variation in style'.[11] Denis Peploe was the son of S.J. Peploe. He studied in Edinburgh and went from there to L'Hôte's studio. He carried on his father's tradition to the extent that he was a painter of landscape and still-life, but he was also a very fine draughtsman. He taught for many years at Edinburgh College of Art (75).

Of the sculptors, William Lamb, who worked for most of his life in Montrose, established his reputation by the bronze that he made of the royal princesses, Elizabeth and Margaret. He was not simply an academic portrait artist, though, and produced a number of imaginative works (77). He was also an accomplished printmaker.

Hew Lorimer left his mark on Scotland through his dedication to monumental stone-carving. He set out to follow his father as an architect, but turned to sculpture under the guidance of Alexander Carrick at Edinburgh College of Art. He then spent a short time with Eric Gill, which was a vital formative experience for him. He was a Catholic convert and this was reflected in the gentle spirituality of his best work, both on a small and a large scale, and some of his large-scale work is truly monumental. On the façade of the National Library of Scotland in 1953, he carved *in situ* the figures of the *Seven Liberal Arts*. (The secondary decoration on the library was done by Elizabeth Dempster (1909–87), James Barr and Maxwell Allan.

Lorimer's figure of *Our Lady of the Isles* is on an even grander scale. It is a Madonna and child, twenty-seven feet high and sited on the west coast of South Uist (76), so that mother and son are gazing out together across the Atlantic towards America. Lorimer carved them from nine blocks of granite, also *in situ,* assisted by Maxwell Allan. Though he was less adventurous, Lorimer was a parallel figure to William Wilson and like him helped to keep alive for a younger generation the special combination of spirituality and humanity that marked the best tradition of the Arts and Crafts movement.

Lorimer and Tom Whalen were close friends, spending a year travelling together after graduation, and passing much of their time studying the Romanesque and early Gothic which remained Lorimer's central inspiration. Whalen was perhaps a more adventurous artist than Lorimer and, excepting the small group of remarkable sculptures by Fergusson, in his art, like that of George Innes, one can see for the first time in Scottish sculpture a reflection of European modernism (78).

In Edinburgh, Alexander Carrick contributed monumental sculpture to a number of buildings, most notably a fine relief of *Christ and the Woman of Samaria* for the Robertson Memorial

Plate 75. DENIS PEPLOE, *Canna Lilies and Mosque*, 1951

Plate 76. HEW LORIMER, *Our Lady of the Isles*, 1954-56

Plate 77. WILLIAM LAMB, *The Daily News, c.*1930

Church, and the two monumental bronze figures of *Safety* and *Security* for the entrance of the Caledonian Insurance Company in St Andrew Square, built by L. Grahame Thomson and Frank Connell and completed in 1940. The interior also has important stained glass by William Wilson with a very imaginative treatment of secular imagery. In 1938 in Glasgow, Tom Whalen, Hew Lorimer, William Wilson, Archibald Dawson (1894–1938), Hugh Adam Crawford (1898–

1982), William Crosbie and several other artists also contributed works to the Empire Exhibition of that year. Whalen's monumental figure of *Service* in the Scottish Pavilion (North) in a highly simplified, neo-classical style, seated on a throne with the torch of knowledge in one hand and the staff of health in the other, was a striking piece of modernist *mise-en-scene* in its setting of black marble and glass. Whalen also executed a number of other works in the exhibition, while in the opposite Scottish Pavilion (South), Archibald Dawson, head of sculpture at Glasgow School of Art, was helped by his students to create a twenty-five-foot-high figure of *St Andrew* standing on the prow of a ship. Hugh Adam Crawford was Dawson's colleague as head of painting at Glasgow, and he painted murals for the church on the exhibition site, for which William Wilson contributed the windows.

This exhibition also included an extensive display of historical Scottish art which was followed in 1939 by the massive Scottish art exhibition at the Royal Academy in London, the largest there has ever been. The principal organiser was Sir James Caw. These were important landmarks in establishing the self-confidence of Scottish art outside of the radical circles of the Scots Renaissance. The Empire Exhibition was a sign of a new spirit of aesthetic adventure and optimism. Sadly, this was overtaken by the war — though it was not entirely extinguished by it — and by the years of austerity that followed.

Plate 78. TOM WHALEN, *Mother and Child*, 1933

Plate 79. BET LOW, *Blochairn Steelworks, c.*1946

CHAPTER THREE

WARTIME AND THE POST-WAR WORLD

During the years between the wars, J.D. Fergusson spent much of his time in the South of France. C.R. Mackintosh was there, too, painting the watercolours that earned his living. The two friends stayed in touch and, during the last eight years of his life, Geddes, too, was frequently there, engaged on his project of the Scots College at Montpellier, where he died. These three were the great figures of early Scottish modernism and in many ways their ideas have remained at the core of the most progressive art that Scots have produced since then. Mackintosh died at the age of sixty in 1928. Geddes died four years later, but Fergusson lived on till 1961, keeping alive the ideas that he had shared with Geddes and Mackintosh for a generation that did not come of age till after the Second World War.

In 1939 Fergusson and Margaret Morris (1891–1980) returned to Scotland and Fergusson explained that they chose to settle in Glasgow, rather than his native Edinburgh, because it was a Celtic city.[1] In the spirit of the Celtic Revival, his Gaelic-speaking ancestry was very important to him and he saw in Glasgow the modern manifestation of what he believed was the Celtic spirit expressed through the achievement of the ship-builders and the engineers in heavy industry. He may have been helped in his optimistic vision of Glasgow by the success and the undoubted adventurousness of the Empire Exhibition in 1938, but he certainly thought that the engineering tradition and what he saw as Glasgow's Celtic non-conformity would together provide a basis for the revival of art in Scotland, untouched by stultifying, academic traditions. 'What we would like to see,' he wrote, 'is art in the same class as the *Queen Elizabeth*.'[2]

Fergusson set out the theoretical base for this in his book, *Modern Scottish Painting*, which was written in 1939 in response to what he saw as the academic bias of the Scottish art exhibition in London that year, although the book was not published till 1943. It is a highly subjective polemic. In it, he uses arguments for the special potential of Scottish art which later find echoes in the writings of Hugh MacDiarmid and Ian Finlay,[3] but which were probably also current much earlier. Fergusson himself was a great talker and he may well have been airing these ideas twenty years before. It could already have been in part Fergusson's ideas, therefore, though coloured by the direct influence of Wyndham Lewis, which were reflected in the kind of things that William McCance was doing and saying in the 1920s.

With characteristic energy, when he settled in Glasgow Fergusson set about trying to achieve a new renaissance there, gathering round himself and Margaret a group of enthusiastic younger artists, though he also found allies outside the immediate circle of visual art. Indeed, three of the permanent survivors of this wartime renaissance in Glasgow were the Citizens Theatre, the Scottish Ballet (which began with Margaret Morris's foundation of the Celtic Ballet) and the Cosmo Cinema (now the GFT). This circle also found an enterprising and sympathetic publisher in William McLellan, who recorded their ideas and activities in a number of publications. Fergusson, for instance, was the art editor for the journal *Scottish Art and Letters* that McLellan published and which appeared somewhat irregularly from 1944 till 1950. In this, alongside the poetry and prose of Scots Renaissance authors like MacDiarmid, Sorley MacLean, Sidney

Goodsir Smith, Robert Garioch and Norman MacCaig, works by the painters in Fergusson's circle are reproduced, often in colour, as are some fine drawings by Fergusson himself. The editor for the first four numbers was R. Crombie Saunders, but for the last number MacDiarmid replaced him, so that on this occasion he and Fergusson collaborated directly. The editorial in this final number, written on the occasion of the PEN Congress in 1950, is on the freedom of the writer. It concludes with a paragraph on the freedom of the artist that has the tone of Fergusson himself, and which certainly echoes his ambitions in Glasgow: 'Give the young independent painters of Scotland the chance of an exhibition and they will show the world and the Ecole de Paris art that is as Scottish as French art is French.'

The members of Fergusson's group of artists formed the New Art Club in 1940, in opposition to the old-established Glasgow Art Club. Three years later they held the first exhibition of their own exhibiting society, the New Scottish Group, formed in 1942. Naomi Mitchison wrote the introduction to the catalogue of the first show and a fully illustrated catalogue was published by McLellan for one of the Group's shows a few years later in 1947. In 1956 the New Scottish Group showed along with another organisation, the Society of Scottish Independent Artists, a title that recalled Fergusson's ambition to create a Scottish equivalent to the Salon des

Indépendants. There were a lot of individuals involved in all of this. Some of them might never have turned to painting without the stimulus offered by Fergusson and Margaret Morris, but others like William Crosbie and Donald Bain were already mature artists. Bain (1904–79) enjoyed a considerable reputation – a monograph on his work was even published by McLellan – but, encouraged by W.Y. Macgregor, his art was originally shaped by the influence of the Colourists, especially Fergusson and Hunter, and he remained very much in Fergusson's shadow. Works with Celtic overtones, like the *Children of Lyr* of 1945, were exceptional in his art which was predominantly landscape and still-life in a free variation on a colourist way of painting (80).

Between 1946 and 1948, Bain was one of several Scottish artists resident in Paris and the expressionist quality of his work at the time does show some affinity with developments there. Crosbie was more independent and he designed the sets for the first productions of the Celtic Ballet. Other painters in this group, like Millie Frood (1900–88), Louise Annand (*b.*1915), Isabel Babianska (*b.*1920) and Marie de Banzie (*b.*1918), produced work that was distinctive in the context of wartime Britain even though their talents were modest. It was, however, the number of artists drawn into it and their willingness to be adventurous that marked the circle of the New Art Club rather than the absolute achievement of any of them individually, though they were certainly lively. Louise Annand, for instance, painted an abstract rendering of *A Meeting of the New Art Club* (1944) which, even if it was only half serious, is unusual for its time in Britain in being purely abstract and also guided by an expressive intention (as distinct from the formal abstraction of contemporary constructivism). Millie Frood produced some remarkable paintings of the people of Glasgow such as *The Ice Cream Stall,* apparently inspired by expressionists like Soutine or Ensor (81).

This group were collectively inspired by the stimulus of the arrival in Glasgow of two refugees, Josef Herman (*b.*1911) and Jankel Adler (1895–1949). Both were of Polish origin,

Plate 80. DONALD BAIN, *Landscape*, 1945

Plate 81. MILLIE FROOD, *The Ice-Cream Stall, c.*1946

but Herman came to Scotland from Brussels and Adler from Paris, and so they could claim to be part of the contemporary world of European painting much as Fergusson himself could claim to have been a partner in the origins of modernism almost forty years before. These two made a considerable impression on the young painters in Glasgow, cut off as they were from all other contact with continental art. Herman arrived in 1940 while Adler came the following year. (It was also in 1940 that Stanley Spencer began work as a war artist on his series of paintings of shipbuilding at Port Glasgow.) Both Herman and Adler moved south in 1943. Herman's influence was perhaps the greater of the two not only because he stayed longer, but because his earthy social realism reflecting his political views was more in tune with the aspirations of some of the more serious painters in Glasgow. It was probably in response to his influence that, like Millie Frood, George Hannah (1896–1947) painted some very solidly 'democratic' pictures such as his *Charwoman,* a back view of a stout female figure scrubbing the steps. Hannah also declared his political intentions in

such pictures by stating his distinctly left-wing views in the journal *Million,* a political-artistic review edited by John Singer and also published by McLellan. Hannah wrote there that 'individual experience can only possess depth and solidity if it mirrors communal experience. This experience is the spirit, the life-blood of all art.'[4] One could compare Walter Crane here – 'The source of art is in the life of a people'[5] – and certainly similar sentiments were expressed by Fergusson, Ian Finlay and others. It is important therefore to see how the views represented by Herman could find correspondence in the native artistic tradition in this way. The kind of work painters like Hannah were doing was not simply the result of an attempt to graft imported political ideas onto art.

The most interesting product of this kind of left-wing commitment was in the work of Tom Macdonald (1914–85), Bet Low (*b.*1924) and Joan Eardley (1921–63). Macdonald trained as an engineer. He moved into Josef Herman's studio when Herman left Glasgow, and he declared his politics when he exhibited a portrait of John Maclean in an exhibition organised by the Clyde Group, an organisation of which he was a founder member. It had a self-declared mission to take literature and art to the working people of Glasgow. Low joined the group in 1946 and she and Macdonald married in 1947. The artists in this group also made it their business to record the industrial landscape. Macdonald's *Transport Depot* (*c.*1946), for instance, is a wholly unadorned industrial landscape (82).

Low's drawings, with their heavy black figures and simplified shapes, clearly reveal Herman's influence, but in *Blochairn Steelworks* (*c.*1946) she achieved a genuinely original and dramatic statement which belongs in the tradition of heroic images of industry that goes back to the eighteenth century (79). Bet Low's picture is painted roughly on a piece of coarse-grained canvas. She seems explicitly to reject the fine art traditions of finish and technical proficiency and this is something that can be seen in Joan Eardley's early work, too. Often Eardley's surviving pictures of the time – like *Glasgow Backland near the Canal,* for instance, of 1944 – are painted

Plate 82. TOM MACDONALD, *Transport Depot, Early Morning*, c.1946

on the roughest of supports with the most per-functory preparation, reflecting the untidy, extemporised nature of the world that they record, so remote from the elegance of 'fine art'.

Bet Low and Tom Macdonald both continued to paint. Macdonald developed an expressive way of painting that reflected the international modernism of the post-war decades, but which never lost its social commitment. He also worked extensively for the theatre and latterly for Scottish Opera. Bet Low became a landscape painter of distinction, painting the Highlands in an eloquent, minimal way. It is of interest that Ian Hamilton Finlay exhibited with Macdonald, Low and Eardley in 1950. Finlay later distanced himself from this background by starting afresh in the 1960s, however, and it was Joan Eardley who was the outstanding artist to emerge directly from 1940s' Glasgow. Its inspiration stayed with her in her paintings of Glasgow children, even though her art opened out to many other influences. She was not the only important artist to come from Glasgow at this time, though, and for this reason her work will be looked at in detail a

little later. Ian Fleming was teaching at Glasgow School of Art and although he was temperamentally in sympathy with some of the left-wing and nationalist views which united the artists in Fergusson's circle, he was already an established artist and did not need Fergusson's leadership. In the early part of the war he developed the social realism of some of his prints of the late 1930s in a series of powerful etchings of the blitz.

Ian Fleming was also the teacher at Glasgow School of Art who most encouraged the two Roberts, as they were called, Robert Colquhoun (1914–62) and Robert MacBryde (1913–66), though Hugh Adam Crawford as head of painting also had an important influence on them. Fleming painted a fine double portrait of them and the two were inseparable from their time at the School, where they graduated in 1937. MacBryde was exempted from war service on medical grounds and Colquhoun only served briefly before he, too, was invalided out of the army. In 1941 they settled in London where they became the best-known Scottish artists of their generation. The great Scottish art exhibition at the Royal Academy in 1939, following as it did

on the hugely successful Empire Exhibition in Glasgow the previous year, had helped to establish the idea of a distinctive Scottish tradition in the south, and in 1942, Colquhoun and MacBryde showed in London with Johnstone, Maxwell, Gillies and Edward Baird in an exhibition that helped to do something to keep this reputation alive. During the war years the two Roberts very much identified themselves by their role-playing as wild, bohemian Scots, although ironically in their painting they were closer to contemporary English art than any of their Scots contemporaries.

MacBryde was a skilled picture maker, using a language that derived from the more decorative side of late cubism, especially from Braque, and which, given that inheritance, works best in still-life (83). Colquhoun and MacBryde were friendly with painters like John Minton and John Craxton and this shows in their work. Colquhoun was a stronger and more original artist than MacBryde, however, and there are also close links between his painting and that of such artists as Graham Sutherland and Francis Bacon. Like them, his art reflects an anguished,

Plate 84. ROBERT COLQUHOUN, *Girl with a Circus Goat*, 1948

nihilistic view of the world. In 1952 Herbert Read, though writing on contemporary sculpture, made a remark which summarises this kind of angst expressed in the art of so many of the best of this generation in England: 'These new images belong to the iconography of despair, or of defiance; and the more innocent the artist, the more effectively he transmits the collective guilt.'[6] It is in keeping with the spirit of this remark that the characters in such paintings by Colquhoun as *Girl with Circus Goat* (84) or *Figures in a Farmyard* (85) are dehumanised, even brutalised by alienation, though the guilt that Read refers to may reflect the artists' sense that the remoteness of their art from the experience of ordinary people is part of their particular feeling of alienation and failure.

Jankel Adler was an important influence on Colquhoun; when he had left Glasgow in 1943 he moved in with the two Roberts in London and it was perhaps through him initially that Colquhoun came to understand the expressive force of Picasso's use of distortion in his work of the 1930s. Colquhoun uses this in a directly expressionist way in his construction of faces,

Plate 83. ROBERT MACBRYDE, *Objects on a Table, No.1*, 1946

but in this he also drew on Picasso's earlier use of masks, not merely for pictorial effect, but to shock. In *Figures in a Farmyard,* for instance, which was painted in 1953, a pig with a brutal mask for a face looks out at us directly. Colquhoun dramatically exploits the inherent ambiguity of the primitive animal mask – is it man or is it beast? – and the pig completely upstages the human characters. Its evil presence is reminiscent of William Golding's tyrannical pig-totem in *Lord of the Flies,* published in 1954. Colquhoun's later work has such force that it can legitimately be placed alongside such potent expressions of the post-war climate of bleak anxiety shaped intellectually by the ideas of existentialism.

Though in a later generation, John Bellany (b.1942) in his earlier work shares something of the bleakness of Colquhoun's vision of the world and, too, he locates it in a specifically Scottish perspective. Few Scottish artists, however, were quite so pessimistic as Colquhoun was in such pictures as *Figures in a Farmyard* or *Two Dancers.* In the latter picture, he takes the theme of the dance – which, in Scottish art particularly, even as recently as Johnstone's *Point in Time*, had been an image of social integration and identity – and turns it into something that seems to speak of the impossibility of human contact. Among his Scottish contemporaries, Joan Eardley was certainly influenced by Colquhoun in her treatment of the human face, but as, for example, in her vivid series of little portraits of *Jeannie*, she used distortion to reaffirm identity, not to deny it. Her work, both as a figure painter and as a landscape painter, if it is not optimistic, is certainly positive and life-affirming and she generally achieves this without being sentimental, though she sometimes comes close to it.

Eardley trained at Glasgow School of Art till 1943. The time that she spent in 1946–47 with James Cowie at Hospitalfield was also important, and it was perhaps Cowie's influence that underlay a certain austerity in her best work, particularly as a landscape painter. But her horizons were really first broadened by the experience of Italy which she visited on a travelling scholarship delayed by the war till 1948. Looking

at her figure paintings of the 1950s such as *The Table,* or the stark *Sleeping Nude* which is unique in her work and exceptional in the painting of her time, there is a directness and intensity which sets her apart from her contemporaries in the south such as John Bratby and the other 'kitchen sink' painters with similar concerns. Even when, as so often, children are the subject of Eardley's paintings, though she does not ameliorate their scruffiness and the untidiness of the world they inhabit, she maintains their dignity.

Eardley was clearly aware of the abstract and semi-abstract painting of the School of Paris. In the late 1950s and early 1960s, because of the success of the Americans and their willingness to work on a grand scale, the kind of abstract expressionist painting that influenced Eardley and also Redpath is now seen as essentially an American achievement. For most people living in Britain in the immediate post-war years, however, the idea that the expressive gesture of hand or arm, translated into paint, could achieve some kind of coherent expression on its own and without reference to any other perceived phenomenon became familiar, if at all, through the work of the School of Paris painters. In France, however much it disrupted artistic life, the war had not broken its essential continuity. Britain, of course, was cut off from this, and, unlike America, it did not have a large population of major European artists as refugees. In Scotland, artists turned to reforging these vital links at the earliest opportunity. School of Paris painting was shown at the SSA as early as 1945, for instance, and it was seen regularly thereafter, including a show of de Staël's work, again at the SSA, in 1956. This exposure culminated in the showing of the Moltzau Collection of painting from the School of Paris in 1958 and in the same year an exhibition at the SSA was devoted to tachisme, which was roughly the French equivalent of American abstract expressionism.

Eardley's understanding of these developments lends a toughness to the surface of her pictures. This was a characteristic which blossomed dramatically as she turned more and more to painting landscape, but in her figure paintings she also brings to her representation memories

Plate 85. ROBERT COLQUHOUN, *Figures in a Farmyard*, 1953, SNGMA

Plate 86. JOAN EARDLEY, *Children: Port Glasgow, c.1955*

of the way in which some of the greatest painters gave dignity and even grandeur to the ordinary. This is already apparent in the inspiration of Van Gogh that is so important in her early drawings of Glasgow and in some of her best Italian drawings, and in a later work like *Andrew with a Comic,* for instance, there are clear memories of Degas's *Diego Martelli,* familiar in Scotland from its presence in the National Gallery of Scotland since it was acquired in 1932.

In the same way, another of Eardley's major paintings of children, *Children: Port Glasgow,* seems to make a reference not to a great painting perhaps, but to a universally familiar one – Henry Holiday's *Dante and Beatrice,* one of the best-known pictures of the nineteenth century, in which Dante turns to look at Beatrice as she walks past unaware of his interest (86). In Eardley's picture, the little girls have a pushchair with a baby and, as they pass, the boys look back at them as the girl pushing the pushchair turns her head defiantly. She has been substituted for an adult woman who was originally in her place and is still visible as she is only partly painted out. This alteration was an inspired afterthought, for thus the children in the picture can be seen experimenting with

Plate 88. JOAN EARDLEY, *Catterline in Winter, c.*1963

their adult roles away from the presence of adults which would have defined them still as children. The Dante and Beatrice reference, even though we only remember it unconsciously as perhaps Eardley herself did, gives a kind of poetic seriousness and dignity to this scene of Glasgow boys and girls. It allows us to compare this picture to Cowie's *Falling Leaves* with its theme of the transition from childhood. In Cowie's picture the imagery is used much more formally, of course, but Eardley did make studies for this painting in the way that Cowie prescribed.

It was part of Joan Eardley's strength as a painter that she continued to absorb and adapt to her own purposes the radical developments in contemporary painting that were going on outside Scotland, not only in France, but latterly also in America. This is clearest in the increasing freedom of her landscape painting, but it is also apparent in late figure paintings like *Children and Chalked Wall,* where her painting echoes directly the graffiti-covered surface of the wall that she represents or *Three Children at a Tenement Window* (87). Dubuffet is part of her inspiration here, but the result is also a better and far less self-conscious translation of the imagery of popular culture into art than was achieved by most of the contemporary Pop artists, and in the latter picture, she also characteristically and success-

Plate 87. JOAN EARDLEY, *Three Children at a Tenement Window, c.*1961

Plate 89. JOAN EARDLEY, *January Flowtide*, 1960

fully combines it with a memory of Rembrandt's *Girl at a Window.*

From 1950 Eardley worked frequently on the north-east coast at Catterline and after she had bought a cottage she stayed there for increasingly long periods. On the clifftops and adjacent farmland round about she painted some wonderful landscapes both in summer and in winter. The summer paintings from the last few years of her life sometimes recall Constable in the way that they immerse us in the richness of summer growth against the sky, as in *Flowers between Cornfields* or *Grasses.* In the latter picture she incorporates the grass and flowers themselves into the picture as collage without in the least disturbing our feeling that it is a painting that we are looking at. The winter landscapes are, if anything, even more memorable in the way they capture the austere beauty of the dark and often frozen countryside as it is seen in *Catterline in Winter*, for instance (88).

Eardley was not an indoor landscape painter. She consistently worked on her landscapes on the spot, whatever the conditions. It is this which gives such authenticity to the seascapes which are the high point of her painting. There is a series of

these pictures of the winter sea painted at the end of her life. She used large horizontal boards and apparently took them right down to the water. They are painted with great breadth and dash. This certainly reflects her knowledge of contemporary American painting, especially the work of De Kooning, perhaps, but there is an urgency about her paintings as she visibly struggles to hold together in a single image both her objective understanding of the perceived facts of what is in front of her and her subjective experience of the inarticulate demands of the wind and the restless water. The balance that she succeeds in reaching between a coherent image and the vast incoherence of the experience that it records is remarkable.

Most of Eardley's contemporaries elsewhere, like Peter Lanyon or Patrick Heron in England, or Soulages or Hartung in France, were happy to take the freedom of expressive abstract painting as self-sufficient, whereas Eardley, true to the landscape origins of the style, saw this freedom as a new way of trying to achieve an ancient objective: to capture in permanent form the dramatic intensity of immediate, transitory experience (89). It is this, not some superficial

resemblance, that links her back to the elder McTaggart and, indeed, through him to Constable and the origins of Romantic landscape painting. It authenticates her claim to be a great painter in the main, European tradition.

Amongst Eardley's contemporaries, the painter who came closest to her was Angus Neil (1921–92). Indeed, for a long time he was quite lost in her shadow, though an exhibition held in Aberdeen in 1994 has made it possible to see that although he was profoundly influenced by her, he did also have a real talent of his own.

Anne Redpath, though she belonged to an older generation, was rather a parallel figure to Joan Eardley. Redpath moved from the Borders to live in Edinburgh in 1949 and during the last fifteen years of her life her painting developed dramatically, partly in response to renewed opportunities for travel. She was always more subjective than Eardley and her subject matter is often emotive in a generalised way, as in her

paintings of church interiors like *Church Interior, Portugal,* or the very late *Ladies Garden, Palaçio de Frontiera,* where the light and colour break up the image in a rich confusion of effect (90). Based in Edinburgh, it was understandable that her approach grew closer to that of Maxwell. She was also close to Robin Philipson and to the younger MacTaggart (who was a neighbour), for whom Rouault was a major influence. It is, however, the expressive urgency that Redpath managed to capture in her later work which sets her apart from her Edinburgh contemporaries. As with Eardley's seascapes, in some of Redpath's late landscapes and still-lifes, like *Landscape: Kyleakin* of 1958 or *White Flowers with a Vase* of *c.*1962, the paint runs across the canvas with such energy that it seems like a fragment of experience caught on the wing (91). Looking particularly at the way she used still-life as a poetic vehicle, even in these late works it is possible to see a direct link back to Peploe and the

Plate 90. ANNE REDPATH, *Ladies Garden, Palaçio de Fronteira, Lisbon,* 1962

Plate 91. ANNE REDPATH, *White Flowers in a Vase, c.1962*

Colourists – reflecting the underlying continuity in Scottish painting where in a small community the bonds between individuals have always been so important.

The renewal of relations with the continent was a vital stage in the development of post-war art, though such mundane things as currency restrictions meant that travel did remain difficult for ordinary people until the early-1950s. But the establishment of the Edinburgh Festival in 1947 provided an opportunity to show international work of all kinds. This ranged over the kind of modern work shown at the SSA and elsewhere, through the major exhibitions of the 1950s devoted to such giants as Cézanne, Monet, Renoir and Gauguin. This re-establishment of links was also a process which generated a lot of hostility from the British public, but it was one in which individual Scottish artists played an important part. It is hard to say exactly why this should have been the case, though in

Scotland the tradition of looking beyond England to the continent certainly survived and was facilitated by the travelling scholarship system.

William Gear (*b.*1915) went straight to Paris after he was demobbed in Germany. He was a graduate of Edinburgh College of Art and he had already spent time in Paris before the war on a travelling scholarship. He had studied with Léger and so, the war over and back in Paris, he was taking up where he had left off. While he was still in Germany, too, he had already held solo exhibitions in Celle and Hamburg and he had helped several German artists back onto their feet. He lived in Paris for three years until 1950. Klee was an important influence on him and he seems to have gravitated naturally towards the kind of expressionism that unified the Cobra group. This group took its name from the initial letters of Copenhagen, Brussels and Amsterdam and was self-consciously northern even though many of its artists were based in Paris. Asger Jorn and

Karel Appel became Cobra's best-known members and the group's work was generally characterised by its stress on expressive intensity even to the point of violence. This was certainly what distinguished Gear's work at the time.

Gear and Jorn had been students in Léger's studio at the same time ten years earlier, but it was actually his friendship with the Scots-born painter, Stephen Gilbert (b.1910), which established Gear's link with the Cobra painters. Between 1947 and 1951 he was working from motifs mostly derived from landscape and still-life, as in *Interior with a Lemon* of 1950, but sometimes also from shapes that he evolved spontaneously and without premeditation. He then developed these intuitively into jagged and expressive patterns of shape and colour, often outlined in black. These become increasingly autonomous and eventually fill the whole field of the picture. Sometimes these pictures are called landscapes, but they may equally have titles which identify their purely abstract character, like *Composition-Blue Centre* of 1949, or *Composition Printanier* of 1950. During the early 1950s, the dynamic tension in these pictures increased to create a 'landscape' crossed by open-ended diagonals in a field of vivid, expressive force, as in *Pastoral* of 1952. Commenting in 1958 on the beginnings of abstract painting in England in the early part of that decade, Lawrence Alloway remarked that at that time 'William Gear stood out as the sole new professional'[7] among his contemporaries. Indeed in 1951 this was notoriously true, for the picture in this style, *Autumn Landscape,* that Gear painted to a commission from the Arts Council for the exhibition '60 for '51', became something of a *succès de scandale* when it won a £500 purchase prize. Like some of the entries for the 'Unknown Political Prisoner' competition sponsored by the ICA in 1952, the abstract style of Gear's picture became a battleground in the cause of modern art (92).

Eduardo Paolozzi (b.1924), too, created an important abstract work, *The Cage,* and a related *Fountain* for a commission from the Arts Council for the Festival of Britain. *The Cage* is a six-foot-high open bronze structure. It looks back to a work of the same title by Giacometti, but in its general abstract language it is also like some of Gear's paintings, and Paolozzi had also been in Paris in the years immediately after the war. He and William Turnbull (b.1922), who was in Paris at the same time, later became associated with the Independent Group in London of which Paolozzi was a founder member, and they both eventually moved away from this kind of expressive abstract art. But in 1948 Gear was host in Paris to another Scottish pioneer of post-war modernism in Britain and in particular of abstract expressionism, Alan Davie (b.1920).

Davie had served in the anti-aircraft batteries during the war and after a period working as a professional jazz musician amongst other things, he returned to painting. In 1948, taking up a travelling scholarship from Edinburgh College of Art where he had begun his studies in 1937, he travelled to Paris and Venice. There he encountered not only some of the most modern

Plate 92. WILLIAM GEAR, *Black Tree*, 1959

European painting at the Biennale, but also recent American painting in the Peggy Guggenheim Collection. His work during the short period of 1948–49 presents a fascinating dialogue between the native Scottish imaginative tradition represented by Maxwell, Gear's personal combination of Cobra and School of Paris painting, and the bigger scale and even greater freedom of the Americans, especially Pollock – though the novelty of American painting should not be overstressed. Gear himself exhibited at the Betty Parsons Gallery in New York in 1949.

After Davie had settled in London in 1949, another influence entered his work, that of William Johnstone who, of course, had his own independent links back into the early surrealist tradition. As head of the Central School, Johnstone exercised his considerable powers of patronage with great discernment. Davie, Turnbull and Paolozzi were among the many promising young artists for whom he found

work. Johnstone was by this time distinctly Jungian in his ideas rather than Freudian as the Surrealists had been. The Jungian view of the unconscious and the survival within it in all of us of the primitive as a set of archetypes is one to which Davie has remained loyal ever since.

During the early 1950s, Davie cultivated pure spontaneity in his painting. In pictures like *Jingling Space* of 1950, or *Peggy's Guessing Box* (1950–51) he was by his own account trying to achieve 'pure intuition';[8] through improvisation, he was seeking a form of expression in which the conscious mind was bypassed to allow freedom for the unconscious to reveal itself. It was a process akin to playing jazz, and the musical analogy helps us into these pictures which defy conventional interpretation. In them, just as in jazz improvisation, shapes evolve from each other, and, as they do so, they develop a dynamic which involves the space around them (93).

Davie had his first solo show with Gimpel

Plate 93. ALAN DAVIE, *Jingling Space*, 1950

Plate 94. ALAN DAVIE, *Wedding Feast*, 1957

Fils in 1950 and the great freedom with which the pictures of these first years back in Britain were painted was outstanding in contemporary art. The way in which he broke with both the definition of form and the decorative elegance of surface that still marked European abstract painting indicates the importance to him of the example of the Americans. In many of the paintings of the mid-1950s, too, like *Woman Bewitched by the Moon No. 1* (1956), *The Creation of Man* (1957) or *Wedding Feast* (1956), the composition is built up of wild, coiling, visceral forms. It is shaped by the violence of true expressionism, where it is the force of the emotion that the artist is seeking to convey that has breached these formal conventions (94).

At the same time, however, by the later 1950s and early 1960s, the shapes in Davie's paintings began to become more concrete and to evoke such archetypal forms as the sun-wheel, the serpent, or the Tau cross or ankh, as in *Entrance for a Red Temple* (1960) or *Oh to be a serpent that I might love you longer!* (1962). This gradually led to a clarification of form and an increasingly lyrical use of colour as he explored a diverse vocabulary of imagery derived from such sources as the Jain art of India and the rock drawings of the Caribs. Although formally his art became very different from the expressive gestures and inchoate imagery of his early painting, as this clearer and more orderly way of painting has evolved through the later part of his career, there has been no radical change of intention. His way of painting is still intuitive and the symbols that he uses are not exploited in the construction of any deliberate meaning. The conscious mind has not usurped the kingdom of the unconscious.

Plate 95. ALAN DAVIE, *Blue Moon*, 1975

Indeed, of all his contemporaries, Davie has remained most loyal to the kind of subjective poetry that Maxwell made his own (95).

In the 1950s, although they were working in different media, the work of Davie and Paolozzi had a certain amount in common. Paolozzi had not studied formally at Edinburgh though he had attended evening-classes. He went south to study at the Slade. Then, following the success of his first solo show at the Mayor Gallery in London, he took the chance to go to Paris in 1947. While he was there, through contact with such figures as Duchamp and Tristan Tzara, he gained a first-hand knowledge of the ideas that had inspired Dada and surrealism. He made a number of works inspired directly by the formal language of such interpreters of surrealism as Giacometti, but the key idea that he derived from the Dada and surrealist approach was the use of collage to create a poetry of random association.

When in 1956 Paolozzi took up making sculpture with renewed energy after his involvement with a number of projects in the Independent Group, the idea of collage inspired works like *Icarus,* which were constructed from found objects and then cast in a way that reflected the inspiration of Picasso's assembled and cast sculpture of the 1940s (96). The random way that these were collaged together and the rough, expressive finish is similar to what Davie was doing in his painting; and in a work like Paolozzi's bronze, *His Majesty the Wheel* (1958–59), even the imagery is similar. This approach to collage also gave Paolozzi the artistic tool to interpret a perception that was his own and which was widely influential: that the visual language we share is composed of *all* the imagery that we make and exchange, and to isolate the fine art tradition from this matrix of visual communication is to cut it off from the root of its vitality. This suggests that visual culture is common property and it is a specific rejection of the élitism which disfigured the approach to modernism of some of Paolozzi's English predecessors. His view, on the contrary, is essentially democratic and has an echo of the Arts and Crafts movement. Indeed, in 1979, showing in Edinburgh, Paolozzi made a remark-

able statement which he titled *Junk and the new Arts and Crafts Movement.* In it, he identified his own position explicitly with the co-operative and social tradition of the Arts and Crafts artists and at the same time took a clear stand on the impending ecological crisis.[9]

The collection of popular imagery had inspired a series of collages that Paolozzi made in the late 1940s from all kinds of pulp material that he had collected and which he first presented

Plate 96. EDUARDO PAOLOZZI, *Icarus (first version),* 1957

publicly in a lecture at the ICA in 1952, contributing a central inspiration to the Pop art movement and published in 1972 under the title *Bunk.* Paolozzi himself developed this idea in the large body of screenprints which he began in 1965 with the set *As is When,* but he also explored it in a series of totemic sculptures.

Some of the other ideas that Paolozzi helped to promote through the Independent Group, in such projects as the exhibition 'This is

Tomorrow' for example, reflect concerns that he has kept to this day about the nature of modern culture as it is reflected in the construction of our cities and the division of the arts and the sciences. These sculptures, like *Icarus, His Majesty the Wheel* or *The Philosopher* (1957) are made from collage, but they all have mechanical overtones. In 1958, again at the ICA, Paolozzi gave a gloss on such imagery when he remarked:

> Rational order in a technological world can be as fascinating as the fetishes of a Congo witch-doctor . . . SCIENTIFIC PHENOMENA become SIGNIFICANT IMAGES, the ENGINE FORCE directing the construction of HELLISH MONSTERS. My occupation can be described as the ERECTION OF HOLLOW GODS.[10]

Figures like *The Philosopher* still looked extemporised, but they were followed by a series like *Konsul,* or *Twin Towers of the Sfinx State II,* both of 1962, made directly from cast machine parts and thus explicitly mechanistic. They are like Jungian archetypes somehow translated into a new imaginative language for the age of technology and the machine. Fritz Lang's film *Metropolis* has always been an inspiration to Paolozzi and if these figures suggest totems for a new, technological civilisation, they are indeed sinister and threatening. The engineer is no longer the high priest of some benign, mechanical world order as McCance saw him, but of something inhuman and bloodthirsty like the religions of the Aztecs or the Maya. In the Geddes tradition, the fate of technological man has been a constant preoccupation of Paolozzi.

The sinister, totemic potency of these free-standing figures is paralleled in William Turnbull's more obviously primitive *Idols* of a year or two earlier, and the relationship between these two artists is important. Paolozzi made several cast *Heads* in the late 1950s, for example, which are closely reflected in a series of painted *Heads* that Turnbull did at much the same time. In Paris Turnbull, like Paolozzi, had learnt something from Giacometti. Giacometti's late, existentialist figures eroded by space find a direct echo in some of Turnbull's earliest work, and the

form of the isolated standing figure remained a constant preoccupation for him (97). He also met Brancusi, and it is his loyalty to a version of Brancusi's 'elementalism' – the potency of the human echo in the stillness of some elemental form – that was the dominant characteristic of his sculpture in the 1950s and 1960s, even when he moved far away from either the techniques or the imagery of Brancusi. In the early 1960s Turnbull turned to making sculpture from stone and wood. He stresses the naturalness of these materials by forming them into elemental shapes that still recall Brancusi. Turnbull's painting was also radically simplified at this time, often consisting of an almost plain canvas, only barely articulated.

Eduardo Paolozzi likes to regard himself as a

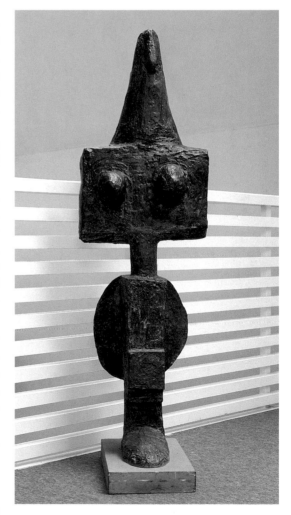

Plate 97. WILLIAM TURNBULL, *War Goddess*, 1956

Plate 98. WILLIAM JOHNSTONE, *Ettrick Raining*, 1936

European rather than a Scottish (or English) artist. As he is a Scots-Italian, this is quite accurate but he has always maintained close links with Scotland nevertheless. He has frequently exhibited in Scotland and has carried out a series of increasingly important commissions here. Davie, too, has kept in touch with Scotland, remarking recently that he regarded himself as the only painter working in the true Scottish tradition.[11] He has exhibited in Scotland on a number of occasions and he has also had an important influence on painting here since early in his career. Turnbull was born in Dundee and worked for the magazine and newspaper firm D.C. Thomson before he was called up to join the RAF. At the end of the war he entered the Slade, but soon left to pursue his own education, first in Italy and then in France. Since then, however, he has kept few artistic links with his native country. Nevertheless, his independence and his refusal to accept the prevailing standards of the English establishment in the 1950s marked him for a Scot, as did the fact that it was in the work of his fellow Scots in England — Paolozzi, Davie

and, of course, Johnstone — that his art and his continental orientation found the most sympathetic echo. From 1952, Turnbull worked for Johnstone at the Central School. At the very least, therefore, Turnbull has a place in this story at this point for there can be little doubt that this group of Scots — together with Richard Hamilton — played a central role in turning British art as a whole away from the kind of introspective pessimism that had marked it so strongly in the post-war years, towards something more positive, social and outward-looking. In the later 1960s, too, in some of his perfectly simple, abstract paintings and in his painted sculpture using pre-formed, steel elements, Turnbull pioneered imagery that anticipated the minimalism of the next decade.

Paolozzi, Davie and Turnbull were very much at the cutting edge of British modernism in the 1950s and, indeed, they have all remained in the forefront of British art since then. It is surely not a coincidence that they shared a common link to William Johnstone who remained one of the most outward-looking artists of the older generation. Throughout the 1940s and even in the 1930s, Johnstone had continued to explore the possibilities of an art based on gesture and accident in the manner of surrealist automatism as it is seen in a remarkable monotype, *Ettrick Raining,* of 1936 (98). He did this most in his drawings, but during the 1950s, perhaps encouraged by Davie and the example of the Americans, he began to develop large-scale paintings from these experiments. A painting like *Red Spring* of 1958–59, for instance, although it is still recognisably inspired by landscape, should have a place in any discussion of abstract expressionism in Britain (99). When Johnstone returned to Scotland in 1960 to live once again in the Borders as a farmer, initially he found himself isolated from other painters, though his friendship with MacDiarmid was as lively as ever, and a remarkable woman, Hope Scott, appeared as the friend and patron who encouraged the flowering of his late style.

In Edinburgh Gillies remained a powerful influence and, among the artists who had their careers interrupted by the war, this is apparent

in the work of Robert Henderson Blyth (1919–70) and Earl Haig (b.1918). But others in this generation like Robin Philipson, James Cumming (1922–91), Charles Pulsford (1912–89), William Burns (1921–72) and Alberto Morrocco (b.1917) explored, though with caution, some of the new and different ideas that had emerged from post-war Europe and America. Their caution was apparent in the way that they all saw the new forms of modernism as providing fresh ways of tackling the conventional business of painting, not as altering any of its fun-

that Hew Lorimer created *Our Lady of the Isles.* These are two of the great monumental works of the period, yet they both really belong stylistically in the 1930s.

Among the painters, Philipson was the most flamboyant and, successively head of painting at Edinburgh College of Art and president of the Royal Scottish Academy, he was also perhaps the most influential. He drew his inspiration from a wide variety of sources. His *Rose Windows* and *Cathedral Interiors* reflect his friendship with Anne Redpath, though also his admiration for

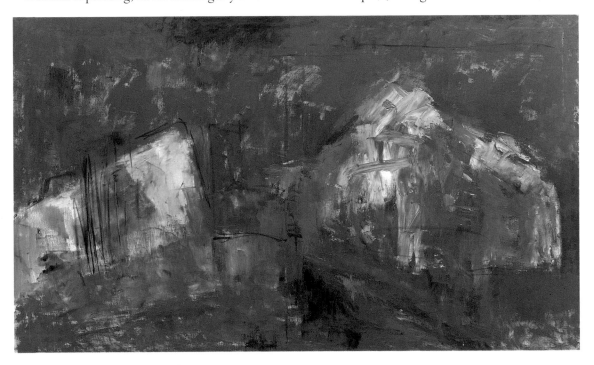

Plate 99. WILLIAM JOHNSTONE, *Red Spring*, 1958-59

damental constituents, nor even as leading them away from it altogether, and it is notable that there were no outstanding sculptors among this group. The standard of sculpture in Scotland was still carried by figures like Hew Lorimer, Tom Whalen, George Innes, Pilkington Jackson and Eric Schilsky (1898–1974) who, good though they were, all belonged aesthetically to an older generation. George Innes did make some interesting modernist works, as did William McCance though he was working in the south. It was during the 1950s that Pilkington Jackson designed the equestrian statue of Bruce for the Bannockburn monument (unveiled in 1964) and

Monet, and in his work of the late 1950s and 1960s, Alan Davie's influence is apparent. The triptych form, for instance, which Philipson latterly made so much his own after his first use of it in *The Burning* of 1960, was probably inspired by pictures by Davie like *Creation of Man* painted three years earlier, though Francis Bacon had also made good use of the form by this time. In the early 1960s, too, American painters like De Kooning who were so important for Redpath and Eardley, also influenced Philipson, but it was really Kokoschka who was the formative influence on his art. His acquaintance with Kokoschka's work began through his

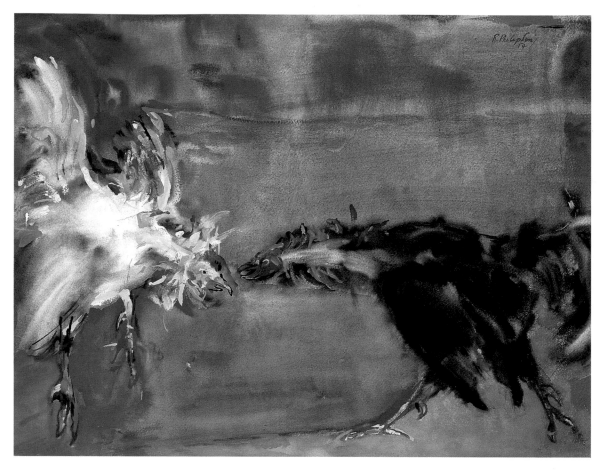

Plate 100. ROBIN PHILIPSON, *Cock Fight, Prelude*, 1954

reading a book on him by Edith Hoffman while he was in the army.[12] The study of such of his paintings as he could see after his return to Edinburgh, where he joined the staff of the College of Art in 1947, led him to model his technique on that of the older painter and he said of him:

> It was not the subject matter which impressed me. My satisfaction was in identifying the achievement of a rich plasticity of form within a limpid and impressionistic structure. I began to learn to construct through the grouping of small lightly placed brushstrokes of rapidly changing hue.[13]

Although Philipson painted a number of important paintings under Kokoschka's influence with observed and identifiable subject such as the dramatic view of Edinburgh Castle, *View from my Studio Window*, or the historic group portrait of

all the artists in the Edinburgh circle, *Interior, Anne Redpath's House, London Street*, it was typical of Philipson that he laid so much stress on the technique of Kokoschka's painting rather than any aspect of the Austrian's imagery. Indeed, he himself said that for him the real significance of Kokoschka was 'the realisation that the paint could be made the true subject of the painting'.[14] This was certainly how his art developed, first of all in his *Cock Fight* pictures and then really for the rest of his career. The first *Cock Fight* was painted in 1952, based on a drawing that Philipson had done in India during the war, and the series continued through the next decade or more (100).

The expressive intention in these paintings is clear, as it is in such later paintings as the powerful *Crucifixion* of 1969/70 with its echoes of Grunewald, Bacon and Graham Sutherland, but in the *Cock Fights* right at the beginning of his

career, Philipson faced a dilemma that he never quite resolved. Like the French Tachiste, George Mathieu, with whose work his painting at this stage had a close affinity, Philipson could not escape from the fact that, in the end, paint *is* a medium. It is a vehicle whose function is to carry something other than itself. However indissolubly the two things may be united, the one remains the medium through which the other is expressed. But in these pictures, instead of the paint expressing the motif, the motif is an expression of the paint. Philipson saw painting as a craft and developed increasingly rich and complex techniques. Nevertheless, for this very reason, some of the grandest pictures that he painted at the height of his powers, though they are spectacular, sometimes seem strangely empty. Paint alone cannot sustain such theatre. He is at his best when the sensuality of the paint is united with the inherent sensuality of the motif, as in his many small, jewel-like studies of nudes (101). Sometimes the painter turns up the key of this sensuality by introducing a note of violence and anxiety. It is the serenity of his late paintings of flowers, however, which makes them among the finest things that he ever did (102).

Philipson held a commanding position in

Plate 102. ROBIN PHILIPSON, *Poppies in a Jug, c.*1989

Scotland and his approach was shared by a number of the artists of his generation. His view of the special importance in Scottish art of technique and handling had a historical precedent in James Caw's description of the primary characteristics of the Scottish school as he saw them at the beginning of the century: 'a masculine quality of handling, combined with a fine use of paint, and . . . of colour'.[15] Like Philipson, James Cumming was also a painter in this tradition for whom technique and the resulting complex surface of his pictures seems often to have been the most important thing, though his painting is always much more austere and formal than that of Philipson. In Cumming's semi-abstract still-lifes and his ambitious, but hermetic, subcubist compositions based on an analysis of microscopic cell structures which are the most familiar of his works, the result, though very perfect, is also at times a little empty. There is, however, one remarkable group of works in which these same qualities are used to comment on the human condition in an oblique, but moving way.

In 1949–50, Cumming used his travelling scholarship to spend a year in the Hebrides (103). The series of pictures that resulted from this experience was painted over the next two decades. Far from being a simple-minded vision

Plate 101. ROBIN PHILIPSON, *Odalisque at a Casement Window*, 1966

Plate 103. JAMES CUMMING, *The Bagmen of Breasclete,*
1957

of an imaginary idyll of unspoiled island life, they
explore the complex mixture of the harshness of
the environment, the alienation of a remote

Plate 104. DAVID DONALDSON, *Still-Life with Aubergines,* 1992

community in the modern world, and its
immense antiquity as it is symbolised in the
standing stones of Callanish. The paradox of this
complexity is made visible by the way that
Cumming's Hebrideans have the mask-like faces
of Colquhoun's brutalised figures, but are pre-
sented in compositions of intricate delicacy and
exquisite surface. There is a real tension between
the perfection of the image and the bleakness of
the vision that it contains.

Cumming and Philipson were ambitious
artists who strove to create a genuinely original
vision; others achieved as much reputation with
less struggle. David Donaldson (*b.*1916), for
instance, began at Glasgow School of Art in 1932
and has remained a Glasgow painter ever since,
serving as head of painting at the School from
1967 till 1981. Unlike so many of his contempo-
raries, his career was not interrupted by war ser-
vice and, on the whole, he has remained content
with the older, well-tried formulae of painting
that derive ultimately from the Impressionists,
though perhaps by way of the Colourists. He
handles these with vigour, however, especially in
his treatment of still-life, and at times he enlivens
his work with humour (104). He brought this
liveliness to his practice as a portrait painter and,
although this was only a small part of his output,
it played an important part in establishing his
reputation. His pupil, Alexander Goudie
(*b.*1933), has ably carried on the tradition that he
established, working as a portrait painter and
also painting extensively in Brittany.

Donaldson and Alberto Morrocco come
from quite different backgrounds, but they are
parallel figures in a way. Both have established
successful careers on the basis of a rich and lively
handling of a relatively conservative kind of
painting. Morrocco trained in Aberdeen under
James Cowie and Robert Sivell and, although he
moved a long way from their ideals of classical
draughtsmanship and adopted a vivid and joyful
palette, he has kept a sense of the importance of
the disciplines of structure in painting. As with
Donaldson, this was the basis of his success as a
portrait painter. His portrait of Lord Cameron,
painted appropriately in Raeburn's studio, is one
of the finest Scottish portraits of recent times. Its

Plate 105. ROBERT HENDERSON BLYTH, *The Mill Lade*, n.d.

strength and simplicity, too, show the qualities that made Morrocco an important teacher in his position as head of painting at Dundee (106).

Robert Henderson Blyth taught at Edinburgh College of Art alongside Philipson and Cumming and under Gillies. He was a graduate of Glasgow and had also spent time with Cowie at Hospitalfield, but in his landscapes, though he used rich and expressive colour, it is the influence of Gillies that is uppermost (105). It is, however, perhaps Earl Haig who is the painter who remained closest to Gillies, though he brings his own distinctive poetry to his treatment of landscape, especially in his watercolour painting (107). One member of this generation who also deserves special mention for the way his integrity as a painter has informed his activity in another field is Edward Gage (*b.*1925). A fine watercolour painter, he has for many years written as art critic for *The Scotsman* (108). He is also author of a study of Scottish art since the

war, *The Eye in the Wind*. Jack Firth's study of modern Scottish watercolour painting[16] is similarly the work of a sensitive painter who has

Plate 106. ALBERTO MORROCCO, *Lord Cameron*, 1974

Plate 107. EARL HAIG, *River Banks*, 1957

informed his writing with the authority of his painter's eye.

Like Henderson Blyth, William Burns was a pre-war student at Glasgow School of Art who migrated to the north-east. In the 1950s he evolved a semi-abstract kind of painting out of such north-eastern subjects as harbours, buoys and fishing boats. With parallels in the painting of the St Ives school, these are among the most accomplished paintings of their kind done in Scotland at the time (109). Also in the north-east, Talbert McLean (1906–92) developed a similar, though even more refined style of painting abstracted from landscape forms. McLean

Plate 108. EDWARD GAGE, *Rain at Assisi*, 1974

trained at Dundee before it became a fully-fledged school of art. A successful career as a cartoonist in London was interrupted by the war, and after he was demobbed he settled in Arbroath as a school-teacher. His proximity there to Cowie at Hospitalfield gave him the inspiration to maintain a distinct and quite independent point of view, though he enjoyed little recognition (110).

Wilhelmina Barns-Graham (b.1912) is a rather similar figure, though she pursued her career in the south. After studying at Edinburgh, she followed her interest in the St Ives painters to the point of going there to settle, and throughout her life has painted in a way that reflects that school's genteel brand of modernism. Margaret Mellis (b.1914) was also a Scottish member of the St Ives circle. She was a student at Edinburgh which she followed by a spell in the studio of André L'Hôte. She married Adrian Stokes and moved with him to Cornwall at the outbreak of the war. She works in a sensitive – though not radically original – abstract style. Craigie Aitchison (b.1926) is another expatriate who has made a distinctive contribution to British art in a highly individual way. He studied at the Slade from 1952–54 and from an early date developed a style of austerely reduced imagery which, particularly when his subject matter is religious, as in his series of *Crucifixions,* for example, can achieve an almost mystical concentration.

Plate 109. WILLIAM BURNS, *Seakirk 1,* n.d.

Plate 110. TALBERT McLEAN, *East Coast*, 1959-60

Plate 111. EDUARDO PAOLOZZI, *Doors of the Hunterian Art Gallery*, 1976-7

CHAPTER FOUR

THE 1960S AND 1970S

The great strength of artists like Gillies, Maxwell, William Wilson or Hew Lorimer and some of the others of their generation, was their passionate integrity and their almost religious commitment to their art. The spirituality of Wilson's stained glass is manifest, and Gillies lived with his mother and sisters a life of almost monastic dedication (relieved, in true monastic fashion, by a passion for home wine-making). To some among the young, the force of the example of such dedication was potent and enduring. It stood for an ideal of truth, but on the other hand this truth was subjectively experienced. It was not articulate. It was passed on by example and, under attack, it could not articulate its own defence. To others among the younger generation, therefore, it could look as though such art belonged in a cosy world where all that artists did was to produce an undemanding commodity for people living in comfortable houses. Certainly in the 1960s, like the Clyde Group before them and whose traditions were maintained in Glasgow by artists like Tom Macdonald, Ian McCulloch (b.1935) and John Taylor (b.1936), a new generation began to look for ways of making art that could provide them with a better justification of their activity to the wider world.

This became more necessary as the infrastructure of the art world underwent accelerating expansion and change. In the 1960s art began to achieve a much higher public profile than before. The origins of these changes could perhaps be traced back to the start of the Edinburgh Festival in 1947. The Festival promoted a major series of exhibitions during its early years, but it also offered an opportunity for artists to exhibit to a new and wider public. It became possible to

reach an international audience without leaving Scotland as so many artists had had to do before. Certainly it was in Edinburgh that a shift was first apparent. There, in 1957, the 57 Gallery was founded as a co-operative by a group that included John Houston (b.1930). In August 1960 the Scottish National Gallery of Modern Art opened in Inverleith House in the Botanic Gardens in Edinburgh. The Scottish Modern Art Society had been founded as early as 1907 'to assist in the enriching of Scottish public collections'. The fine collection that the Society formed eventually went to the Edinburgh City Art Centre, but the idea of a national gallery devoted to modern art had first been mooted in the late 1930s. The institution that was eventually created, however, has been inhibited by the split between its two very different functions — one as a historical museum of twentieth-century art, and the other as a centre for contemporary art.

In 1961 Ian Hamilton Finlay and Jessie McGuffie founded the Wild Hawthorn Press which heralded Finlay's increasingly radical contribution to the art life of Scotland. In 1966 he and his wife began their garden at Dunsyre in Lanarkshire, later christened *Little Sparta*. In 1963 the foundation of the 57 Gallery was followed by a similar enterprise in Glasgow, the Charing Cross Gallery, founded by Bet Low, Tom Macdonald, John Taylor and Cyril Gerber. Richard Demarco (b.1930) also began to operate out of the Traverse Theatre in Edinburgh in 1963. The following year a gallery was established there, and in 1966 Demarco opened his own gallery in the city's Melville Crescent. It was in 1970 that he achieved the high point of his career by bringing Joseph Beuys to Edinburgh

and to the attention of the British public for the first time. The occasion was an exhibition of art from Dusseldorf. While he was in Scotland Beuys gave a performance on Rannoch Moor which expressed his feeling for the spirituality of the place. Five years later, Demarco followed this with the organisation of a spiritual journey through Scotland and, as it were, back through time entitled *The Road to Meikle Seggie.* It was a timely reminder of the place of spirituality in art, the relationship of spirituality to place and of place to history. Consciously or not, it picked up on ideas that had inspired Johnstone and Fergusson and which, before them, had been formulated by Geddes.

In 1967 the Scottish Arts Council was created in place of the Scottish Committee of the Arts Council of Great Britain, and in 1969 the Council opened its own gallery in Charlotte Square, Edinburgh. In 1968, as the Charing Cross Gallery closed, the Compass Gallery was founded in Glasgow by Cyril Gerber. The Printmakers Workshop was founded in Edinburgh in 1967, to be followed in 1973 by the Glasgow Printmakers and by Peacock Printmakers in Aberdeen the following year. There was also in Edinburgh the short-lived Ceramic Workshop which opened and closed its doors between 1970 and 1974. The controversial circumstances of its closure produced an ingenious conceptual work, *£1512,* being the residual assets invested in untouchable Treasury bonds with the forecast that they would double in value every five years. The co-operative print-workshops, carrying on the tradition of E.S. Lumsden, have played a central role in the revival and continued vitality of printmaking. Among them, Peacock Printmakers' notable success has owed a great deal to the energy of Arthur Watson (*b.* 1951), a considerable artist himself, and to the dedication and hard work of others like Beth Fisher (*b.* 1944) and Frances Walker (*b.* 1930).

In 1975 both the Fruitmarket Gallery opened in Edinburgh and the Third Eye Centre opened in Glasgow. At much the same time, the Hunterian art collection was given a new gallery in Glasgow on the initiative of Andrew McLaren Young. This eventually included a reconstruction

of Mackintosh's house which had stood nearby, representing an important stage in the rehabilitation of Mackintosh which has played such a central part since then in the rebuilding of Glasgow's self-image. In 1976 two sets of double doors were also commissioned from Paolozzi for the new museum. Originally to have been in bronze, they were eventually cast in aluminium, but they represented a major public commission and an important recognition of Paolozzi's status (111).

Thus during the 1960s and early 1970s a whole new stratum of art organisations was created which reflected a significant shift in the economy and organisation of living art and the new importance of public subsidy (though the Hunterian was built without it). Hitherto, in spite of the appearance of occasional small groups like the Edinburgh Group or the Society of Eight, the opportunities for an artist to exhibit were mostly controlled by the large exhibiting societies. Opportunities for making exhibitions of any ambition had been limited, too, apart from the very important exhibitions promoted in the Festival – though the track record of the SSA in bringing modern work into Scotland was very good. The real economy of art since the First World War had depended on the assumption that the vast majority of artists would teach, the lucky ones in one of the country's four art schools, but most in secondary schools. The exhibiting societies had kept their power as they had remained till now the only way to reach the public. Among the societies, originally the RSA was on its own, but then it was joined by the RGI, SSA, RSW and the SSWA (now the SSAC).[1] While they were still in the ascendant, the activity that the societies controlled was extended by a small group of dealers among whom only Aitken Dott, which became the Scottish Gallery, has survived to the present from the palmy days of the art market of the late nineteenth century, though Alexander Reid's firm continues as Reid and Lefevre in London.

These changes in structure meant that, more and more, the one-person show became the main avenue for an artist to reach the public; and through installations, the one-person show itself

could become an art work. The 57 Gallery, the Charing Cross Gallery and Demarco provided the first opportunities for artists to do this. Cyril Gerber and Richard Demarco were especially important during the early 1970s for the solo shows that they gave to promising young artists. Little of all this development would have been possible without the public subsidy going into the arts through the SAC and, to a lesser extent, through local government as, in spite of the level of activity that all this reflected, the art market in Scotland remained – and remains – half-hearted. The habit of buying art among the Scottish public has never returned to the peak that it reached in the late nineteenth century. This is no doubt largely a reflection of the lack of real wealth, but it also reflects a breakdown of confidence between the artist and the wider public which is only now gradually being restored.

The most successful painters like Joan Eardley or Robin Philipson still found their principal markets in the south through various London galleries, but the growth of a layer of subsidised but independent galleries meant that a new generation could look for success at home beyond the old commercial environment. It did not take long for artists to realise that this also meant that the art works produced did not need to take account of the art market, and so could be of a scale, character and durability which would have been wholly inappropriate in a market geared to private sales. The artificial boundaries between painting and sculpture became less and less relevant as all kinds of intermediate forms were explored. At this time, too, the SAC was still actively building up the collection of contemporary Scottish art that had been begun by its predecessor, the Scottish Committee of the Arts Council of Great Britain, and it bought across the whole range of this kind of activity, providing a small but important market.

The painters who came of age in the middle and late 1950s were encouraged to broaden their horizons by the example of artists like Eardley and Redpath, but still generally looked for success along established lines. In both Edinburgh and Glasgow, however, in the generation that followed them – those who came of age in the early 1960s – there was a reaction against the apparent conservatism of their predecessors. This was perhaps partly because the structural changes taking place were also mirrored in a change of

Plate 112. WILLIAM BAILLIE, *Blue Shrine with Offering*, July 1989

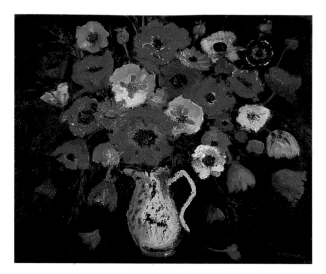

Plate 113. DAVID McCLURE, *Poppies,* n.d.

mood. The decade generally was a period when innovation was fashionable. It was also a period in which fashion itself entered art. In all this, the evolution of art in Scotland nevertheless remained a close-knit affair. Unlike almost all the other institutions of higher education in Scotland, the four art schools have kept their character and their continuity. This has often been criticised as causing inbreeding and it has also given very great powers of patronage to the colleges. But it has meant that the vitality of personal exchange between the generations has been continuous. Whether this has involved

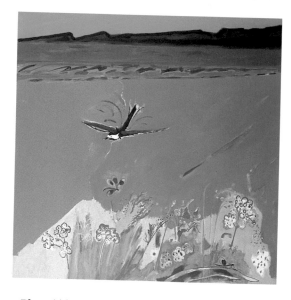

Plate 114. DAVID MICHIE, *Wagtail and Damsel Fly,* 1988

handing on something or reacting against it, there has never been a vacuum.

Elizabeth Blackadder (*b.*1931) is one of the most successful artists of her generation, and her art shows the strengths of this kind of continuity. She was a student at Edinburgh University and concurrently at the College of Art in the joint arrangement of the Fine Art degree. At the College, Gillies was head of painting and in Blackadder's early work reflections of his approach can be recognised alongside echoes of Redpath. It is not so much a matter of detailed influence from picture to picture, however, as a general feeling of the way in which the image created should relate to and yet also say something independent about the external motif, the thing that is seen. At the same time, the much freer approach of Philipson also played a part.

In 1955 Blackadder went to Italy on a travelling scholarship. Her drawings from this time are vigorous and direct, based on an expressive use of the pen that has a parallel in the work of Henderson Blyth who was teaching at Edinburgh until 1954. By the early 1960s, though, as she established herself as a painter, Blackadder's work became much freer and broader. The drawing is summary and the colour is handled in a way that often leaves large areas without articulation, encouraging the viewer to see the flatness of the canvas. *White Still-Life, Easter,* for example, was the painting that won her the RSA's Guthrie Award in 1962. At first sight, the continuity of subject and treatment with Redpath is apparent, but compared to the solidity and permanence of Redpath's painting, Blackadder's composition is an almost random collection of objects on a flat ground. This is divided roughly into areas that could be identified as table or curtain, but which have little definition. The composition is a loose association of experiences treated in a summary and extemporised way.

David Michie (*b.*1928), William Baillie (*b.*1925) and David McClure (*b.*1926) have also all in different ways stayed loyal to this kind of lyrical approach to painting, and of these three, McClure has remained closest to its Scottish origins in the work of Redpath and Maxwell

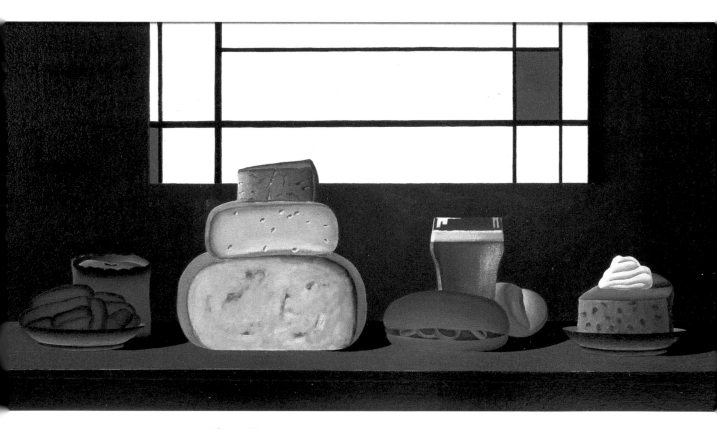

Plate 115. JACK KNOX, *Buffet in a Dutch Museum*, 1977

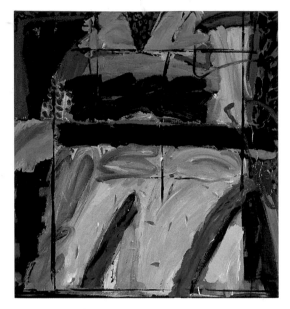

Plate 116. DENNIS BUCHAN, *Dock Window*, 1993

(113). In the early 1960s, however, the example of American painting promoted a new kind of breadth and freedom. It had as an accompaniment the minimalisation of the need for representation, and in David Michie's work, for instance, colour invests with the poetry of association things that are evoked rather than painstakingly described (114). William Baillie, who is now president of the RSA, is also a watercolour painter of distinction (112).

Looking at the work of other contemporaries such as John Houston, Jack Knox (*b.*1936) or William Crozier (*b.*1930), it is easy to see the strength of the American example and its corollary, the assumption that painting should be abstract to be modern. There was also throughout the 1960s and 1970s a constant pressure to be 'international', to make it into the art magazines by conforming to some imaginary external norm. Even such independent spirits as Paolozzi and Turnbull working in the south turned to a kind of impersonal, high-tech style which matched this mood. It is striking, however, that though they drew strength from it, very few of this generation in Scotland became paid-up subscribers, as it were, to this international abstract style. According to one's point of view, the extent to which they resisted these pressures can be seen either as a measure of the inherent conservatism of Scottish art, or of the strength of the core of convictions on which it was founded.

In the early 1960s, Knox and Crozier were both painting abstract pictures, as was Dennis Buchan (*b.*1937). Crozier's works preserve a landscape reference and are, in fact, close to the kind of painting that William Johnstone was doing in the 1950s. Crozier moved back to a more direct approach to landscape, though incorporating into it the freedom of colour and handling that he had learnt from the Abstract Expressionists. Knox moved through several phases till the early 1970s, when he abandoned these freedoms altogether in favour of a dramatically simple treatment of real things, and returned to still-life that was inspired directly by Dutch painters of the seventeenth century. This change was stimulated by a visit to Amsterdam in 1972 (115). The bold images that he has painted and drawn since then – for he is a powerful draughtsman – do not sacrifice subtlety to achieve simplicity, and are amongst the most individual and satisfactory works of their time. In Glasgow, Philip Reeves (*b.*1931) has used collage for many years with striking success, in a way that also combines a subtle, abstract language with the evocation of the visible world. Dennis Buchan has also remained loyal to a kind of semi-abstract painting and, like William Burns before him in the north-east where he works, his abstraction is

Plate 117. IAN HOWARD, *Bell Jar 1*, 1991

Plate 118. JOHN McLEAN, *Landfall*, 1993

based on landscape elements (116).

Buchan has lived and worked in Arbroath for many years, as has William Littlejohn (*b.*1929) who also paints in a semi-abstract way, and the heritage of Cowie and the quiet influence of Talbert McLean have meant that Arbroath has preserved a kind of small-scale school of its own. Talbert McLean himself later took to painting free, abstract pictures, inspired by American models, but in which he preserved his own acute sense of visual discipline and poetry. His shift into pure abstraction was probably stimulated by the example of his son, John (*b.*1939), who is one of a small group of Scottish painters to practise pure formal abstraction. Others are Colin Cina (*b.*1943), Fred Pollock (*b.*1937), Derek Roberts (*b.*1947), Alan Gouk (*b.*1939), Iain Robertson (*b.*1955) and Russell Colombo (*b.*1947). In the 1970s, John McLean, Pollock and Gouk were to some extent identifiable as a group of expatriate Scots working in London in a related manner, and indeed in 1977 they showed as a group together with a fourth painter, Douglas Abercrombie (*b.*1934), at the Fruitmarket Gallery in Edinburgh. Though they all have their

Plate 119. DEREK ROBERTS, *Harmony, Blue and Ochre*, 1994

Plate 120. ALEXANDER FRASER, *Muchalls Garland*, 1993

origins as painters in American post-painterly abstraction, they have developed somewhat differently. McLean has emerged as the really original painter among them, using shape, ground and depth, transparency and intensity of colour in a kind of painting which is as purely visual as music is aural (118). Colin Cina has also always worked in the south. In the late 1960s he took to painting in a form of pure geometrical abstraction which he has only modified since by introducing 'dramatic' elements into the formal structure.

Derek Roberts came to abstract painting from the background of the 'painterliness' of the older Edinburgh painters and has remained distinct from the others in this group, above all by his devotion to Matisse as a model (119). At one time Sandy Fraser (*b.* 1940) might also have been included among the Scottish abstract painters, as he was painting in a way that related directly to colour-field painting; but at an early date he began to reintroduce the figure into his painting. He is an exquisite draughtsman and in recent years has returned to a fully figurative way of painting, including some very fine com-

Plate 121. JOHN HOUSTON, *At the Coast, Evening*, 1993

missioned portraits (120). Though he is younger, Ian Howard (b.1952), who is now head of painting at Dundee, paints in a somewhat similar way, combining real elements in an essentially abstract composition (117). Neil Dallas Brown (b.1938), a graduate of Dundee, who also belongs to this generation, never abandoned the idea of draughtsmanship, building up his images from finely drawn figures and animals

to exploit, but it remains recognisably rooted in experience, especially that of the sea and the sky. One of his favourite motifs, the Bass Rock seen against a broad, dramatic sky, first appeared in his work as early as 1963 (122). For Houston, Americans like Rothko and Clifford Still were only members of a greater community of painters exploring the metaphysical experience of space and light. It was a tradition that began

Plate 122. JOHN HOUSTON, *Evening Sky over the Bass Rock*, 1963

in sinister, enigmatic relationships.

John Houston did not go quite so far towards full abstraction as Knox or Crozier, but moved from a kind of expressive, semi-abstraction close in style to Robin Philipson to a much broader and more atmospheric way of painting. This was based on landscape. It was clearly indebted to the Americans in the sense of space that he was able

with Turner and had continued with painters like Munch, Ensor and Nolde, echoes of whom are found in Houston's work, and in whom Gillies and his contemporaries had found inspiration before him. In 1969 Houston spent a period on the Great Lakes. This was the closest that he came to American painting, but it was essentially through sharing the experience of the landscape

Plate 123. JAMES MORRISON, *Clouds over the Grampians*, 1982

that had inspired it. This eventually bore fruit in a series of outstanding watercolours of great breadth and freedom painted in the late 1970s and early 1980s (121). Among Houston's contemporaries, Ian McKenzie Smith (b.1935) developed in a similar way, using the new breadth of abstract painting to evoke the atmosphere of sky and seascapes. His small, almost minimal, canvases are quite exquisite (124).

Joan Eardley's influence remained strong among west coast painters. She provided the starting point for James Morrison (b.1932), for example, though he never emulated the freedom of abstract painting. In his concentration on a particular aspect of the northern landscape – for instance, the luminosity of the sky and the sharp focus and dark accents of a winter landscape beneath a wide horizon – he is perhaps a parallel figure to McIntosh Patrick (123). At his best he captures as Eardley does, though with far less drama, the austere beauty of the north-eastern landscape. Recently he has extended this in a series of paintings done in the Arctic which have a magnificent and dramatic severity.

Duncan Shanks (b.1937) was also a student at Glasgow. He, too, has always remained principally a landscape painter, but he clearly belongs in an expressionist tradition. Eardley is part of this, but it also makes sense to talk of Munch and of De Kooning when looking at his work from the 1970s. From there he has evolved into one of the most effective and original landscape painters of his generation (125). Mardi Barrie (b.1931) is another painter who has carried on even more directly the landscape tradition established by Joan Eardley. Barbara Rae (b.1943) on the other hand was a student at Edinburgh when Philipson was in charge and, more than any of her contemporaries, she has preserved his sense of the potential richness of a painted surface. She has applied this almost exclusively to the painting of pictures inspired by landscape, but these are marked by her own decorative sense and are a wholly original development of the Edinburgh tradition (126).

In the slightly earlier generation, Frances Walker is outstanding in the strength and consistency of her convictions, and as a teacher at

Plate 124. IAN McKENZIE SMITH, *Winter*, 1992-93

Aberdeen she has had an important influence. Walker was in the same year at Edinburgh as Houston and Michie and, after spending time in Yugoslavia and in Italy on a travelling scholarship, she went to work as a peripatetic teacher in the Western Isles from 1956–58. Thus began her lifelong engagement with their scenery and lifestyle, reflected in her acquisition of a house on Tiree where she has worked regularly. Her art is austere in its concentration on the structure of landscape, but it is not in the least prosaic. Through her presentation of the rocky landscapes of the west, the ever present sea and the perennial rhythm of the tides, she draws together the stark immensities of geological time with the

Plate 125. DUNCAN SHANKS, *The Dam Burn*, 1983

Plate 126. BARBARA RAE, *Olive Terraces, Lanjaron*, 1990

fragile and transitory human presence (127). Kirkland Main's landscapes, though very much in the Gillies tradition, are in some ways compara-

Plate 127. FRANCES WALKER, *Green Geo*, 1989

ble as they invest the image of the place that he paints with a sense of the history that inhabits it.

Frances Walker thus presents the core convictions on which the best painting of this generation has been based. At first sight, she is some way away from Elizabeth Blackadder, but throughout the 1960s Blackadder also continued to work as a landscape painter, producing such lovely pictures as *Broadford, Skye*, in which the memory of Gillies is still a real presence, though the whole image has a breadth and simplicity that is quite new (128). Essentially, therefore, the syntax has evolved, but it is still carrying the same message: that the painting is rooted in something strongly experienced and particular. In the 1970s in Blackadder's work, this process becomes even clearer as she builds up an image out of vividly painted real things, especially flowers, which are described with a kind of botanical accuracy that matches Walker's sense of the structures of geology. There is some affinity here with John Busby's (*b.*1928) work too, for he paints evocative, semi-abstract landscapes, but also brilliant studies of birds and wildlife.

In Blackadder's painting, the elements she describes are often united in a loose pictorial association in which space and interval are an essential and active part of the composition (129). The example of Japanese art is important here, but the result is like a song: the concrete particularity of the images evoked by the words is supported and enhanced by the abstract qualities of key, harmony, rhythm and extension in time, endorsed by repetition. In her painting, the images are evoked in paint, key and harmony by colour, and time and rhythm by space and the division of the image. The painting of this generation, therefore, even while it expanded them, was still nevertheless shaped by the aesthetic ideas of the older generation.

There were alternative points of view available within the Scottish tradition, however. In the south, Davie and Paolozzi were developing along lines that conformed with the ideals of the original Scottish Renaissance, even if this was unconscious, and, back in Scotland, these ideals were still being vocally promoted by MacDiarmid. In Glasgow, J.D. Fergusson lived

Plate 128. ELIZABETH BLACKADDER, *Broadford, Skye,* 1970

on till 1961 to be survived for almost two decades by Margaret Morris, who kept his legacy alive through the creation of the Fergusson Foundation and her own biography of him. Pat Douthwaite (*b.*1936) began her career as a painter in the late 1950s stimulated by Fergusson, and so is testimony to his continuing influence even in old age. In Glasgow, too, at a practical level painters like Bet Low, Louise Annand and Tom Macdonald were still working and engaged with the business of painting in modern society in a way that echoed Fergusson's initiatives. Tom Macdonald's powerful paintings of boxers and wrestlers anticipate and challenge Peter Howson (131). Also in Glasgow John Taylor was working in a similar way, painting pictures that reflected his radical social concerns (130), while Ian McCulloch remained committed to the idea of large-scale public painting (132). This culminated in his large, abstract paintings commissioned for the new Royal Concert Hall in Glasgow in 1990 which achieved the remarkable distinction of being taken down on the insistence of the leader of the District Council in 1992, a bizarre comment on Glasgow's success as City of Culture.

In 1960 William Johnstone returned to his native land. He did not have a solo show there till 1970, but during the last twenty years of his life he produced an extraordinary late style. This was heralded by such dramatic pictures as *Northern Gothic* of 1959 and developed into paintings like *East Wind* of ten years later (133). In both of these, he scales up the free, abstract drawings that he had been making since the 1930s on the surrealist 'automatic' principle. The stimulus for this move into such large-scale, free abstraction may have been the example of Jackson Pollock, but the style was Johnstone's own, and he continued to paint creatively till the very end of his life, as a magical painting like *Fragments of Experience,* painted when he was

Plate 129. ELIZABETH BLACKADDER, *Gold Screen and Fans*, 1991

almost eighty, so amply demonstrates. In the early 1970s, he collaborated with the Edinburgh Printmakers on two remarkable sets of illustrations to the poetry of MacDiarmid and of Edwin Muir. In these he used a style of brush drawing inspired by Zen ideals that he developed during these years. It was a style that he eventually extended into a series of large-scale plaster reliefs of dramatic simplicity. Their grandeur and originality is a fitting testament to the continuing vitality of Johnstone's art. His prints were also instrumental in inspiring Charles Booth-Clibborn to found the Paragon Press, carrying on the tradition of the artist's folio print published to a parallel text. Based in London, the Paragon Press has nevertheless produced, mostly at Peacock Printmakers, nine such folios with Scottish artists.

Against the background of the rather different tradition of social engagement in the west, the emergence in Glasgow of artists like Alan Fletcher (1930–58), Carole Gibbons (*b.*1935), Alasdair Gray (*b.*1934) and others looking for a

Plate 131. TOM MACDONALD, *Wrestlers*, 1964

more strongly social base for their art, was not surprising. Gray, of course, has surpassed all the others in fame through his success as a novelist, but this should not obscure the fact that there is common ground between his painting and his novels and, by extension, that of the contemporaries closest to him. Indeed, his first novel, *Lanark,* if it is not directly autobiographical, nevertheless gives a vivid and convincing account of the trials and tribulations of an art student trying to find direction in a largely directionless world. Whether or not consciously, Gray's account echoes Joyce Carey's creation, the anarchic painter Gulley Jimson. In his paintings like *Cowcaddens in the '50s*, Gray seems to share Gulley Jimson's ambition to create a monumental, social panorama, a vision that is extended into the brilliant illustration and decoration of his books (136). Gray himself found success through a literary medium, but amongst the others of this group, the most talented is Carole Gibbons, though she has enjoyed little success or recognition. She paints from the life in a free and expressive way, but her images are held together by a subtle and intuitive discipline which is quite distinctive (134). Like Gray, John Byrne's (*b.*1940) career as a painter has been overshadowed by his success as a writer and, as with Gray, for Byrne there is considerable common ground between his painting and his writing, both being marked by his wit and his sense of irony (135).

Plate 130. JOHN TAYLOR, *When the Sun Came Out*, n.d.

Plate 132. IAN McCULLOCH, *The Return of Agamemnon IV*, 1990

On the east coast, John Bellany (*b*.1942), Sandy Moffat (*b*.1943) and others engaged in a sim-

ilar rebellion against the aestheticism of the older generation who were their teachers. They did this within the context provided by the art institutions, but they were not alone. The early 1960s saw an increasing amount of radical art activity outside the conventions of painting. The Edinburgh Festival and the evolving Fringe gave Edinburgh an international audience. Jim Haynes, founder of the *International Times*, one of the journals of the 1960s' 'revolution', was based in Edinburgh. He was also instrumental in the foundation of the Traverse and ran the Paperback Bookshop where Demarco began his career as an exhibition impresario and where Ivor Davies (*b*.1935) presented his first 'happenings' using explosives in a series of dramatic, auto-destructive events. A variety of other similar events took place in and around these various organisations, too. Notably, in 1963, at a conference on the Theatre of the Future held in the McEwan Hall during the Edinburgh Festival, an irreverent intervention included the progress of a naked girl in a wheelbarrow across the stage. Mark Boyle (*b*.1934) was among those involved in this 'happening' and he was currently showing at the Traverse a series of junk reliefs.

The presentation of junk as art was hardly

Plate 133. WILLIAM JOHNSTONE, *East Wind*, 1969

new. Its pedigree went back through Schwitters and the Surrealists to Duchamp, while among contemporaries it had been raised to a high level of sophistication by Robert Rauschenberg who

Plate 134. CAROLE GIBBONS, *Portrait of Angus Neil,* n.d.

was, coincidentally, shown at the Whitechapel Gallery in London in 1964 (an exhibition that was one of a series devoted to the work of major contemporary Americans). Bringing junk into the field of aesthetic consciousness had a certain affinity with Paolozzi's earlier *Bunk* project, too. In the context, however, Boyle's work should be seen as part of a wider intention to shock the old art world while at the same time establishing distance for the new. Working in partnership with Joan Hills and eventually their whole family, he went on to make a more original series of works which grew out of the junk idea and the need to shock. These were reliefs of random sections of the surface of the ground, reproduced in precise detail and to exact scale. The first was made in 1964 and, in 1969, a project to produce a thousand of these was launched with the title, *Journey*

to the Surface of the Earth. The objective was to create an art that was pure, existential vision — 'to see without motive and without reminiscence' (137).[2]

The Boyle reliefs are as radical a reduction of the business of art to the elements of experience as one could wish to see. Boyle himself was not trained in an art school and perhaps such a radical intervention needed to come from outside the tradition of art-making. In the mid-1960s, Boyle's younger contemporary, Bruce McLean (*b.*1944) launched a similar critique of the preoccupations of contemporary art, but he did so within the context set by art education (though in the south, for he studied at St Martin's School in London). In a series of witty parodies using rubbish, ephemera and performance (139), he mocked the formalist aesthetic which was evolving at this time in the work of artists like Anthony Caro along the lines set by American formalism. It is perhaps ironic that McLean has since developed into a very accomplished abstract artist himself.

Boyle and McLean both attacked what they saw as the established position of art from the outside, much as Paolozzi had done and was continuing to do, especially in his screenprints. He began these with the series *As is When* in 1965, in which he took the junk imagery of his earlier col-

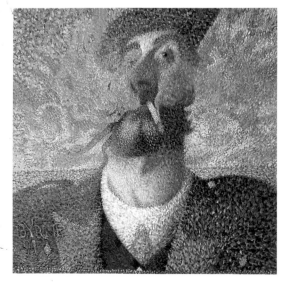

Plate 135. JOHN BYRNE, *Caledonian Smoking Picture,* 1991

Plate 136. ALASDAIR GRAY, *The Cowcaddens in the '50s*, 1964

Plate 137. MARK BOYLE, *Addison Crescent Study*, 1969

lages and through it, again using collage, he presented a commentary on the philosophy of Wittgenstein. He thus demonstrated directly his vision of the way that art has to reflect the indivisibility of experience. As he uses it here, collage echoes the way that all the facets of our thoughts and perceptions intercut each other without the least respect for the categories that we put upon them. Wittgenstein and Mickey Mouse (who also features) are only two aspects of a single culture. We have to take the diversity that such extremes reflect in order to understand its unity, a unity which Paolozzi himself reaches in these prints.

There is some common ground between such radical departures from the artistic norm and the ambitions of painters like Bellany and Moffat. In the climate of 'anything goes' that marked the early 1960s in Edinburgh, they chose to pursue their ambitions within the established frame of reference of painting and they were encouraged by Robin Philipson, then head of painting at the Edinburgh College of Art where they were both students. In a sense, therefore, they were as much indulged offspring of the system as rebels against it. They showed their works outdoors during three successive Edinburgh Festivals, in 1963 on Castle Terrace and subsequently against the railings outside the National Gallery, a gesture of defiance of the establish-

Plate 138. SANDY MOFFAT, *Poets' Pub*, 1980

ment that had a little of the air of a 'happening' about it. The latter was also a location that was handy for the nearby Milne's Bar where MacDiarmid and his circle fore-gathered, and he was a primary inspiration to the young painters.

Plate 139. BRUCE McCLEAN, *Nice Style at Hanover Grand*, 1973

Among the associates of MacDiarmid, John Tonge was important for he had been an early spokesman for the visual arts in the Scots Renaissance and was a friend in London of Colquhoun and MacBryde. The ideas that he could pass on were also mediated to some extent by the enthusiasm of Alan Bold for such left-wing interpreters of the function of art as John Berger and Frederick Antal. Bold was a contemporary and friend and the literary champion of Bellany and Moffat; but through MacDiarmid the young painters also had a direct link back to ideals which, in their political aspect at least, had hitherto played little part in the Edinburgh art life that was centred on the College of Art and the Academy. A study for Léger's late painting of heroic workers, *The Constructors: the Team at Rest* was bought for the National Gallery in 1964 and Moffat's work at the time clearly reflects his enthusiasm for Léger. This is an explicit link to the interests that MacDiarmid and McCance had

Plate 140. JOHN BELLANY, *Allegory*, 1964

shared in the 1920s. Later, as a portrait painter, Moffat became the recorder of this remarkable group of people (138).

Bellany entered Edinburgh College of Art in 1960, but as early as 1964 he had painted *Allegory,* which remains one of his most impressive pictures (140). It is a triptych based directly on the traditional iconography of the Crucifixion. On the three crosses, instead of human figures there are gigantic bodies of gutted fish or the carcasses of sacrificed whales. They recall directly Rembrandt's paintings of flayed oxen. Beneath these is a group of the people of Port Seton, the fishing port that was Bellany's home. The triptych was a form which Alan Davie had used very inventively six years earlier, and Bellany and Moffat freely acknowledge the importance to them of Davie's example. Following Davie, Philipson had adopted this form for the first time in 1960, and he also had the habit of using motifs like the Crucifixion to lend drama to his painting. In spite of his undoubted debt to Philipson, however, it would be wrong to see Bellany as merely a wayward follower of the Edinburgh School. There is a particularity, both in the image and in the actual surface of the paint that describes it, which sets his painting of this time apart. This is vividly seen in the very fine portrait of his father that he painted in 1966.

During the next few years, Bellany developed these qualities in a series of paintings that incorporate fishermen and their activity into images that recall Millet, Courbet and Rembrandt, and in which he successfully uses the Christian symbolism of fish and fishermen to suggest wider themes. *Kinlochbervie,* for example, is a fish gutters' table set out like a Last Supper, giving it a touch of the grotesque that recalls the beggars' banquet in Bunuel's film *Viridiana.* During the 1960s Bellany developed this kind of painting, adding grim, alienated figures inspired by a visit to Buchenwald in 1967 to the melancholy fishermen and the seascape that is their environment to create such haunting pictures as *The Obsession* of 1968.

This picture has as subtitle, Gauguin's title invoking the mystery of life, *Whence do we come?*

What are we? Whither do we go? It is a general question as Bellany puts it. It is not one that relates in any precise way to the iconography of his painting and the strength of such pictures lies in their power of association rather than any programmatic, social-realist meaning. It is rather that a kind of Christian imagery is invoked without its being specified, and it is then overlaid with echoes of social realism. This is very much how Millet had combined these same elements to create an image of the perpetual suffering of the human condition, exemplified in the imagery of religion but not alleviated by its beliefs. There is a certain flavour of contemporary angst in Bellany's painting, too, but underlying all these things is a strong sense that the tangible conviction with which the images are described reflects an autobiographical quality: the fact that they are rooted in something that the artist himself has experienced at first hand.

It was not till 1971 that an exhibition called 'Scottish Realists' was mounted by the Scottish Arts Council, including works by Bellany, Moffat, Bill Gillon (*b.*1942), Robert Crozier (*b.*1940) and Ian McLeod (*b.*1939). The SAC's title reflected the feeling that this group stood for something that was distinctive and, as the title made clear, that it was 'realist', a term that at the time had connotations of social engagement (141). Crozier painted some strong and

Plate 141. IAN McLEOD, *Footballers,* 1969

Plate 142. JOHN BELLANY, *Homage to John Knox*, 1969

simple, social-realist pictures of Edinburgh life which anticipate Howson's subject matter, though with much less melodrama. Ian McLeod, too, was an artist whose work based on draughtsmanship made an impact at the time, but who has been unfairly forgotten. The painter Geoffrey Roper (*b*.1942) might also be seen as belonging to this group. He studied at Edinburgh College of Art between 1960 and 1962 having started his training at Nottingham and although perhaps less self-consciously radical, he has always painted in a powerfully realistic way, often choosing industrial subjects and images of labour in landscape settings.

By the time that this exhibition was mounted, Bellany himself was beginning to move away from the kind of painting that justified the term 'realist'. In the late 1960s his imagery increasingly reflected his personal life and he began to use symbolic creatures – fish, cats, dogs, etc – in a way that led more and more towards a private language, though it often recalls Colquhoun's use of masks. In this process he was also taking inspiration from the German New Realists of the interwar years, from painters like Max Beckmann and Otto Dix. Beckmann's influence is directly apparent in another large triptych, *Homage to John Knox,* painted in 1969 (142), which seems to attempt to generalise a personal sense of guilt. The central part of that picture reappears in *The Fishers,* one of the finest paintings from the early 1970s and a transitional picture which was followed two years later by the closely related painting *The Sea People,* in which the artist's feeling for the expressionist tradition, implicit in his admiration for Dix and Beckmann, takes the upper hand. The figures are distorted and there are echoes of Munch in the sky behind them.

This kind of painting is a reminder of how strongly the Northern expressionist tradition had become rooted in Scotland. Philipson, after all, had begun with Kokoschka, and John Houston, to whom Bellany remained close, was also inspired directly by Munch in landscapes very similar to the one that is visible in the background of *The Sea People.* In this respect, though Bellany rose to international stardom, if his

painting in the 1970s is seen in the context of the work of his Scottish contemporaries, he is not so far from several of them who might at first sight seem very different.

Throughout the 1960s, it was very much painting that made the running. Sculpture, when it was excluded from architecture and townscape by the bareness of the modern style, was dealt a heavy blow from which it could not recover quickly. Various attempts were made to establish a new milieu for it through the idea of the open-air sculpture exhibition. In Scotland the first of these was held in Glasgow as early as 1949, and in 1955 William Keswick established his private sculpture park at Glenkiln in Dumfriesshire. In the later 1960s public sculpture exhibitions of this kind became more frequent.

The first purchase for the new Scottish National Gallery of Modern Art was Henry Moore's *Reclining Figure,* and although individu-

Plate 143. MICHAEL SNOWDEN, *Longniddry Girl*, 1991

als like Benno Schotz, Hew Lorimer and Tom Whalen were still active in the 1960s, the immediate future for sculpture, far more than for painting, lay with the idea of an international style. There was at the same time a reaction against stone-carving in favour of the new medium of steel construction. Stone-carving had been an important agent of continuity for several of the older generation, though alternatively throughout this period at Edinburgh College of Art, Eric Schilsky (1898–1974) was teaching modelling from the life as the only true faith for a sculptor. He found an able disciple in Michael Snowden (b.1930) (143) and an important facilitator in George Mancini, a great craftsman, who kept alive the skill of the bronze-founder. Vincent Butler (b.1933) joined Schilsky at Edinburgh College of Art in 1963 and has also remained in close sympathy with his ideas.

Nevertheless, the story of sculpture over the next decade was very much a matter of the adaptation of aspects of the current international style. The exception to this was in the area of cross-over with pictorial art. By the 1960s Fred Stiven (b.1929), for example, was making boxes – collections of objects put together within a frame and endowed with mystery. Stiven was one of a group of artists brought together in 1975 in an exhibition called 'Inscape' which, by its very title, indicated how far this kind of art

had moved from the extroverted colour painting of others in this generation. It was, indeed, a moment when art seemed to be turning in on itself. Paul Overy described it in the catalogue as limited in its scope to the exploration of a private language akin to contemporary poetry.[3] It was characterised by a kind of introspection that sometimes almost approached autism in the way that it resulted in private languages that were inaccessible to anyone other than the artist. This criticism, though, could not be directed against artists like Will Maclean (b.1941) and Ian Hamilton Finlay who were also part of this show.

Because it demanded a public situation, sculpture was inevitably more controversial than anything that the painters might do. Such introspection was hardly appropriate, therefore, though it did appear, and it was in this same year that the first public sculpture park was established at Glenshee. Perhaps Glenshee was safely remote; certainly such sculptures as were given urban sites were usually met with a hostile response, but they were also sometimes very badly judged. Artists-in-residence in the new towns in the beginning of the community art movement, like David Harding (b.1937) at Glenrothes, had rather more success, but then it is a job for which tact is an essential qualification.

In 1973 Gavin Scobie (b.1940), Gerald Laing (b.1936) and Andrew Mylios (b.1935) held a

Plate 144. GAVIN SCOBIE, *Book: Wittgenstein's Dream*, 1979

Plate 145. JAKE HARVEY, *Hugh MacDiarmid Memorial*, 1982-84

joint open-air exhibition at Cleish Castle. Michael Spens, restoring the castle, had recently commissioned a ceiling there from Paolozzi. Gerald Laing had had some success as a Pop artist in America, but had settled in the north-east of Scotland where he, too, restored a castle. At this time he was making large formalist sculptures exploiting symmetry. He later moved back to making figurative and portrait sculpture in an academic style. Andrew Mylios was also working in an essentially formalist idiom, though his images were related to streamlining. Mylios was involved with the Glenshee project and was also one of the founders of the Scottish Sculpture Trust whose aim was to promote sculpture. In 1978 the Trust launched a more ambitious sculpture park in the forest at Carrbridge, which eventually included some thirty works by a wide variety of artists.

Gavin Scobie had trained at Edinburgh as a designer. He turned to making sculpture in the early 1970s, and from 1974 he endeavoured to live as a full-time sculptor. He went to work in a remote part of the countryside in Easter Ross where the landscape was decorated with his sculpture. David Smith was certainly a formative influence on him, but working still within the general lines of American formalism, first in extruded aluminium, then in cor-ten steel, he developed a language of his own, related to the movement of the human figure. It is seen at its best in the elegant shape of *Eve* made in 1975. In 1977 he won the commission to install a sculpture outside the new Eden Court Theatre at Inverness. The work that he made uses the language of constructed steel sculpture, but it does so to invoke the analogy of the reclining human figure to the landscape in a way that is almost classical. Inevitably, there was an outcry against such 'modern art', though it is a modest and eloquent piece and the year was 1977. Scobie is technically very gifted and he developed his work in bronze, teaching himself the techniques and producing his best work in this medium in a

Plate 146. BILL SCOTT, *Man of the World*, 1991

steel and called *Window Exchanging Glances with the Landscape*. It showed the inspiration of Julio Gonzalez and was a form which he eventually developed into the successful model which won the competition organised by the Scottish Sculpture Trust in 1983 for the Hugh MacDiarmid Memorial at Langholm. The resulting sculpture installed on a hill near the poet's birthplace was the most ambitious piece of public sculpture of the period (145). Eighteen feet across and shaped like an open book in two great wings, it is made of cor-ten steel and bronze. The wings of the book, set against the landscape and the sky, contain an anthology of motifs from MacDiarmid's writing, especially his autobiography, *Lucky Poet*. Harvey's encounter with the poet's work through this commission inspired him to turn to his own life as a Borderer for inspiration, leading to a series of works like *Poacher's Tree* in a similar style, presenting aspects of the experience of his boyhood.

Two other sculptors to make a real contribution were Fred Bushe (*b.*1931) and Douglas Cocker (*b.*1945). In 1980 the Scottish Sculpture Workshop was founded at Lumsden with Bushe as director and, thanks to his energy, it has since proved an important generator of activity in the north-east and further afield. Bushe's own sculpture is characterised by strong, simple shapes. Sometimes these are formed into massive constructions, but they are never weakened by over-elaboration (148). Frank Pottinger (*b.*1932) is Bushe's contemporary and has also worked as a

series of bronze books, which also seemed to function as shrines for the mysterious objects that they contained (144). More recently he has developed an elegant visual language using wood and glass in a series of works that evoke interiors and so which return to the figurative implications of his earliest work.

In 1975 Richard Demarco undertook a survey of Scottish sculpture, and of those he showed, Bill Scott (*b.*1935) (146), Jake Harvey (*b.*1948) and Ainslie Yule (*b.*1941) have continued to work creatively. Jake Harvey showed a large, screen-like sculpture made from wrought

Plate 147. ALAN JOHNSTON, *Untitled*, 1990

Plate 148. FRED BUSHE, *Moonbeam*, 1990

(*b.*1946), Alan Johnston (*b.*1935), Glen Onwin (*b.*1947) – the last four all contemporaries at Edinburgh College of Art – and several others all took to making art which, although the style of each was quite distinctive, had the common characteristic that it was virtually monochrome. Several of them, too, abandoned paint altogether. These artists were all Edinburgh-based, but at much the same time Will Maclean, trained in Aberdeen but by then teaching in Fife, also abandoned painting in favour of constructions. Nor was it only the younger generation who were susceptible to these pressures. John Houston, for instance, records that in the mid-1970s, because of the extent to which painting was in disrepute, he found it difficult to paint at all. In 1976 Graeme Murray, a graduate of Edinburgh College of Art of this generation, founded a gallery whose policy was shaped by minimalist loyalties of this kind; throughout the 1970s and 1980s he not only showed artists from this group, but also brought important international artists to Scotland.

The motives for these shifts were no doubt as various as the artists themselves. Certainly the

full-time sculptor in the north-east for a number of years – as has Doug Cocker. Though Cocker trained in Dundee, he only returned to Scotland to teach at Aberdeen in 1981. His work will be discussed in Chapter Five.

In painting, as in sculpture, the 1970s saw an intensification of the dialogue between the aspirations of a new generation and art elsewhere. Although the success of Bellany and others in extending the native Scottish tradition and developing it into something new proved important for this generation, at the same time, stimulated by the new aesthetics of conceptual and minimal art, a number of artists reacted against painting altogether – or at least against painterliness. This was not peculiar to Scotland, of course. It was a universal fashion at the time, but in Scotland it had special pertinence because of the stress on the process of painting itself which was still current here. In Edinburgh in the early 1970s Ken Dingwall (*b.*1938), Robert Callender (*b.*1932), Elizabeth Ogilvie (*b.*1946), Eileen Lawrence

Plate 149. KENNETH DINGWALL, *Will*, 1991-92

Plate 150. ROBERT CALLENDER, *Ribs: For Those in Peril on the Sea*, 1985

1970s saw an intensification of the pressure to conform to artistic models from outside; in an international perspective, an artist like Alan Johnston can be seen as a practising minimalist, consciously reducing the syntax of his art to its most rudimentary element, the single pencil mark, for example, and then building up from that a structure that is elegant in its austerity (147). Johnston has been one of the most successful artists of his generation. His work has been widely exhibited overseas and at the time of writing he is working on a major commissioned exhibition for the Wittgenstein House in Austria. Ken Dingwall could also be identified in a general sense as a minimalist, but in his case, the thing that he has rejected – the display of emotion which could be seen as the fatal indulgence of many of the Edinburgh painters of the older generation – was, paradoxically, for a long time the key preoccupation of his art. In the older generation this could be seen as too facile, displayed as it was through vivid colour and violent brushwork. In Dingwall's work the opposite is true. It is screened and refined in a way that transforms it and preserves its essential privacy even while making art out of it. Like Johnston, by the early 1970s, Dingwall was using the individual marks of the brush or pencil – even when he used paint, these were usually in greys and

blacks, or monochromatic blue – to build up an image in which these marks are the visible structure. Recently his art has become more formal, but formerly he used this structure as a layer or screen through which we catch glimpses of something different, warm and intense (149).

Robert Callender and Elizabeth Ogilvie have worked side by side for many years. They held a joint exhibition in 1980 which was called 'Watermarks' and their common theme has always been the sea. Callender at the time was painting scenes of the rocks and shores of the far north-west in a dark, monochromatic style. He began to make constructions from cardboard and by the early 1980s these had evolved into extraordinary, painted replicas of wooden boats – sometimes whole and sometimes wrecked and halfway to driftwood – and other marine material and detritus of all kinds. He developed his system of cardboard construction so that he was able to make replicas of very large objects, even a full-size set of lock gates or the wooden ribs of a wrecked fishing-boat which he installed in the Talbot Rice Gallery in 1985 (150).

In a way this kind of fidelity might seem at first sight similar to the Boyle family replicas, but

Plate 151. EILEEN LAWRENCE, *Prayer Sticks 106, 107, 108*, 1992

Plate 152. ELIZABETH OGILVIE, *Sea Sanctuary*, 1989

though Callender's images are low-key, they are poetic and evocative. These are qualities that Ogilvie shares, though she reaches them by different means. She was a sculpture student under Eric Schilsky, but she reacted into a kind of home-grown minimalism, dominated by the use of the pencil – by the mark of graphite. She moved from white reliefs through fastidious pencil drawings of waves and the sea, often on a very large scale, to making more and more sophisticated objects. These are still basically drawings, but she also uses such Japanese forms as the scroll and screen. She uses hand-made paper and other related materials to make surfaces of fragile beauty. Her iconography evolved from the surface movement of the sea to incorporate some of its vegetation in life-size drawings of giant fronds of seaweed. In an overt movement towards poetic content, latterly she incorporated writing and imagery derived from the experience of the sea-dependent people of St Kilda from whom she is descended (152).

There are certain parallels in these latter works between Ogilvie and Will Maclean, but she is closer to Eileen Lawrence who also depends largely on drawing. In the 1970s, she was building up her pictures from a precisely drawn description of natural objects like eggs and feathers, but carried out with a kind of veracity that gives them great intensity. Lawrence, too, used scrolls and hand-made paper to present these images, arranging them with a careful attention to spacing and symmetry which is also ultimately Japanese in origin and which enhances the sense of the metaphysical presence in the objects that are described. It is significant that, looked at from the outside, both Ogilvie and Lawrence can be seen to be working in a way that has a great deal in common with Blackadder, though at first sight she might seem to belong to a different generation, just as Bellany and Philipson are linked, though they seem to stand for such different things. With Lawrence, the comparison with Blackadder is particularly clear in her more recent work, in which she uses colour, though in a very controlled way (151).

An artist from a quite different background who also came close to this approach was Rory

Plate 153. RORY McEWEN, *Persimmon*, 1971

McEwen (1932–82), who took the precise language of botanical painting and developed a wonderful poetry from it by exploiting interval and position in a way which, in its refinement, suggests the meditative beauty of the Chinese Sung painters (153). In John Mooney's (*b.*1948) work the close observation of botanical forms, specifically cacti and succulents, is a feature of one group of paintings. Like his contemporaries, Onwin and Lawrence, Mooney has reacted against painterliness, but he has done so in a way that is quite distinctive. Recently his work has grown freer, but up till now he has used a very precise and detailed way of painting. It exploits the ambiguity in the fact of painting itself, in which a flat surface can undergo a metamorphosis into space and form and then back again.

The images that he builds up are complex, sophisticated and often humorous. His immaculate paintings of cacti, for instance, also celebrate the cactus as a prickly phallic symbol unwittingly domesticated in the bourgeois drawing-room or conservatory. At other times he works on the idea of metamorphosis itself as the objects that he describes go through a set of variations, usually from the perfectly innocent to the powerfully suggestive (154). Mooney's art is surrealist in the way it exploits the ambiguities of the painted world. David Evans (*b.*1942), who is a little older, and who came to Scotland from Wales, is more directly surrealist in his inspiration, however, drawing on Magritte's exploitation of the enigmas that it is possible to create even when painting the world in what is appar-

ently a completely non-committal way.

In the 1970s in Mooney's generation, Glen Onwin turned away from conventional methods of paint or pencil altogether. But like Lawrence, he turned to an analysis of the physical detail of nature that, by its very closeness, while it emulated the scientific approach, could also capture something of our sense of the presence of the transcendental in the mundane. Before he returned to the forms, if not the substance, of painting in the 1980s, Onwin's most ambitious project was also a classic example of the exhibition as art work. This was an installation based on the chemistry and natural history of salt. It was presented in its most complete form in 1978, though it had evolved over several years from an earlier project based on an East Lothian salt-marsh which he exhibited in 1975. He revealed salt in the perfection of its cubic crystal, rather like Alan Johnston's pencil mark, as the most fundamental constituent element in a landscape of great complexity, creating as he did so an installation of austere beauty (156). Onwin's next major project, called *Revenges of Nature* (1988), was more directly ecological. It also evolved over a number of years and was an attempt to present summary statements about man and nature in the context of contemporary concerns about pollution and ecological disaster. It was a series of very large two-dimensional images made up from a variety of substances, but it lacked the elegant economy of his earlier installations.

Never far away in Scotland, the sea is a ready and convincing witness to the deterioration of the environment under the pressure of human pollution. In this way it figures in the work of Will Maclean, but his art is also more human in its concerns than that of Onwin. For Maclean, the experience of fishermen and the sea, as it was for Bellany, was something personal, for the sea was in his family background, but it is also a poetic link with the primeval from the unmediated confrontation of fishermen with nature. The imagery that Maclean evolves from it parallels his use of a similar kind of human and historical perspective that he finds in the Gaelic culture which is also his roots. Maclean was a student at much the same time as Bellany. The latter's success no doubt encouraged him, and the force of his example may perhaps be seen in the fishing imagery of some of Maclean's early paintings.

Plate 154. JOHN MOONEY, *Coming to a Head*, 1992

Plate 155. WILL MACLEAN, *Abigail's Apron*, 1980

But in 1973 a major project, the *Ring Net,* took him out of painting into the detailed study of a historic aspect of the fishing industry. This project ended up as a collection of some four hundred drawings and other works which documented in detail the boats, the equipment and the life of the men who used them in this particular form of west-coast fishing which, by historical accident, disappeared soon afterwards.

For Maclean, such an immersion in the process of record and the actual detail of an industry and its attendant lifestyle was a turning point in his career, and the experience was reflected in the particularity and the allusive complexity of the constructions which he turned to making in the early 1970s.

Maclean's earliest assemblages combine found and made objects with exquisite workmanship. They draw on a wide variety of sources to combine personal, maritime, archaeological and even magical references. Sometimes these are taken from the history and mythology of such sea-going communities as the whalers. At other times, closer to home, they reflect on the tragic history of the Highlands, whether in general, or from some very personal memory as in *Abigail's Apron.* This is a carved wooden apron in a wainscotted interior, a homage to a Highland aunt, but also an elegiac personification of a vanishing, once universal personality in the old Highlands, stern perhaps, but intensely human and with a sense of hospitality that contained an echo of a more heroic age (155).

In his approach to Gaelic culture, Maclean has taken inspiration from the great Gaelic poet, Sorley MacLean, in his ambition to create a visual language that could be rooted in – and so could adequately reflect – the tragic experience of the Gaels. He has achieved this in a remarkable series of works in which he treats themes which he shares with Neil Gunn as well as with Sorley MacLean, two of the great men of the Scots Renaissance. Links like these are important for, even more clearly with Maclean than with Bellany, they represent the way that visual art to flourish must be rooted in the wider culture of the nation. Recently, he has produced a striking set of etchings illustrating Gaelic poetry, called *A*

Plate 156. GLEN ONWIN, *The Recovery of Dissolved Substances,* 1979

Night of Islands.[4]

Of all the artists whose work spans this period, this breadth of cultural perspective is most apparent in that of Ian Hamilton Finlay. Chronologically, as he was born in 1925, Finlay's contemporaries are artists like Paolozzi, Davie and Turnbull. After serving in the army during the war, he began his artistic career as a painter in Glasgow in the late 1940s, but he then abandoned art altogether and only returned to it by the oblique, but as it transpired singularly fertile, route of writing poetry and short stories. As a visually inclined poet interested in typography, he followed Apollinaire's example to develop the visible appearance of his poetry through the formal symmetry of similar and related words and through the layout of the poem itself. His art has never lost touch with this origin and even when there are no actual words in it, it is usually open to extension by visual pun or implied verbal meaning.

In making his art, Finlay has also always preserved the neutrality of the printed page. Much of it, of course, is actually printed, but even when he is working in wood or stone, he works in collaboration with other artists and craftsmen to produce things which explicitly lack the evidence of the artist's touch – the thumb print of the creator, as it were. He therefore consciously distances himself from something that has been a central part of the post-romantic aesthetic of

Plate 157. IAN HAMILTON FINLAY, *Star Steer*, 1966

self-expression. To this extent, Finlay's starting point was the same as that of the minimalist generation and, too, of Paolozzi in his screenprints with their borrowed imagery and their neutral and inexpressive surface. Both Finlay and Paolozzi can be seen as pioneers in the critique of modernism which was eventually christened post-modernism.

The concrete poem *Star Steer* which Finlay composed in 1966, but which has appeared in a series of forms since, is a good introduction to some of his central concerns (157). The words of the poem are arranged to evoke the pattern of starlight on water as they conjure up the age-old principles of navigation whereby man in this imperfect, sub-lunary world can find his way by appeal to the perfect and unchanging order of the heavens. It is a model for our need to find and create order in the chaos of nature, an aspiration which, for Finlay, is expressed in the neo-classical style. It is characteristic of Finlay, too, that this finds expression in an image of the sea, and so in the continuing significance of the primeval

relationship of man and nature, as here through navigation or, by extension, in the lives and activity of fishermen, where this relationship is still that of the primitive hunter. *Star Steer* is closely analogous to another of Finlay's best-known works, *Starlit Waters,* one of many poetic and visual variations on the names and numbers of fishing boats that he began in the early 1960s and which have proved a fertile source of imagery for him. It is an area of interest that Will Maclean shares with him, but through the connotation of the fisherman as hunter, this imagery gives Finlay the opportunity to develop another dimension of this theme of man and nature. Many of these boat names are drawn from classical pastoral literature, such as *Amaryllis.* Thus they provide an opportunity to reflect on the true nature of the pastoral tradition as typifying not a romantic idyll, but the hard and unforgiving character of nature and man's relationship to it, and the presence of unredeemed nature, implicit in the violent activity of the hunter, in the construct 'human nature'.

It is this unredeemed nature that Finlay has identified at times by using metaphors of military violence as he does in another of his best known works, the stone relief *Et in Arcadia Ego.* In this he takes the image in the painting by Poussin of the same title, the reminder of the presence of death even in the innocence of Arcady, and enlarges it by substituting a tank for the sarcophagus in Poussin's picture, to invoke not only the inevitability of death, but also this violence. Such imagery of violence at times, as here, is a reminder of its constant presence and threat in human nature, which is nature barely tamed, but where it is also the source of creativity. This and the polemical side of Finlay's work has played a part in the inspiration of Alexander (Sandy) Stoddart (*b.*1959), sculptor and self-appointed champion of neo-classicism. His heroic bust of Henry Moore, for example, is explicitly a post-modern critique of aspects of the modernist tradition in sculpture which, for Stoddart, are represented by Moore. Stoddart was for a while quite closely associated with Finlay, but a younger sculptor, Kenny Hunter (*b.*1962), has independently also made

a subtle commentary on the continuing significance of classicism and its place at the root of our culture.

The whole programme of Finlay's art is expressed in the garden which he and his wife Sue began on a bleak hillside in Lanarkshire in 1966. The very existence of the garden is a metaphor for the struggle to create order in the face of nature. It is therefore definitively neo-classical and in its arrangement it recalls great, classical gardens like Stourhead. It is much denser in its imagery, though – a kind of living concrete poem of great complexity (158). In the garden the last small monument at the edge of the moor is a stone inscribed with the single word 'Fragile'. It is a reminder that harmony is not some kind of sump of placidity but, like the garden, the result of a fierce and constant struggle to maintain the balance between order and destructive disorder. For him, art is one means of maintaining the balance between these opposing forces. This was how Geddes saw it, too. MacDiarmid and others carried it forward and, in the late twentieth century, it is an idea which has continued to give vitality and relevance to art in Scotland, in the hands not only of Finlay, but of artists like Will Maclean and outside of Scotland by Paolozzi. It is also an idea which has continued to inspire the best of the artists of the generation that matured in the 1980s.

Plate 158. IAN HAMILTON FINLAY, *The Great Piece of Turf*, 1975, Little Sparta

Plate 159. KEN CURRIE, *The Troubled City*, 1991

CHAPTER FIVE

Old Themes and
New Beginnings

T he year 1979 was a watershed in the modern Scottish consciousness. In the years immediately before the referendum on Scottish autonomy that year, there was a growing anticipation of change, and, in the arts at least, this was coupled with a sense of optimism. The outcome of the vote, rigged in effect as it was, was a profound disappointment to many people. But looking back on the years that followed, the decade of the 1980s was nevertheless one of singular creativeness and independence among the artists. Perhaps in the longer term, the disappointment of 1979 was also a liberation. Certainly a new generation appeared who seemed free from any inherited stylistic preoccupations and willing to reject any tendency to introspection and the security of a private language. Instead, turning towards the public, they were able successfully to join the best of the older generation in restating the fundamental seriousness of the business in which they were engaged.

In 1982 the Scottish Arts Council organised an exhibition with the title 'Scottish Art Now' for the Edinburgh Festival. It included John Kirkwood (b.1947), Michael Docherty (b.1947), Ian McKenzie Smith, Jack Knox, Graham Durward (b.1956) and Derek Roberts. With the exception of Durward, who was a newcomer, the list of names was a retrospective one; but by coincidence a rather different picture was presented by an exhibition in the New 57 Gallery upstairs in the same building as the Fruitmarket. This exhibition was called 'Expressive Images' and was drawn from the year's graduation shows at the four art schools. (The 57 Gallery became the New 57 Gallery when it moved to the upper floor of the Fruitmarket from its original site in

Rose Street.) Among the young artists included in this show, the outstanding talent was Steven Campbell (b.1953). Compared to anything to be seen in the Fruitmarket downstairs, his art was raw and immediate. All pretence of gentility was gone. It was unquestionably powerful, but its power was also clearly rooted in the traditional language of painting. The preciousness of 1970s' art had been jettisoned along with its gentility.

Campbell's canvases were large and roughly painted, dominated by massive figures who were engaged, if at all, in enigmatic activities. *The Admiral,* for instance, is a huge figure in naval costume reaching out to put his hand on the shoulder of a smaller figure in front of him. He is reminiscent of the stony Commendatore at the end of *Don Giovanni,* but there is no explanation offered of the apparent narrative. Instead, here as in the other paintings, we are presented with the bold and uncompromising fact of the painted figure which as Campbell presented it had echoes of Picasso's neo-classical period as well as of Courbet.

These paintings of 1982, when Campbell was fresh from art school, were outstanding. The artist's consciousness of the inherited language and challenges of the medium is very apparent in them, but they were perhaps also characteristic, nevertheless, of a shift that was taking place. A generation was coming of age for whom Paolozzi's observation of the comprehensiveness and universality of visual culture was no longer a self-conscious artistic attitude, but a fact of life. The fluidity between different kinds of image was such that some at least of the old cultural boundaries simply had no meaning.

David Mach (b.1956), another of this new generation of talented young artists to emerge at

Plate 160. DAVID MACH, *Outside In*, 1987

the beginning of the decade, made his work from waste materials. Mach's first projects of this kind were a series of constructions, a *Rolls-Royce Car,* a *Reclining Nude* and an *Eiffel Tower,* all made from thousands of books. In Edinburgh in 1986, he used ten thousand car tyres to build a Parthenon in Princes Street Gardens, and the following year he used thirty tons of magazines for an installation at the Riverside Studios in London. By this stage in the late twentieth century, this kind of work, which might be termed monumental rubbish, could have carried all sorts of burdens of significance – along with a fair helping of *déjà vu* as well, perhaps – but Mach managed to make his constructions into simple existential acts. As such, they were even less self-conscious and less part of the inherited dialogue of art than Mark Boyle's reliefs had been, and yet Mach was creating both a performance and, in effect, a piece of monumental sculpture, albeit an ephemeral one (160).

There were echoes of the American artist, Cristo, in the way that Mach organised a team of helpers to make something in which the significance lay as much in the process as in the product. This is perhaps a clue to a new element that had entered the dynamic of art – the media, especially television. To make an impact an artist had to make news, so art that was a success was art that generated an event. There was also an irresistible pressure from television to see the real news in art as success in the perennial pursuit of the youthful genius, though the model was very much that of the pop music industry rather than the evidence of history that this elusive phenomenon was anything more than a myth dependent on a romantic idea. In such a climate, an artist could succeed as Mach did by making what was effectively a single 'hit'.

This was the unspoken assumption of the exhibition in 1987 which professed to sum up what seemed to be the dramatic new departures in Scottish art of the decade, 'The Vigorous Imagination'. Here were not just one or two, but a whole school of youthful geniuses, pop stars too. In fact, separated from this kind of hype, the range of talent in this exhibition was striking, though it was unified more by the freedom of the artists in the visual language that they used and the associations that they made, than by any evident set of common concerns. The artists in 'The Vigorous Imagination' exhibition came from a variety of different backgrounds, but if there had been a moment at the beginning of the decade when it seemed as though there was something quite new emerging in Scottish art, it was when a group of figurative painters appeared in Glasgow; Campbell himself, together with Peter Howson (b.1958), Ken Currie (b.1960) and Adrian Wiszniewski (b.1958) were the principals among them. In this group, Campbell, who was considerably older than the others, was the undoubted driving force, and his achievement has done much to shape the evolution of Scottish painting in recent years. The success of this group as a whole was also an important factor in Glasgow's cultural renaissance.

Plate 161. STEVEN CAMPBELL, *Through the Ceiling, Through the Floor,* 1984

Plate 162. PETER HOWSON, *The Three Faces of Eve*, central panel of a triptych, 1990

All four of these painters were students at Glasgow at much the same time and all four turned to dramatic, large-scale figurative painting. This seemed new in a Scottish context in spite of the achievement of Bellany and his colleagues, but it was a rising fashion in Europe, especially in Italy and Germany (though to a lesser extent in Britain, too). In 1979, for instance, there was an exhibition at the Fruitmarket Gallery dedicated to what was called rather grandly the 'new figuration', and in 1983 it was a sign of the times that there was an exhibition at the same gallery of the fashionable Italian figurative painter, Sandro Chia.

The importance of figures like Chia reflected the way that part of the change that was taking place was a shift from an American-dominated climate to one where the direction came from Europe; and if one thing has characterised the art of the last decade or so in Scotland, it has been the importance not just of European art in general, but, picking up on a tradition that stretched back to before the war, of German art in particular. In 1981, for instance, Joseph Beuys returned to Scotland and left an indelible mark on several artists. Other German artists like the figurative painter Immendorf played a part in Steven Campbell's early inspiration alongside Chia, and the radical vision of an artist like Anselm Kiefer is echoed in the constructions of David Mach perhaps as much as the example of Beuys. Kiefer may have played a part in the atmospheric paintings of Phil Braham (*b.*1959), too, and also perhaps in the recent landscapes of Sandy Moffat. There was also a parallel between Bellany and Moffat's position and George Baselitz's rebellion in Germany, also in the early 1960s, against prevailing taste and through the medium of a return to figurative art. There is therefore a good reason why Baselitz in particu-

Plate 163. KEN CURRIE, *The Great Reform Agitation: Unity is Strength*, 1987

lar has been such an important example for a number of Scottish artists. It was perhaps because of this underlying sympathy that Berlin has stood in the last decade for what Paris had been for an earlier generation, and several artists have had first-hand experience of German art there. Gwen Hardie (b.1962) went on a DAAD scholarship in 1985 and Margaret Hunter (b.1948) managed to get there without such support. For both painters direct contact with Baselitz was a crucial influence, though with very different results.

Such an interest in Germany was not new in Scotland, of course, and, in spite of the apparent novelty of much that was being done, the continuities are important, too. At Glasgow, Sandy Moffat was one of the teachers who most encouraged this new generation. He perpetuated through them the rebellion against aestheticism that he and Bellany had begun. Sandy Moffat had shared Bellany's enthusiasm for the German New Realists and his own portrait style owes something to Beckmann. Léger had been another early enthusiasm for Bellany and Moffat, and it is important that Moffat also encouraged this kind of historical sense in the younger generation. Léger's ideal of a monumental art for an industrial society had had echoes in Scotland through McCance, MacDiarmid, Paolozzi, and in some of Tom Macdonald's large-scale paintings. It can still be seen in the background of Campbell's interest in Picasso's neo-classicism, or in the murals of the history of Scottish labour that Ken Currie painted for the People's Palace in Glasgow in 1986–87.

In this group of Glasgow painters who graduated at the beginning of the 1980s, Campbell was undoubtedly the leading figure. He went to art school as a mature student after he had served an apprenticeship and worked as a steel fitter. From the start he was determined to make his mark, but initially he worked in the semi-theatrical field of performance. Bruce McLean, Gilbert and George and others were an important part of his inspiration, but in some of the performances that he arranged and presented while he was a student, the central importance to him of film was also clear. The cinema in gen-

eral, with its flexible narrative and its ability to make sense of the non-sequitur through the conventions of the cutting-room, has played a constant part in his inspiration. His degree show in 1982 was all painting, however, and soon after graduation he won a scholarship which took him to New York, where he remained until 1986. He achieved some celebrity with his first solo show there and went on to considerable success, a success which served as an inspiration and an encouragement to younger artists back in Scotland, for not since Gear, Paolozzi, Davie and Turnbull forty years before had a Scottish artist moved so effortlessly into the mainstream. The pictures Campbell was painting at this time evolved from the rather static figures of his 1982 show towards a more animated kind of narrative seen at its best in a picture like *Through the Ceiling, Through the Floor* (161). In such pictures, the figures are heftily real to the point of caricature, but the world they inhabit fails to respect their assumptions about the nature of reality and so delivers them a variety of nasty surprises.

The unpredictable, half-comic world in these paintings is a suitable analogy if not for the physical world that we inhabit then certainly for the psychological one, and though there is comedy and irony in Campbell's work at this time, it is serious too. From the beginning of his painting career, he showed himself to be familiar with the classical language of 'history painting' and to want to try to make it work in a way that would be appropriate to the uncertainties and moral ambiguities of the late twentieth century. Initially the only way he could do this was by setting up a dramatic situation and then undercutting it to avoid the pompousness inherent in the historical style. Following his example, but without his discrimination, Peter Howson has also tried to paint in the manner of the grand tradition of figure painting. Through Sandy Moffat's example, his early work reflects the inspiration of artists like Beckmann and Léger and he moved on to imitating the heroic style of history painting represented by artists like Géricault. He is at his best, however, in single figures like the early study of *Rosie* of 1986, for instance, which seems to replace with genuine compassion the bourgeois

Plate 164. ADRIAN WISZNIEWSKI, *The Master Gardener*, 1988

self-pity of the kind of Lucien Freud image to which such a nude study is related. The same can be said of the single heads in Howson's *Saracen's Head* series of etchings of 1988 and in a lot of his smaller works, but in his more ambitious compositions the unalleviated brutality of a grim and smoky, futuristic world like that in *Blade Runner* becomes self-defeating as social criticism (162). In *Patriots* of 1991, for example, a group of National Front worthies are likened in their brutishness to the pit-bull terriers that they have straining on the leash. Such an image achieves a certain force but, lacking subtlety, it comes dangerously close to comic-book bombast. It asks

only for the easy, reassuring liberal response of condemnation without the troubling salt of irony, or the needle of self-recognition that punctures complacency. Like Bastien-Lepage's rural 'realism' a century before, it subtly reinforces distance while appearing to confront us with an immediate reality. Howson has, however, achieved a considerable reputation, serving as a war artist in Bosnia for example.

Of the four contemporaries, Adrian Wiszniewski is closest to Campbell. Like Campbell, he began his career as a student, not exactly as a conceptual artist, perhaps, but in an environment in which he could draw directly on

the stimulus offered by conceptual art. It is one of the sources of strength of these two Glasgow artists that they have proved able to reinvest some of the traditional language of painting with the radical intellectual and imaginative inquiry and the iconoclasm of the conceptual movement represented by artists like Bruce McLean and Gilbert and George. As a painter Wiszniewski's touch is much lighter than Campbell's however. He has great technical skill and his work recalls at times Matisse and the Fauve tradition but, like Campbell, he creates a pictorial universe which is a projection of the uncertainties and ambiguities of the world that we inhabit. In his paintings, too, young men with the innocent faces of the inhabitants of P.G. Wodehouse's bourgeois Arcadia are beset by the complexities of a world

that is continually surprising (161).

Ken Currie, on the other hand, has worked hard to find an idiom that would express his social and political concerns. In the People's Palace murals, he interprets his subject in a pictorial language which recalls the work of the Mexican muralists such as Diego Rivera and their American followers (163). There are also echoes of the banner art of the trade unions, and the result is an appropriately grand and solemn set of paintings. It is ironic, however, that these paintings should celebrate a heroic industrial past at just the moment it was vanishing for ever. It is a retrospective world in which the labourer in heavy industry, a creative hero to McCance and J.D. Fergusson fifty or sixty years before, has a nostalgic role as a sentimental evocation of a van-

Plate 165. JOHN BELLANY, *Sunset Song*, 1991

ished innocence rather like that of the shepherd in eighteenth-century pastoral. Pictorially, though, Currie's pictures – and, even more, the large conté crayon drawings that relate to them – have a direct and unsentimental force that is entirely convincing.

At this time, because Currie was painting a vanishing or vanished world, it was difficult for him to continue in that vein. Understandably, he moved to a description of the alienated, post-industrial world which was also Howson's subject. To evoke this Currie pushed his images to the edge of hysteria, though without crossing over into it, drawing inspiration from the horrors of Otto Dix's wartime prints and the dark side of Goya, though they also look back to the work of older Glasgow realists like Millie Frood and Tom Macdonald. The results are dark and pessimistic, yet surely also profoundly true (159).

The post-industrial world became a fact of life earlier in Scotland than in most places. First into the industrial revolution, Scotland was also first out. Before Ken Currie, John Kirkwood had made this the subject of his art. His most impressive productions are sculptural evocations of the post-industrial wasteland, huge black and rusting *Bulkheads* which are also vaguely anthropomorphic in a threatening way. Fred Crayk (*b.*1952) has also specialised in evoking this desolate, half-human world in a series of landscapes that present not only the industrial wasteland with its own strange beauty, but also the uncertainty of the human place in it.

Kate Downie (*b.*1958), who trained in Aberdeen, has also developed an impressive iconography, not so much of the post-industrial landscape perhaps, but rather of the city which reflects it and which also has connotations of continuity and civilisation that are called in to question by so much of the real, modern, urban environment. It is this world between, rather than a simple-minded reflection of the cityscape, that she records in paintings which are often appropriately fierce, dark and inhospitable, though at times they also record the light and gaiety of a city street. Sometimes her pictures recall the urban paintings of Tom Macdonald and

Plate 166. KATE DOWNIE, *City*, 1992

Bet Low from the late 1940s, but the peculiar psychological stress of the changes of the 1980s is also reflected directly in works like these (166).

Perhaps this also underlies the expressionism of some of the other artists of this generation, which is often dark and violent and far removed from the purely painterly expressionism of an older generation. June Redfern (*b.*1951), for instance, is an artist whose early inspiration lay in contemporary German painting like that of Baselitz and who developed this in a distinctive way (167). Redfern was for a short time one of a small group of artists working in a similar manner who were associated with the 369 Gallery, opened in 1979 by Andrew Brown. Rather like Graeme Murray, Andrew Brown was a graduate who opened a gallery very much linked to his own generation. Among many other artists launched on their careers by Andrew Brown, Fionna Carlisle (*b.*1954) and Caroline McNairn (*b.*1955) have been particularly closely associated with the 369.

Margaret Hunter, who also showed with the 369 Gallery, was in direct contact with Baselitz.

Plate 167. JUNE REDFERN, *Horsemen Pass By*, 1993

She developed from his influence a powerful way of rendering the human image. Originally, like several of her contemporary women artists, her concern was the female form and, by extension, the mother and child. She took inspiration directly from primitive art, laying stress on the universality of such imagery in a way which recalls Alan Davie and the Jungian view of symbolism, and she has developed this into an idiom which, while it is still primitivistic, is also topical. Based in Berlin, her recent work reflects on the ambiguity and insecurity of post-reunification Germany, particularly the former East Germany (168). There, the post-industrial state has been reached almost in a matter of months. Hunter's work includes very powerful drawings and sculpture as well as painting and though her inspiration is in Germany, the human stress that she records could equally be a reflection of post-industrial Scotland.

Like Margaret Hunter, Gwen Hardie lives and works in Berlin, and like her she has taken important inspiration from Baselitz. This has allowed her to develop a kind of primitive directness which raises her representation of the body to the level of something iconic, yet also child-like. Her first distinctive work was a series of large-scale representations of parts of the body painted with a deceptively soft touch. She went to work with Baselitz and under his inspiration sought to find a more elemental imagery for a

new iconography of the female form. Some of the most successful results in the late 1980s were a series of papier-mâché reliefs and free-standing sculptures like *Withheld* of 1989. It stands seven feet high and is recognisably female in form without being precisely anatomical. Her concern with technique and surface led her to make a series of pictures which are apparently purely abstract, but where there is still a suggested analogy between the paint surface and the surfaces of the body. She has recently returned to concentrate on the torso to create images which have such an intense beauty that it suggests – as few artists have been able to do – how our physical existence, far from being a barrier against our understanding of the metaphysical, is in fact the only route by which we can hope to reach it (172). They belong, as Joan Eardley's best work does, in the long struggle to find a way of reconciling the empirical with the metaphysical. Though she is older and her imagery is more diverse, Jacki Parry's (*b.*1941) sculpture has something in common with the three-dimensional images that Gwen Hardie makes (171).

A refreshing antidote to the cult of the

Plate 168. MARGARET HUNTER, *Figure with Bronze Cones (The Receiver)*, 1992

youthful genius, Margaret Hunter came back to painting after she had brought up a family. Lys Hansen (b. 1935) also appears as a contemporary as she too only returned to painting in the late 1970s, though she had studied at Edinburgh College of Art twenty years before (169). She also had an opportunity to work in Berlin in the mid-1980s. In her direct concern with the position of women expressed through powerful, expressionist images, she shares a point of view, not only with Hunter and Hardie, but with another Edinburgh-trained artist, Sam Ainslie (b.1950). Ainslie came to Scotland in the late 1970s to study tapestry. Like a good many of her colleagues working with tapestry, she moved away from any conventional idea that it is essentially a woven textile medium, and took it as an invitation to unlimited technical invention. This has led her to make images which combine painting with textile in a kind of collage and in a way that is peculiarly suited to her subject (170). She has several times had the opportunity to work on a heroic scale. In 1987, for instance, in an exhibition in the Third Eye Centre whose radical agenda was declared in its title, 'Why I Choose Red' she exhibited a work that was seventy feet long entitled *Woman in Red confronts her own Reflection.* A gigantic banner, it was a kind of emblematic narrative of a woman's process of self-discovery.

Scotland was early in fostering women artists and as a result there is a distinguished group from Phoebe Traquair to Elizabeth Blackadder and the new generation working today. These women first of all successfully shed the idea that as an extension of the domestic arts, applied art and illustration were the proper field in which women artists should work. Nevertheless, within this group, only Cecile Walton, very precociously, in her single painting *Romance,* had taken on the idea that there could be a female iconography distinct from the conventions of the masculine tradition. It was only in the 1980s and in response to the wider women's movement that this present, powerful group of women artists took up this challenge.

There are, of course, also a number of women artists who have not chosen to work in

the particular field of art that is about women. Kate Whiteford (b.1952), for instance, began as a purely abstract painter, and her work is still usually abstract in form. Exceptions to this were the very large drawings made on Calton Hill imitating such prehistoric land drawings as the White Horse on the Berkshire Downs – drawings designed to be seen by the gods. Her choice of images on this occasion was a huge fish, a spiral, and a shape that completed the plan of the classical temple on Calton Hill – the abortive National Monument, or Edinburgh's Folly – as though it were the proscenium of a Greek theatre. The fish stood for the Celtic 'salmon of wisdom', a symbol that runs through Neil Gunn's *Highland River.* The spirals were directly inspired by megalithic carvings. Whiteford developed a formal language based on the mystical idea of drawing as it appears in such prehistoric imagery, or in the present in Australian Aboriginal painting. In this kind of art, the process carries meaning which is not literally visible, but which nevertheless informs the image. The hand as it draws a spiral travels through the actual labyrinth that the spiral in turn invokes. Once again there are clear analogies with Alan

Plate 169. LYS HANSEN, *Berlin Beckons,* 1993

Plate 170. SAM AINSLIE, *1917-1992*, 1992

Davie who has taken inspiration from similar rock-drawn imagery in the West Indies. Beyond Davie, of course, there is the earlier work of William Johnstone with its links to the fiction of Lewis Grassic Gibbon and Neil Gunn, rooted in the ancient continuities of the land (173).

The difference between Kate Whiteford's work and these earlier models lies in the way in which she presents the images in all their stark simplicity, drawing on the impact of the unadorned abstract shapes, usually set against a field of unbroken strong colour, in order to give

their presence maximum force. Callum Innes's (*b.*1962) work presents a parallel in the way that he uses drawing as the basis for an austere abstract language. In Innes's case, though, this owes more to the minimalist tradition represented by Alan Johnston (174).

Jake Harvey's recent work is closer to Kate Whiteford's in his use of the language of abstract art to convey a sense of the mysteries of continuity reflected in the potency of Pictish and neolithic imagery, a potency still manifest even when its original meaning is entirely lost to us (177). Harvey turned from forged steel imagery in the style of the MacDiarmid Memorial to work in stone in the later 1980s. In this medium he carried out a series of works that are very simple in form, but which suggest objects of primeval use, both tools and utensils like quernstones or bowls, and religious objects, symbols of power and sexual potency both male and female. Part of Jake Harvey's inspiration for these recent works was in the prehistoric sites of Orkney. Frances Pelly (*b.*1947) has been working in Orkney for several years and her current sculpture, though very different from Harvey's, evokes the ancientness of the place. She does this through a use of landscape forms which seem unconsciously to echo the early abstract landscapes of William Johnstone, expressing the

Plate 171. JACKI PARRY, *Pages of a Diary,* 1985-87

Plate 172. GWEN HARDIE, *Still Point*, 1993

Plate 173. KATE WHITEFORD, *Calton Hill Drawings*, 1987

Plate 174. CALLUM INNES, *Repetition Thirty Five*, 1994

human presence in the landscape through an interplay between its forms and those of the human body (175).

Douglas Cocker has also continued to work inventively through the language of sculpture. In his earlier career, he moved from making metal sculpture in the international style, to making boxes, enclosed and hermetic and in a way rather like the work of Fred Stiven. His vision really opened out in the 1980s, however, as he developed a language of his own using wood to make monumental structures. These are reminiscent of the forms of classical architecture yet are formally inventive and politically charged. He leaves the bark on the wood that he uses so that the natural processes of decay (and thus of mortality) mock the apparent permanence of the structures that he creates. In one of his most successful works in this style, *The State of the Nation,* he makes this contrast even more explicit, for the stable image of a classical temple is set on a rocking-chair base (176). Gareth Fisher (*b.*1951) also produces constructions with strong political and environmental themes running through them (180).

In the great variety of approaches to image-making that have characterised the 1980s and, indeed, the 1990s, the one that most distinguishes this period from previous decades is the prevalence of the use of the human figure as an active agent in a narrative drama. In the 1960s, of course, Bellany and others had pioneered a return to a kind of narrative in which the figure was represented in a way that consciously drew on older traditions of figure painting. In Bellany's best early pictures, the figure is a potent human presence. It is not merely a formal element in a composition. Later Bellany returned to a more straightforward kind of narrative painting (165), and in the 1980s there was a dramatic flowering of this kind of art, not only with Campbell and the other Glasgow painters who were his contemporaries, but with younger Glasgow artists like Stephen Conroy (*b.*1964) and Alison Watt (*b.*1965). Both shot to success on the back of the media myth of the youthful genius, but they have also exploited with great skill the language of figurative painting which their predecessors had restored to respectability. With Campbell and Currie, their historical sense is an aspect of a much broader vision, a way of placing their own art in a wider context; but with Conroy and Watt this has come much closer to historicism, to the imitation of the superficial effects of historic styles without consideration of the forces that

Plate 175. FRANCES PELLY, *Moon in a Boat Noust*, 1992

Plate 176. DOUG COCKER, *State of a Nation*, 1985

shaped them.

Conroy draws directly on a variety of models. Degas is a favourite, but one is reminded of Edward Hopper more than of any other artist by his use of warm and simplified light to explore the poetry of the apparently mundane. The anachronism of the imagery that Conroy frequently uses – for example in his paintings of men

Plate 177. JAKE HARVEY, *Power Symbol*, 1992

in evening dress at the theatre – reflects this kind of historical source, but he also uses this kind of anachronism to create a strange detachment. It hovers on the brink of the surreal without ever actually explicitly taking us into a wholly different reality, and so creates an atmosphere of mystery. In fact, his young men with their uniform appearance and dead-pan faces and the vague echo that they carry of belonging to another time suggest that it is Gilbert and George in their suits and ties and with their neat haircuts who have stepped into the picture (178).

Gilbert and George were also an important early model for Steven Campbell, and Conroy started at Glasgow School of Art the year that Campbell left in a blaze of glory. Inevitably he was influenced by him, but in Conroy's painting the technique with which he describes contingent factors like light and texture are all-important in a way that is absolutely different from anything that Campbell ever aspired to. It is this which gives his paintings their distinctive quality, and through his command of such things Conroy has managed to make some memorable images which have touched the popular imagination in a

Plate 178. STEPHEN CONROY, *Che Gelida Manina*, 1988-89

Plate 179. ALISON WATT, *Crown of Thorns*, 1993

way that few of his contemporaries have been able to do.

Alison Watt was a year behind Conroy at Glasgow and like him went straight to instant celebrity, winning the John Player Portrait Award in 1987 before she had completed her post-graduate year and going on to a commission to paint the Queen Mother for the National Portrait Gallery in 1989. Watt's success in England perhaps reflects the extent to which her work can be aligned with the tradition of English figure painting represented by Coldstream and Lucien Freud. Certainly, it depends on academic draughtsmanship, and in the way she draws she is closer to the English tradition than she is to James Cowie, for example, to whom she has been compared. Cowie can endow his drawing itself with mystery and enigma. When Watt creates enigma, she does so through the manipulation of the imagery, and like Conroy her work is distinguished by a historicising tendency. She picks up elements of imagery and technique from a variety of sources and recombines them in a way that is self-consciously surreal and enigmatic. Although she does not use chiaroscuro as Conroy does but paints using a light tonality, as with his painting the real quality of her work lies in her command of the classic painterly virtues of texture and surface (179).

These qualities are also the distinguishing feature of the work of Peter McLaren (b.1964), a graduate of Edinburgh who likewise saw very early success. This depends on his painting of essentially only one image, a man on a bicycle, much as Philipson thirty years before him succeeded with the single image of his *Cock Fight* series (181). Like Philipson, McLaren endows his image with energy by the sheer virtuosity of his technique, and it is really this painterly energy that is epitomised in the image that he has chosen. A very different approach to the traditions of technique is adopted by Peter Thomson (b.1962) and Helen Flockhart (b.1963) who both paint in a manner that recalls the painting of fifteenth-century Flanders, but they use the sharp focus of this technique to give a vivid expressive impact to their imagery of contemporary life (182) (183).

There are also many other figurative artists such as Joyce Cairns (b.1947), Alan Watson (b.1957), Keith McIntyre (b.1959), Jock McFadyen (b.1950), Henry Kondracki (b.1953), Robert McLaurin (b.1961), Ian Hughes (b.1958) and Calum Colvin (b.1961), all currently working in a wide variety of modes. McFadyen and Kondracki use comedy as their vehicle and their work hovers on the edge of caricature. Of this group, Joyce Cairns is closest to Bellany both in style and in time, for her distinctive way of painting evolved in the 1970s. She was a student at Gray's School of Art from 1970, returning there to teach in 1976. She has taken as her subject matter the life surrounding the harbour with its fishermen, sailors and the crews of the oil-rigs. Like Bellany – and more so as in recent years his work has become once again directly figurative – her approach has been shaped in part by the example of German painting between the wars, not only Beckmann and Dix, but also George Grosz. Her pictures of an anarchic, short-term society governed by base appetites is like Grosz's vivid evocation of a world where everything is for sale but nothing has value. Her art is very

Plate 180. GARETH FISHER, *Angel not in Adoration*, 1993

Plate 181. PETER McLAREN, *Cyclist*, 1986

much of its time, therefore, and rather like Steven Campbell she does not stand back and comment adversely on what is going on, but reflects on the ambivalence of all our attitudes by including herself in the picture (184). Alan Watson's painting has a certain amount in common with that of Joyce Cairns and before her of Bellany and he too draws on the fishing community and the oil-rig workers for his subject matter.

Keith McIntyre's most familiar image is the Moffat ram. After moving to live in Moffat for a period in 1983 – a town where, in homage to the sheep on which its wealth is based, a statue of a ram graces the main street – McIntyre did a long series of works in which the ram (and especially the curl of his horn) was a conspicuous feature. Latterly, he has painted complex, surreal townscapes in which conventional reality is suspended. McIntyre trained at Dundee, as did Ian Hughes and Calum Colvin, and they have all at times used a similar kind of compound imagery. Ian Hughes is best known for his passionate expressionism, however, improvising over a pho-

Plate 183. PETER THOMSON, *Public Park*, 1993

tographic image of a face, for instance, with violent and incoherent brushwork. He walks a tightrope between order and chaos, vividly conveying his feeling of how the world itself walks that tightrope and often topples off into psychotic confusion (187). Calum Colvin builds up an image as a kind of vast collage of objects and images which range from everyday waste to the classical images of fine art. He then paints over this and photographs the finished product on a large scale.

There is a certain similarity of technique here to the work of Ron O'Donnell (*b.*1952) who also works in this intermediate area between art, installation and photography. Calum Colvin's imagery sometimes recalls the compound pictures made by Gilbert and George. Like their pictures Colvin's theme is frequently male sexuality, but the process he uses is also very close to the way that Paolozzi makes his screenprints. The objective, too, is rather similar, for it enables the artist to impose a tangible unity and a single surface on a compound experience whose diversity is equal to the visual confusion of everyday life, but from which, nevertheless, we somehow successfully make sense. Like Paolozzi, he brings the iconography of the fine art tradition into direct and some-

Plate 182. HELEN FLOCKHART, *Woman Holding Flower*, 1992

Plate 184. JOYCE CAIRNS, *Last Supper*, 1989

Plate 185. CALUM COLVIN, *Anger* from *The Seven Deadly Sins and the Four Last Things*, 1993

Plate 186. GEORGE WYLLIE, the *Straw Locomotive* burning, *Glasgow*, 10.30 p.m., 22 June 1987

Plate 187. IAN HUGHES, *Truman Capote*, 1994

times ambiguous confrontation with the mundane. Colvin's most ambitious recent project was an exhibition in 1993 inspired by Hieronymous Bosch's painting *The Seven Deadly Sins and the Four Last Things* (185). It was a remarkable undertaking which, with its starting point in the religious crisis of the Reformation impending when Bosch painted his picture, provides a complex commentary on the moral crisis of man and the environment in the late twentieth century.

It has not only been the younger generation who have succeeded in commanding the headlines in the last decade or so. The master of the art has been George Wyllie (*b.*1921) who has understood better than most that in the media age, art works best as an event. In so doing, Wyllie has restated art's claim to see through convention and, by questioning it, to raise questions of the nature of true morality. Wyllie started as an amateur; like Robert Burns and the Douanier Rousseau, he was a customs officer. From 1965 he had been working at sculpture and latterly he had exhibited a number of ambitious works, when in 1979 he began to concentrate on it full time. His art at first ranged from the sim-

ply jokey to work that had a more serious intention. Wit has been its strength, and its capacity to ask questions is incorporated into Wyllie's chosen title for the art he makes, *Scul?ture*. He found his feet in the orchestrated theatre of the media event, paradoxically reaching a level of seriousness which escaped him in the conventional language of sculpture.

Joseph Beuys was an important example to Wyllie in this evolution. He had been impressed by Beuys on the German's first visit to Scotland in 1970, and in 1981 he worked with him directly, assisting on the *Poorhouse Doors* project. (Beuys 'adopted' a set of doors from a former Edinburgh poorhouse.) The idea that art can challenge society in its complacency was not new in Scotland, of course. Not only did it go back to Geddes and beyond; it had also recently found a new champion in Ian Hamilton Finlay, but as Wyllie's own development showed, it received a boost from the example of Beuys who successfully separated this kind of challenge from the constraints of the conventional language of art.

In two major works, his *Straw Locomotive* in 1987, and his *Paper Boat* two years later, Wyllie invoked the ghost of heroic, industrial Clydeside to present reflections which were both witty and full of philosophic resonance. In the first of these, he made a full-size replica of a steam loco-

Plate 188. BRIAN JENKINS, *Inside Out*, 1991

motive in straw. He had it slung by the great Finnieston crane, lonely monument to Clydeside's former industrial grandeur, which quite dwarfed the locomotive as it had dwarfed even its hundred-ton, steel predecessors (186). Eventually the locomotive was burnt like the Wicker Man, to reveal, when the flames died down, a question mark at its heart.[1]

The *Paper Boat* was even more ambitious. Fashioned like a paper boat, and as fragile, it was nevertheless a full-sized sea-going craft. Launched on the Clyde like the great ships before it, it was taken first to London where it challenged Margaret Thatcher from the

Plate 189. ALEXANDER STODDART, *Italia*, clay model in the artist's studio, 1990

Thames and then, in 1990, it went to New York where it sailed up to the World Trade Centre. It was 'carrying the conscience for capitalism', for there, symbolically, its captain delivered a copy of Adam Smith's 'other' book, *The Theory of Moral Sentiments,* in which its author (another customs officer, incidentally), through his idea that society depends for its existence on sympathy and that sympathy depends on imagination, provided at the very outset what is still missing from the world dominated by capitalism.[2]

The *Paper Boat* carried the cryptic letters, QM, which it was revealed stood not for *Queen Mary,* one of the great ships that Fergusson had seen as the cathedrals of Clydeside and a symbol of imaginative co-operation, but for 'question mark', a symbol of the need to rethink, not just from first principles, but from fresh premises altogether. A few years later, Wyllie summed it up:

> The meaning of what we presently believe to be correct has to be re-defined. We cannot shape a new order by using the same methods and attitudes which have brought us to the point where their failure is globally evident.[3]

These works and a number of others like them epitomised the very ephemerality of the media event in order to make a serious commentary on the lack of any permanent values in the headlong rush into de-industrialisation. Wyllie consciously looks back to Geddes in his perception of the role of art in tackling such central questions of value in society, and Geddes's watchword, 'synergy', has become one of Wyllie's slogans. It stands for the urgent need to bring back into a single stream the different channels down which human energy has been diverted.

In recent years, a considerable amount of artistic effort has gone into this kind of broad social objective, pursued above all through the medium of installations. In 1988 the Glasgow Garden Festival saw a series of large-scale installations, including works by Wyllie, Paolozzi and Ian Hamilton Finlay. Also in Glasgow, the

Plate 190. IAN HAMILTON FINLAY with KEITH BROCKWELL and NICHOLAS SLOAN, *A View to the Temple*, 1987

Plate 191. EDUARDO PAOLOZZI, *The Wealth of Nations*, 1993

Bellgrove Station Billboard Project led by Alan Dunn was one of the events put together for the 1990 City of Culture celebrations. Sixteen artists co-operated in a series of installations using the billboard format to present some challenging examples of an ideas-based art. A show in New York in 1991,[4] selected by Alan Johnston and including Craig Robertson and Douglas Gordon who were part of the Bellgrove Project, made an interesting counterpoint to the appearance there of George Wyllie's *Paper Boat*.

In Edinburgh in 1992, for the European Summit Meeting in December of that year, 'Lux Europae', a massive project of outdoor light installations, was held. It may not have been a critical success but it met a warm reception from the people of the city, proving, if it were necessary, that art does not need forever to struggle on a tightrope between élitism and condescension. Artlink in Edinburgh has for a long time taken this as axiomatic, promoting the development of equal partnership between the disabled and the non-disabled through art. Projectability is a parallel organisation in Glasgow. The artist, Brian Jenkins, himself disabled, produced a remarkable work for the 'British Art Show' in 1990. Jenkins is a photographer, but for this show and again in Edinburgh in 1991 he produced a huge self-portrait. In his statement in the catalogue, he put his objective very succinctly: 'My work is made as an exploration of defiance, creating difficulties and obstacles which I strive to overcome.'[5](188)

The objective of 'Lux Europae' was to bring together artists from all the member countries of the European community, but it also provided an opportunity for younger Scottish artists like Kenny Hunter to appear before a wider public. George Wyllie's kind of ideas-based interventions have also found an echo in the work of some of the younger artists associated with the Transmission Gallery in Glasgow, such as Douglas Gordon (*b.* 1966), Christine Boland (*b.* 1965) and Ross Sinclair (*b.* 1966). More than anything, it is this continuing engagement of the artist, not just with the superficial issues that face society but with the need constantly to struggle to formulate and reformulate values, that has distinguished art in Scotland. In a very different

style but with similar objectives, Sandy Stoddart has promoted in Glasgow a remarkable return to the idea of the civic monument. Working on his own initiative, he successfully realised a series of very large-scale sculptures for the new Italian Centre and the Athenaeum in Glasgow. Using classical figures such as the gods Mercury and Athena, he has sought to reinvest his art with the full moral rhetoric of neo-classicism (189).

Although media pressure has always been towards art that is instantly newsworthy, this has not deflected artists from their purpose. Some, like George Wyllie and David Mach, have successfully exploited it. Others have ignored it, but have gone on to make some of the most serious and challenging work of recent times. For 'Documenta' in 1987 (a major exhibition held every four years in Cassel in Germany), for example, Ian Hamilton Finlay made an extraordinary avenue of four full-sized guillotines (190). They were titled *A View to the Temple*, which announced the artist's challenge to the secularisation of art and through art to the secularisation of society. It declared with monumental grandeur and awesome simplicity the place of the French Revolution in the moral history of the West. In a small set of related prints, Finlay added texts by Poussin, Diderot, Robespierre and himself. It is the quotation from Diderot which perhaps explains most succinctly the place of this kind of image in his art: 'Frighten me if you will, but let the terror which you inspire in me be tempered by some grand moral idea.' Finlay's own epigram condenses this thought: 'Terror is the piety of the revolution.' It is terse, but it is also explicitly spiritual and there is a strange echo, not just of the Revolution but of the voice of the fathers of the Reformation who in Scotland created the idea of the metaphysical society.

In his two recent, major public commissions in Edinburgh, Eduardo Paolozzi, too, has attained public recognition with art at the highest level of intellectual and imaginative endeavour. The first of these commissions came from Edinburgh District Council. The result is *Manuscript of Monte Cassino* (1991). Cast in bronze, it consists of a gigantic hand, foot and

Plate 192. STEVEN CAMPBELL, *Painting in Defence of Migrants*, 1993

ankle, together with some scattered stones as though the human elements were fragments of sculpture among some unnamed classical ruin. The work is installed in front of St Mary's Cathedral, almost within sight of Paolozzi's birthplace. It is a challenging, contemplative piece of sculpture. The artist's fascination with the colossal relics of classical civilisation, present in the Monte Cassino work in the giant hand and foot, reflects his sense of the tension between the fragility of human aspiration – symbolised by two mating grasshoppers in the palm of the hand – and the scale of nature. He reflects on time and on history, on the continuing potency of the legacy of the classical tradition, but also on how even it is transient, for the passage of time has left it in ruins. But Paolozzi also reflects on the duality of his own origins, between the classicism of Italy and the classicism of Edinburgh.

The second of these commissions, *The Wealth of Nations,* installed in 1993, was commissioned by the Royal Bank of Scotland for a new building at South Gyle on the edge of Edinburgh. It must be the largest and most ambitious piece of public sculpture made in Britain for many years (191). It represents a great, fallen giant, struggling as the classical Laocöon struggled with the serpents who overpowered him, but Paolozzi's figure is struggling not with living serpents but with the abstract, mechanical shapes of the modern world of technology. The artist's works in the 1950s often had titles like *Icarus* and *Prometheus,* mythological characters who challenged the gods and were punished for their temerity. In a series of recent works that includes not only the *The Wealth of Nations,* but also such works as *Newton* and his monumental *Self-Portrait as Hephaestos,* he has returned to this theme. In them he reflects on the tensions between human aspirations and the chasms of uncertainty that surround them as a result of the exploitation of the very gifts by which they have been empowered.

In 1990 Steven Campbell mounted a major show at the Third Eye Centre in Glasgow. In the late 1980s his work had become increasingly intellectual; it was sometimes even verbal in the way it played on meanings. In the Third Eye, reacting against this yet unable to break with it completely, he created an installation that was almost anti-painting. The walls of the gallery were covered edge to edge with pictures. Light and music created an atmosphere that was more cinema than gallery. It was three years before he showed again and he did so only after a painful re-exploration of picture-making through a series of collages made in part with lengths of string – dyed, cut and glued length by length to create a surface. From this he went on to create in 1993 a remarkable series of paintings in which he took up challenges about the nature and significance of the art that he had set himself long before. As Paolozzi successfully relates the human aspirations inherent in the classical tradition in sculpture to the needs of his own time, in a key picture in this group, *Painting in Defence of Migrants,* Campbell's composition reflects that of Cézanne's great *Bathers* in the National Gallery, London (192). This is one of the primary images in modern art, yet Campbell manages to echo it in an act of homage without subordinating his own composition to it. Rather, he evolves from it something that is quite new, a picture in which he reflects on insecurity and contrasts the orderly migration of the birds with the panic-stricken flight of humans before dangers of their own making. Thus, just as Paolozzi has done in sculpture, Campbell remakes the classical tradition in painting in terms that can express the anxieties and uncertainties of the late twentieth century. It is a remarkable ambition, fulfilled with great success.

In a very different way, but with the same theme of migration and the insecurity of modern life as Campbell in his *Painting in Defence of Migrants,* Will Maclean in his recent work has looked back, not so much to the origins of modernism in the wider sense, but to one of the greatest images of early modern art in Scotland. In a work called *The Emigrant Ship* (193), he consciously invokes McTaggart's great painting, *The Sailing of the Emigrant Ship.* Indeed, he incorporates a small version of McTaggart's picture into his own work which, like a number of his recent compositions, is more a painting than a relief or construction – and Maclean did train as a painter. At the centre of this work is a rendering of the lattice window of a church, a reference to the

church at Glencalvie in Sutherland where the people, driven out of their homes in the Clearances, sought shelter and were denied it. In their despair, one of them wrote on the window of the church that they were 'the wicked generation'. Guiltless, they took upon themselves the guilt of those who persecuted them. For both Maclean and McTaggart, the Clearances and the forced emigration that accompanied them were a particular historical tragedy, felt in a very personal way. They were, however, also an opportunity to make a work that could reflect more widely on man's inhumanity to man, on the gap between innocence and experience and the perennial problem of coming to terms with the brutality of unredeemed nature that so often dictates human behaviour.

The common theme of these two works unites the end of this book with its beginning, not, I believe, because of the coincidence of one artist's interest in art history, but because of the underlying continuity and the profound seriousness of the concerns and ambitions of the artists whose story I have endeavoured to tell.

Plate 193. WILL MACLEAN, *The Emigrant Ship*, 1992

NOTES

INTRODUCTION

1. See p.13

CHAPTER ONE

1. In the preceding sentences, Mackintosh had written: 'But it will still require many years of hard, earnest work by the leaders of the modern movement before all obstacles have been swept aside, wholly or even in part. First, the "artistic" – if you will forgive me the word – scoffers must be suppressed, and those who have been influenced by such scoffers must be taught through constant and unrelenting efforts and the gradual success of the modern trend that this is no foolish hobby-horse for a few who wish to become famous easily by way of eccentricity . . .' quoted in W.G. Fisher, *Wiener Werkstatte* (London, 1990), p.26.

2. Richard Muther, *A History of Modern Painting* (1896), IV, pp.34–5, quoted in Maria Makela, *The Munich Secession* (Princeton, 1990), and Roger Billcliffe, *The Glasgow Boys* (London, 1985), p.297.

3. Melville's picture has several features in common with Guthrie's masterpiece, *The Hind's Daughter,* and the comparison reveals how Guthrie, too, challenges the simple-mindedness of this agricultural pastoralism, or at least his sitter does. She looks straight out of the picture with complete self-possession and even implicitly threatens us with her knife. In this exchange between Melville and Guthrie, the key picture is Melville's lost portrait of a little girl, *Evie,* which seems to have been inspired by Manet's *Bar at the Folies Bergères.* See Duncan Macmillan, *Scottish Art 1460–1990* (Edinburgh, 1990), p.264.

4. At the British Independent Exhibition.

5. Paper to the Edinburgh Architectural Association, 1917.

6. Margaret Armour, 'Mural Decoration in Scotland', *Studio* x, 1897.

7. The text of the scheme and so no doubt of the music that they are singing is in fact the canticle 'Benedicite Omnia Opera'; see Elizabeth Cumming, *Phoebe Anna Traquair* (Scottish National Portrait Gallery, 1993), p.17

8. Ibid., p.29.

9. From Pater's character, Denys l'Auxerrois, from *Imaginary Portraits;* ibid, p.65.

10. Sir John Cockburn recorded how it was *The Evolution of Sex* that led him in the 1890s in South Australia to promote what was to become the first woman's franchise in history. Philip Boardman, *The Worlds of Patrick Geddes* (London, 1978), p.436

11. I am indebted to Frankie Jenkins for this suggestion.

12. Jude Burkhauser in *Glasgow Girls,* (Edinburgh, 1990), p.102 argues that the rose design originated with Jessie Newbery, *c*.1900. This may be so, but the design principle was common to this whole group.

13. Tom Hewlett, *Cadell* (London and Edinburgh, 1980), p.40.

14. James Caw, *Scottish Painting 1620–1908* (London, 1908), pp.433–35.

15. J.D. Fergusson, *Modern Scottish Painting* (Glasgow, 1943), p.95.

16. John Middleton Murry, *Between Two Worlds* (London, 1935), p.135.

17. Henri Bergson, *Creative Evolution,* edited and translated by F.L. Pogson (London, 1959), p.186.

18. The title is probably related to the word Eurhythmic, a contemporary neologism created by Emile Jaques-Dalcroze.

19. Helen Meller, *Patrick Geddes, Social Evolutionist and City Planner* (London, 1990), p.19.

20. *Scotland*, Spring 1937, p.17.

CHAPTER TWO

1. *Cloud Howe* in *A Scots Quair* (London, 1946), p.230.

2. Quoted in John Kemplay, *The Edinburgh Group* (Edinburgh City Art Centre, 1983), p.7.

3. For a biography of Robertson and of Cecile Walton, see John Kemplay, *The Two Companions* (Edinburgh, 1991).

4. William McCance, 'The Idea in Art', *The Modern Scot,* I, no.2, 1930.

5. William Johnstone, *Points in Time* (London, 1980), p.177.

6. Lewis Grassic Gibbon, 'The Land' in *A Scots Hairst* (London, 1967), pp.73–74.

7. 'Art and Atavism: the Dryad', *Scottish Art and Letters,* no.1, 1944, pp.47–49.

8. Thomas Hart Benton, 'Mechanics of Form Organisation in Painting', *The Arts,* November 1926.

9. 25 April 1934, property of Ian Fleming.

10. See Ian Hamilton Finlay and Duncan Macmillan, *The Poor Fisherman* (Talbot Rice Gallery, 1991).

11. Private letter.

CHAPTER THREE

1. Margaret Morris, *The Art of J.D. Fergusson* (Glasgow, 1974), p.179.

2. J.D. Fergusson, *Modern Scottish Painting* (1943), p.46.

3. Hugh MacDiarmid, *Aesthetics in Scotland* (MS written in 1950), edited by Alan Bold and published in Edinburgh, 1984; Ian Finlay, *Art in Scotland* (Oxford 1948).

4. *Million,* edited by John Singer (Glasgow, 1943), p.40.

5. Inscribed by Crane in the marquetry floor of the South London Art Centre, Camberwell.

6. Herbert Read, *New Aspects of British Sculpture,* Venice Biennale, 1952.

7. Quoted in Sarah Wilson, *William Gear, 75th Birthday Exhibition,* Redfern Gallery (London, 1990), p.9.

8. Quoted Alan Bowness, *Alan Davie* (London, 1967), p.16.

9. Talbot Rice Gallery, 1979.

10. *Uppercase No. 1,* quoted in Diane Kirkpatrick, *Eduardo Paolozzi* (London, 1970), p.38.

11. Quoted in Andrew Patrizio, *Alan Davie* retrospective exhibition, McLellan Gallery (Glasgow, 1992).

12. Edith Hoffman, *Oskar Kokoschka,* 1947

13. Quoted in Roger Billcliffe, *Robin Philipson Retrospective* (Edinburgh College of Art, 1989).

14. Ibid.

15. James Caw, *Scottish Painting, Past and Present* (1908), p.495.

16. Edward Gage, *The Eye in the Wind: Scottish Painting Since 1945* (London, 1977); Jack Firth, *Scottish Watercolour Painting* (Edinburgh, 1979).

CHAPTER FOUR

1. The Royal Glasgow Institute, the Scottish Society of Artists, the Royal Scottish Society of Watercolour Painters, the Scottish Society of Women Artists, now the Scottish Society of Artists and Artist Craftsmen.

2. Mark Boyle, *Beyond Image: Boyle Family,* Hayward Gallery, 1986–87, quoted in Hartley, *Scottish Art Since 1900* (NGS, 1989), p.37.

3. *Inscape* (Scottish Arts Council, 1975).

4. Paragon Press and printed at Peacock Printmakers.

CHAPTER FIVE

1. The Wicker men of the Druids were colossal images of wicker-work or wood which used to be burnt at the midsummer festivals in many parts of Europe. See Sir James Frazer, *The Golden Bough* (abridged edition, London, 1959), pp.654–55.

2. In *George Wyllie: Scul?ture Jubilee* (Third Eye Centre, 1991), p.54.

3. Ibid, p.58

4. *Walk on: Six Artists from Scotland,* Jack Tilton Gallery, New York. The artists involved were Craig Robertson, Kevin Henderson, Douglas Gordon, Karen Forbes, Graeme Todd and Angus Hood, with an introduction by Murdo MacDonald.

5. *The British Art Show 1990,* the South Bank Centre.

LIST OF PLATES

copyright © Christies

Plate 14. Frances Macdonald, *The Choice*, n.d., watercolour, pencil and gold paint on paper, 35 x 30.6cm, Hunterian Museum and Art Gallery, the University of Glasgow

Plate 15. Jessie M. King, *Kind Fates Attend the Voyaging*, 1909, pen, ink, watercolour and gold, 30.5 x 26cm, Barclay Lennie Fine Art

Plate 16. John Duncan RSA RSW, *A Symbolist Head*, *c.*1905, tempera on panel, 44.1 x 36.75cm, Private Collection, photo: courtesy of Bourne Fine Art

Plate 17. Charles Rennie Mackintosh RSW, *Gilardia, Walberswick*, 1914, pencil and watercolour, 24.5 x 18.2cm, Glasgow School of Art Collection

Plate 18. Robert Brough ARSA, *Dolly Crombie*, *c.*1896, oil on canvas, 128.7 x 118.8cm, Aberdeen Art Gallery

Plate 19. John Campbell Mitchell RSA, *Low Tide with Three Figures Bathing*, 1917, oil on canvas, 98 x 68.6cm, the University of Edinburgh, gift of Lord Cameron

Plate 20. Stanley Cursiter RSA PRSW, *The Cliffs, Yesnaby, Orkney*, 1950, oil on canvas, 49.5 x 60.5cm, the Robertson Collection, Orkney

Plate 21. Samuel John Peploe RSA, *Street in Paris*, *c.*1907, oil on canvas, 27.2 x 22.2cm, Christies Scotland Ltd

Plate 22. Samuel John Peploe RSA, *Still-Life: Roses in a Blue and White Vase*, *c.*1924, oil on canvas, 50.8 x 40.6cm, Christies Scotland Ltd

Plate 23. Samuel John Peploe, *Cyclamen*, *c.*1930, oil on canvas, 42.9 x 36.75cm, Hope Scott Collection, the University of Edinburgh

Plate 24. John Duncan Fergusson, *Les Eus*, *c.*1910-13, oil on canvas, 213 x 274cm, Hunterian Art Gallery and Museum, the University of Glasgow

Plate 25. John Duncan Fergusson, *Rhythm*, 1911, oil on canvas, 163 x 115.5cm, the University of Stirling

Plate 26. John Duncan Fergusson, *The Chinese Coat*, 1908, oil on canvas, 98 x 88.2cm, Private Collection, courtesy of Bourne Fine Art

Plate 27. Francis Campbell Boileau Cadell, *Iona*, *c.*1924, oil on board, 37.5 x 44.5cm, Christies Scotland Ltd

Plate 28. Francis Campbell Boileau Cadell, *Reflections*, *c.*1915, oil on canvas, 116.8 x 101.6cm, Glasgow Art Gallery and Museums

Plate 29. Francis Campbell Boileau Cadell, *The Red Chair*, *c.*1920, oil on canvas, 61 x 50.8cm, Private Collection, courtesy of Tom Hewlett

Plate 30. George Leslie Hunter, *Still-life with Fruit on a White Tablecloth*, 1921, oil on canvas, 41.65 x 51.45cm, Private Collection, courtesy of Bourne Fine Art

Plate 31. George Leslie Hunter, *Houseboats, Balloch*, *c.*1924, oil on canvas, 45.7 x 55.9cm, Glasgow

Art Gallery and Museums

Plate 32. Sir David Young Cameron RA RSW RWS ARSA, *Tewkesbury Abbey*, 1915, etching and drypoint, 42.2 x 22.5cm, Hunterian Art Gallery and Museum, the University of Glasgow

Plate 33. William Strang RA, *Socialists*, 1891, etching, 25.4 x 30.5cm, Hunterian Art Gallery and Museum, the University of Glasgow

Plate 34. James Pryde, *Lumber: a Silhouette*, *c.*1920, oil on canvas, 151.8 x 131.1cm, Scottish National Gallery of Modern Art

Plate 35. Sir Muirhead Bone HRSA HRWS, *The Great Gantry, Charing Cross*, 1906, etching and drypoint, 28 x 43.5cm, Hunterian Art Gallery and Museum, the University of Glasgow

Plate 36. Sir Muirhead Bone HRSA HRWS, *A Via Dolorosa: Mouquet Farm* from *The Western Front*, 2 vols (London, 1917)

CHAPTER TWO

Plate 37. Alice and Morris Meredith Williams, detail of the frieze of servicemen and women in the Shrine, the Scottish National War Memorial, *c.*1927, bronze, by courtesy of the Trustees, photo: Joe Rock

Plate 38. Pilkington Jackson ARSA, *Reveille*, *c.*1925-27, gilt bronze, life-size, the Scottish National War Memorial, by courtesy of the Trustees, photo: Joe Rock

Plate 39. Phyllis Bone RSA, *Reindeer*, *c.*1927, cast concrete, Zoology Building, the University of Edinburgh, architect Sir Robert Lorimer

Plate 40. Alexander Carrick RSA, *Royal Engineers Memorial*, the Scottish National War Memorial, *c.*1925, bronze, by courtesy of the Trustees, photo: Joe Rock

Plate 41. Robert Douglas Strachan HRSA, *Cain*, *c.*1927, detail of stained-glass window in the Shrine, the Scottish National War Memorial, by courtesy of the Trustees, photo: Joe Rock

Plate 42. Cecile Walton, *Romance*, 1920, oil on canvas, 101.6 x 152.4cm, Private Collection, photo: Joe Rock

Plate 43. Eric Robertson, *Le Ronde Eternel*, 1920, oil on canvas, 161.7 x 147cm, Private Collection, courtesy of Bourne Fine Art

Plate 44. John Bulloch Souter, *The Breakdown*, 1926-62, oil on canvas, 50.8 x 53.3cm, Private Collection, courtesy of Tom Fidelo

Plate 45. David MacBeth Sutherland RSA, *Donkey Rides, Portobello Beach*, *c.*1926, oil on canvas, 98 x 122.5cm, Robert Fleming Holdings Plc

Plate 46. Norah Neilson Gray, *The Belgian Refugee*, 1916, oil on canvas, 125.7 x 87.6cm, Glasgow City Art Gallery and Museums

CHAPTER THREE

CHAPTER FOUR

CHAPTER FIVE

SELECT BIBLIOGRAPHY

A bibliography up to 1990 will be found in *Scottish Art 1460-1990*. Except for major works or where no modern alternative exists, this present bibliography is limited to recent publications. Books and exhibition catalogues are cited without distinction.

General Books and Catalogues

Mungo Campbell, *The Line of Tradition*, National Galleries of Scotland (Edinburgh, 1993)

Ian Finlay, *Art in Scotland* (Oxford, 1948)

Jack Firth, *Scottish Watercolour Painting* (Edinburgh, 1979)

Robert Fleming Holdings plc, *A Picture of Flemings*, 3 vols. Text for vols 2 and 3 by Bill Smith (privately printed, London, n.d)

Andrew Gibbon-Williams and Andrew Brown, *The Bigger Picture* (London, 1993)

Esmé Gordon, *The Royal Scottish Academy 1826-1976* (Edinburgh, 1976)

Julian Halsby, *Scottish Watercolours 1740-1940* (London, 1986)

William Hardie, *Scottish Painting 1837 to the Present* (London, 1990)

Bill Hare, *Contemporary Painting in Scotland* (Sydney, 1993)

Paul Harris and Julian Halsby, *The Dictionary of Scottish Painters 1600-1960* (Edinburgh and Oxford, 1990)

Keith Hartley, *Scottish Art Since 1900*, Scottish National Gallery of Modern Art (Edinburgh, 1989)

Wendy Kaplan (ed.), *Scotland Creates: 5000 Years of Art and Design*, Glasgow Museums and Galleries (Glasgow, 1990)

Duncan Macmillan, *Scottish Art 1460-1990* (Edinburgh, 1990)

National Gallery of Scotland (Fiona Pearson and others) *Virtue and Vision, Sculpture and Scotland 1540-1990* (Edinburgh, 1991)

National Galleries of Scotland, *Scotland's Pictures* (Edinburgh, 1990)

Cordelia Oliver, *Painters in Parallel*, Scottish Arts Council (Edinburgh, 1978)

Paul Scott (ed.), *Scotland: a Concise Cultural History* (Edinburgh, 1993)

The Concise Catalogue of the Scottish National Gallery of Modern Art (Edinburgh, 1993)

Anne Wishart and Cordelia Oliver, *The Scottish Society of Artists: The First 100 Years*, Scottish Society of Artists (Edinburgh, 1991)

Groups of Artists and Topics

Barbican Art Gallery, *A Paradise Lost: The Neo-Romantic Imagination in Britain 1935-55* (London, 1988)

Barbican Art Gallery, *The Last Romantics* (London, 1989)

Roger Billcliffe, *The Glasgow Boys* (London, 1985)

Roger Billcliffe, *The Scottish Colourists* (London, 1989)

Jude Burkhauser (ed.), *Glasgow Girls: Women in Art and Design 1880-1920* (Edinburgh, 1990)

The Compass Gallery, *The Compass Contribution: 21 Years of Contemporary Art, 1969-1990* (Glasgow, 1990)

Elizabeth Cumming, *Glasgow 1900*, Van Gogh Museum (Amsterdam, 1992)

Alan Dunn and others, *The Bellgrove Station Billboard Project* (Glasgow, 1990)

Edinburgh College of Art, *The Edinburgh School* (Edinburgh, 1972)

Denis Farr, *New Painting in Glasgow 1940-46*, Scottish Arts Council (Edinburgh, 1968)

The Fine Art Society, *Glasgow 1900* (Glasgow and Edinburgh, 1979)

T.S. Halliday and George Bruce, *Scottish Sculpture: a Record of Twenty Years* (Dundee, 1946)

William Hardie, *The Hills of Dream Revisited*, Dundee Art Galleries and Museums (Dundee, 1973)

John Kemplay, *The Edinburgh Group*, City of Edinburgh Art Centre (Edinburgh, 1983)

An Lanntair, Stornoway, *As an Fhearann: From the Land; a Century of Images of the Scottish Highlands* (Edinburgh, 1986)

Duncan Macmillan and others, *Scottish Art Now*, Scottish Arts Council (Edinburgh, 1982)

Duncan Macmillan and others, *The Scottish Show*, Oriel Gallery (Wales, 1988)

Paul Overy, *Inscape*, Scottish Arts Council (Edinburgh, 1975)

Pamela Robertson, *From McTaggart to Eardley: Scottish Watercolours and Drawings (1870-1950),* Hunterian Art Gallery (Glasgow, 1986)

Scottish Arts Council, *Scottish Realism* (Edinburgh, 1971)

The Scottish Gallery, *Contemporary Art from Scotland 1981-82* (Edinburgh, 1982)

Scottish National Gallery of Modern Art, *The Vigorous Imagination: New Scottish Art* (Edinburgh, 1987)

Individual Artists

(Monographs or substantial catalogues in alphabetical order by artist)

Why I Choose Red: Sam Ainslie, Third Eye Centre (Glasgow, 1987)

Craigie Aitchison: Paintings 1953-1981, Arts Council of Great Britain (London, 1982)

Craigie Aitchison: New Paintings, Thomas Gibson Fine Art (London, 1993)

Donald Bain, William Montgomerie (Glasgow, 1950)

Donald Bain, Dundee Art Gallery (Dundee, 1972)

Donald Bain: Memorial Exhibition, Glasgow Print Studio (Glasgow, 1980)

Edward Baird, Montrose Public Library (Montrose, 1981)

Edward Baird 1904-1949, Patrick Elliot, National Galleries of Scotland (Edinburgh, 1992)

Wilhelmina Barns-Graham: Retrospective 1940-1989, Douglas Hall (Edinburgh, 1988)

John Bellany, Scottish National Gallery of Modern Art (Edinburgh, 1986)

A Long Night's Journey into Day: the Art of John Bellany, Sandy Moffat, Glasgow Art Gallery and Museum (Glasgow, 1992)

John Bellany, John McEwen (Edinburgh, 1994)

Elizabeth Blackadder Retrospective, Scottish Arts Council (Edinburgh, 1981)

Elizabeth Blackadder, Judith Bumpus (Oxford, 1988)

Muirhead Bone: Portrait of the Artist, Peter Trowles, Crawford Centre for the Arts (St Andrews, 1986)

Mark Boyle: Journey to the Surface of the Earth, ICA (London, 1969)

(Mark Boyle) *Beyond Image: Boyle Family Exhibition*, Hayward Gallery (London, 1986)

Philip Braham, Raab Gallery (London, 1989)

Cadell: The Life and Work of a Scottish Colourist, Tom Hewlett (London and Edinburgh, 1988)

Joyce Cairns: Ship to Shore, Peacock Printmakers (Aberdeen, 1991)

(Robert Callender) *Sea Salvages*, Talbot Rice Gallery (Edinburgh, 1989)

D.Y. Cameron: The Vision of the Hills, Bill Smith (Edinburgh, 1992)

Steven Campbell, Fruitmarket Gallery and Riverside Studios (London and Edinburgh, 1984)

Steven Campbell: On Form and Fiction, Third Eye Centre (Glasgow, 1990)

The Paintings of Steven Campbell: The Story So Far, Duncan Macmillan (Edinburgh, 1993)

Doug Cocker: Sculpture and Related Works 1976-86, Third Eye Centre (Glasgow, 1986)

Colquhoun and MacBryde: A Retrospective, Glasgow Print Studios (Glasgow, 1990)

Calum Colvin: Works 1989, Salama-Caro Gallery (London, 1989)

Calum Colvin, Fruitmarket Gallery (Edinburgh, 1990)

Calum Colvin: The Seven Deadly Sins and the Four Last Things, Portfolio Gallery (Edinburgh, 1993)

Stephen Conroy, Marlborough Fine Art (London, 1989)

James Cowie, Richard Calvacoressi, Scottish National Gallery of Modern Art (Edinburgh, 1979)

James Cowie, Cordelia Oliver (Edinburgh, 1980)

(Hugh Adam Crawford) *Crawford and Company*, Cordelia Oliver, Third Eye Centre (Glasgow, 1978)

William Crosbie, Scottish Gallery (Edinburgh, 1980)

William Crozier, Scottish Gallery (Edinburgh, 1989)

Ken Currie, Third Eye Centre (Glasgow, 1988)

(Ken Currie) *The People's Palace History Paintings: A Short Guide*, Glasgow Museums and Art Gallery (Glasgow, 1990)

Ken Currie: The Age of Uncertainty, Glasgow Print Studio (Glasgow, 1992)

Stanley Cursiter Centenary Exhibition, Pier Art Centre (Stromness, 1987)

Alan Davie, Alan Bowness (London, 1967)

Alan Davie: Works on Paper, Duncan Macmillan and others, Talbot Rice Gallery and British Council (Edinburgh and London, 1992)

Alan Davie, Douglas Hall and Michael Tucker (London, 1992)

(Richard Demarco) *The Artist As Voyager: New Work by Will Maclean and Richard Demarco*, Alan Woods, Peacock Printmakers (Aberdeen, 1991)

Kenneth Dingwall, Scottish Arts Council (Edinburgh, 1977)

David Donaldson, Roger Billcliffe, Glasgow Museums and Galleries (Glasgow, 1983)

Patricia Douthwaite: Paintings and Drawings 1951-88, Third Eye Centre (Glasgow, 1988)

Joan Eardley, William Buchanan (Edinburgh, 1976)

Joan Eardley, Cordelia Oliver (Edinburgh, 1988)

Joan Eardley 1921-1963, Fiona Pearson, National Galleries of Scotland (Edinburgh, 1988)

J.D. Fergusson Memorial Exhibition, Andrew Maclaren Young, Scottish Arts Council (Edinburgh, 1961)

The Art of J.D. Fergusson: A Biased Biography, Margaret Morris (Glasgow, 1974)

(J.D. Fergusson) *Colour, Rhythm and Dance*, Elizabeth Cumming and others, Scottish Arts Council (Edinburgh, 1985)

Ian Hamilton Finlay, Frankfurter Kunstverein, 3 vols (Frankfurt, 1991). (Vol. 1 by Thomas Kellein also published Basel, 1990)

(Ian Hamilton Finlay) *The Poor Fisherman*, Duncan Macmillan and Ian Hamilton Finlay, Talbot Rice Gallery (Edinburgh, 1991)

Evening will come. They will sew the blue sail: Ian Hamilton Finlay and the Wild Hawthorn Press 1958-1991, Graeme Murray (Edinburgh, 1991)

Ian Hamilton Finlay: A Visual Primer, Yves Abrioux (new edition, London, 1993)

Ian Fleming, Peacock Printmakers (Aberdeen, 1982)

William Gear, Karl and Faber (Munich, 1988)

William Gear: 75th Birthday Exhibition, Sarah Wilson, Redfern Gallery (London, 1990)

W.G. Gillies: Retrospective Exhibition, Scottish Arts Council (Edinburgh, 1970)

William Gillies, T. Elder Dickson (Edinburgh, 1974)

William Gillies: A Very Still Life, W. Gordon Smith (Edinburgh, 1991)

Gwen Hardie: Paintings and Drawings, Fruitmarket Gallery (Edinburgh, 1987)

Gwen Hardie: New Paintings etc, Scottish National Gallery of Modern Art (Edinburgh, 1990)

Gwen Hardie: Mind in Body, Annely Juda Fine Art (London, 1994)

Jake Harvey: Sculpture 1972-1993, Duncan Macmillan and Douglas Hall, Talbot Rice Gallery (Edinburgh, 1993)

J.W. Herald, Kenneth Roberts (Forfar, 1988)

John Houston: Works on Paper, Duncan Macmillan (Edinburgh, 1987)

John Houston: Paintings, Scottish Gallery (Edinburgh, 1990)

Ian Howard: Paintings, Prints and Related Works, Third Eye Centre (Glasgow, 1987)

Peter Howson, Flowers East (London, 1991)

Peter Howson, Robert Heller (Edinburgh, 1993)

Ian Hughes, Scottish National Gallery of Modern Art (Edinburgh, 1988)

Kenneth Hunter: Hyperboreans, Compass Gallery (Glasgow, 1992)

Introducing Leslie Hunter, T.J. Honeyman (London, 1937)

Margaret Hunter: Idea and Images, 369 Gallery (Edinburgh, 1988)

Margaret Hunter: Changing Places, Collins Gallery, University of Strathclyde (Glasgow, 1992)

Alan Johnston, Owen Griffith, The Fruitmarket (Edinburgh, 1987)

(Alan Johnston) *The Artist, the Mountain and the Plain*, Mark Francis, MOMA (Oxford, 1978)

(Alan Johnston) *Between the Natures*, Mikio Takata, Gallery Shimada Yamaguchi (Tokyo, 1989)

Alan Johnston, Pier Gallery and Fruitmarket Gallery (Stromness and Edinburgh, 1988)

Alan Johnston at Haus Wittgenstein, Joseph Masheck (Vienna, 1994)

Dorothy Johnstone, Aberdeen Art Gallery (Aberdeen, 1983)

Points in Time: An Autobiography, William Johnstone (London, 1980)

William Johnstone, Douglas Hall (Edinburgh, 1980)

William Johnstone, Arts Council of Great Britain (London, 1981)

(William Johnstone) *The Hope Scott Collection of the University of Edinburgh*, Duncan Macmillan, Talbot Rice Gallery (Edinburgh, 1991)

The Enchanted World of Jessie M. King, Colin White (Edinburgh, 1989)

Jack Knox: Paintings and Drawings 1960-83, Cordelia Oliver, Third Eye Centre (Glasgow, 1983)

Gerald Laing: A Retrospective 1962-1993, Fruitmarket Gallery (Edinburgh, 1993)

William Lamb 1893-1951: Catalogue of the Contents of the William Lamb Memorial Studio, Norman K. Atkinson (Montrose, 1979)

Hew Lorimer, Duncan Macmillan, Talbot Rice Gallery (Edinburgh, 1988)

(Sir Robert Lorimer) *Lorimer and the Edinburgh Arts and Craft Designers*, Peter Savage (Edinburgh, 1980)

Eileen Lawrence, Bath Festival (Bath, 1986)

Eileen Lawrence: Paintings 1977-1992, Usher Gallery and Fruitmarket Gallery (Lincoln and Edinburgh, 1992)

Bet Low, Cordelia Oliver, Third Eye Centre (Glasgow, 1985)

The Early Life of James McBey: An Autobiography 1883-1911, Nicholas Barker (ed.) (Oxford, 1977)

(Robert MacBryde) *Colquhoun and MacBryde: A Retrospective*, Glasgow Print Studios (Glasgow, 1990)

William McCance (1894-1970), Dundee City Art Gallery (Dundee, 1975)

William McCance 1894-1970, Patrick Elliott, National Galleries of Scotland (Edinburgh, 1990)

Tom Macdonald, Third Eye Centre (Glasgow, 1976)

Tom Macdonald: Paintings, Drawings and Theatre Designs, Third Eye Centre (Glasgow, 1986)

Rory McEwen: The Botanical Paintings, Douglas Hall, Royal Botanic Gardens (Edinburgh, 1988)

Jock McFadyen, Scottish Gallery (London, 1989)

David Mach: 101 Dalmatians, Tate Gallery (London, 1988)

David Mach: Fuel for the Fire, Mel Gooding, Riverside Studios (London, 1986)

Charles Rennie Mackintosh and the Modern Movement, Thomas Howarth (London, 1977)

Mackintosh Watercolours, Roger Billcliffe (London, 1978)

C.R. Mackintosh: The Poetics of Workmanship, David Brett (London, 1992)

Margaret Macdonald Mackintosh, Pamela Reekie, Hunterian Art Gallery (Glasgow, 1983)

Bruce McLean, Mel Gooding (Oxford, 1990)

John McLean, Francis Graham-Dixon Gallery (London, 1991)

John McLean, Talbot Rice Gallery (Edinburgh, 1994)

Talbert Mclean, Duncan Macmillan, Talbot Rice Gallery (Edinburgh, 1991)

Will Maclean: Sculptures and Box Constructions, 1974-1987, Alan Woods, Claus Runkel Fine Art (London, 1987)

Will Maclean, New Work, Duncan Macmillan, Runkel-Hue-Williams (London, 1990)

The Artist As Voyager: New Work by Will Maclean and Richard Demarco, Alan Woods, Peacock Printmakers (Aberdeen, 1991)

Symbols of Survival: The Art of Will Maclean, Duncan Macmillan (Edinburgh, 1992)

William MacTaggart, H. Harvey Wood (Edinburgh, 1974)

William McTaggart 1885-1910, Lindsay Errington, National Gallery of Scotland (Edinburgh, 1989)

John Maxwell, Scottish National Gallery of Modern Art (Edinburgh, 1976)

John Maxwell, David McLure (Edinburgh, 1976)

Margaret Mellis 1940-1987, Redfern Gallery (London, 1987)

A View of the Portrait: Portraits by Sandy Moffat, Scottish National Portrait Gallery (Edinburgh, 1973)

Seven Poets: An Exhibition of Paintings and Drawings by Sandy Moffat, Third Eye Centre (Glasgow, 1981)

(Margaret Morris) *Colour Rhythm and Dance*, Elizabeth Cumming and others, Scottish Arts Council (Edinburgh, 1985)

James Morrison, Scottish Gallery (Edinburgh, 1988)

Alberto Morrocco, Clara Young and Victoria Keller (Edinburgh, 1993)

(Elizabeth Ogilvie) *Sea Papers*, Talbot Rice Gallery (Edinburgh, 1984)

(Elizabeth Ogilvie) *Sea Sanctuary*, Duncan Macmillan, Talbot Rice Gallery (Edinburgh, 1989)

(Glen Onwin) *Saltmarsh*, David Brown, Scottish Arts Council (Edinburgh, 1975)

(Glen Onwin) *The Recovery of Dissolved Substances*, Arnolfini Gallery (Bristol, 1978)

(Glen Onwin) *Revenges of Nature*, Fruitmarket Gallery (Edinburgh, 1988)

Eduardo Paolozzi, Diane Kirkpatrick (London, 1970)

The Complete Prints of Eduardo Paolozzi, Rosemary Miles, Victoria and Albert Museum (London, 1977)

Eduardo Paolozzi, *Lost Magic Kingdoms*, Museum of Mankind (London, 1985)

Paolozzi Portraits, Robin Spencer, National Portrait Gallery (London, 1988)

(Eduardo Paolozzi) *Nullius in Verba*, Duncan Macmillan and others, Talbot Rice Gallery (Edinburgh, 1988)

Jacki Parry, *Daly River Night: Images of North-Western Australia*, Third Eye Centre (Glasgow, 1988)

James McIntosh Patrick, Roger Billcliffe, MacManus Art Gallery (Dundee, 1987)

Frances Pelly: Nousts, Pier Gallery (Stromness, 1992)

Denis Peploe, Scottish Gallery (London, 1990)

(S.J. Peploe) *Peploe: An Intimate Memoir of the Artist and his Work*, Stanley Cursiter (London, 1947)

S.J. Peploe, Guy Peploe, National Gallery of Scotland (Edinburgh, 1988)

Robin Philipson, Maurice Lindsay (Edinburgh, 1974)

Robin Philipson, Roger Billcliffe, Edinburgh College of Art (Edinburgh, 1989)

J.Q. Pringle, David Brown, Scottish Arts Council (Edinburgh, 1981)

James Pryde, Scottish National Gallery of Modern Art (Edinburgh, 1992)

June Redfern: To the River, Third Eye Centre (Glasgow, 1985)

June Redfern: Artist in Residence, National Gallery (London, 1986)

Anne Redpath, Patrick Bourne (Edinburgh, 1989)

Four Seasons: Paintings by Derek Roberts, Laing Art Gallery (Newcastle, 1988)

Derek Roberts, Francis Graham-Dixon (London, 1994)

The Two Companions: The Story of Two Scottish Artists, Eric Robertson and Cecile Walton, John Kemplay (Edinburgh, 1991)

Bronze in My Blood: The Memoirs of Benno Schotz, Benno Schotz (Edinburgh, 1981)

Gavin Scobie, Duncan Macmillan (Edinburgh, 1984)

Gavin Scobie: Recent Sculptures, Reed's Wharf Gallery, (London, 1994)

Duncan Shanks: Falling Water, Duncan Macmillan, Talbot Rice Gallery (Edinburgh, 1988)

Duncan Shanks: Patterns of Flight, Roger Billcliffe, (Wrexham, 1991)

Duncan Shanks: Hill of Fire, Roger Billcliffe Fine Art (Glasgow, 1994)

The Stained-Glass Windows of Douglas Strachan, A.C. Russell (Aberlemno, 1972)

Catalogue Raisonné of the Printed Work of William Strang, David Strang (London, 1962)

William Strang RA, 1859-1921, Philip Athill, Sheffield City Art Galleries (Sheffield, 1981)

D.M. Sutherland (1883-1973), Aberdeen Art Gallery, (Aberdeen, 1974)

John Taylor: Paintings Prints and Drawings, 1961-82, Third Eye Centre (Glasgow, 1982)

Phoebe Anna Traquair, Elizabeth Cumming, National Gallery of Scotland (Edinburgh, 1993)

William Turnbull, Richard Morphet, Tate Gallery (London, 1971)

William Turnbull: Sculptures, Waddington Galleries (London, 1987)

Frances Walker: The Tiree Works, Peacock Printmakers (Aberdeen, 1990)

(Cecile Walton) *The Two Companions: The Story of Two Scottish Artists, Eric Robertson and Cecile Walton*, John Kemplay (Edinburgh, 1991)

Alison Watt, The Scottish Gallery (London, 1990)

Tom Whalen, Saltire Society (Hamilton, 1973)

(Kate Whiteford) *Votives and Libations in Summons to the Oracles*, Crawford Art Gallery (St Andrews, 1983)

Kate Whiteford, Rites of Passage, Third Eye Centre (Glasgow, 1984)

(Kate Whiteford) *Sitelines*, Martin Kemp, Graeme Murray Gallery (Edinburgh, 1992)

William Wilson, Fiona Pearson, National Galleries of Scotland (Edinburgh, 1994)

Adrian Wiszniewski, Walker Art Gallery (Liverpool, 1987)

Adrian Wiszniewski, Fruitmarket Gallery (Edinburgh, 1990)

Adrian Wiszniewski, William Hardie Fine Art (Glasgow, 1994)

George Wyllie: Scul?ture Jubilee 1966-1991, Third Eye Centre (Glasgow, 1991)

Ainslie Yule, Sculptures and Drawings, Scottish Arts Council (Edinburgh, 1978)

Ainslie Yule: Art Machine, Threescore Years and Ten, Richard Demarco, Kingston University (Kingston, 1993)

INDEX

Note: *Italic* entries refer to *Plate numbers*